BELOW FROM ABOVE

BELOW FROM ABOVE

AERIAL PHOTOGRAPHY

GEORG GERSTER

ABBEVILLE PRESS · PUBLISHERS · NEW YORK

English-language editor: Alan Axelrod
Translator: Natasha Roy

First published 1985 by Birkhäuser Basel under the title
Flugbilder.
© Georg Gerster
Abbeville Press, Inc.
Translation © Abbeville Press, Inc., 1986.

Printed and bound in Yugoslavia.

Library of Congress Cataloging-in-Publication Data

Gerster, Georg.
 Below from above.

 Translation of: Flugbilder.
 I. Photography, Aerial. I. Title.
TR810.G47 1986 779'.092'4 85-32022
ISBN 0-89659-602-8

PREFACE

In this book I offer the most exciting discoveries made in twenty years of enduring passion for aerial photography. I have borrowed forty-three images from my previously published volumes, *Grand Design (Der Mensch Auf Seiner Erde)* and *Brot und Salz.* These images have already been recognized as classics of the genre. For good reason I did not want to exclude them from the selection. Ninety aerial photographs are new.

I decided to dispense with any general theme in the presentation of these images, unless one agrees that the view from above as a means of thinking about the world is a theme in itself. With the exception of the double-page spreads, the images are always placed side by side: sinister next to bright, hot next to cold, destruction next to construction, tranquil beside shocking, puzzling next to self-evident. I expect a tension of opposites to result from the juxtaposition, so that unrelated images will find their own theme in confrontation. Mutually enlightening, the pairs complement each other formally. Each answers the opposite, sometimes in argument, occasionally with irony. No juxtaposition is intended to disparage: my apologies to the camels (plate 79) coolly swaying through the Iranian highlands, forced to share the spread with marathon skiers gasping for breath (plate 78).

I do not intend to proffer further explanations for the pairings. In the juxtaposition of Berne and Fez (plates 88, 89), one could of course philosophize about how different, though equally appealing, urban solutions to the same problem of living closely together can be, but I don't want to belabor the obvious. On the other hand, I have spared no effort in solving potential riddles by way of extended captions or by at least supplying specific and sometimes even technical information to further a factual appreciation of each object found. I see my best aerial photographs as inspiration for flights of thought—and a reliable flier will take off only after he has done his homework on the ground.

This does not prevent thoughts from occasionally flying away from or ahead of weighty explanations. So be it. But all the more gratifying if, finally searching for some pedestrian explanations, at the very end one's thoughts come down with sober questions as to *where? how? what?* and *what for?* And twice as gratifying if the imaginary reality found coincides with the photographic discovery. So, for example, if plate 1 in this book prompts viewers to think dirty thoughts, they need not be ashamed, for, as they have found out from the caption, the image really *is* about dirt.

I wish you an eventful flight.

INTRODUCTION: FOUND OBJECTS

As an aerial photographer I look for things I have not lost and find what I am not looking for. When I come to think about it, I realize that I pursue an irregular and unstructured vocation. In my country—Switzerland—invention is valued more highly than finding; the German language does not offer so much as a single word to justify the openendedness of my quest. Therefore, to cover myself, I seek refuge in an English word: *serendipity*, which denotes the faculty of finding—or, more to the point, the luck in finding—pleasant, valuable, and amusing things that one had not even dreamt of looking for.

Again, there is no German term in art history to account for the results of serendipity, the discoveries that one can keep because they belong to everyone and no one. For these I followed the example of art historians and borrowed a French expression, *objets trouvés*. And for good reason. Even French law makes no clear verbal distinction between a finder and an inventor: the one is always a little of the other.

Enough hair-splitting. However, I would like to make another preliminary remark before spilling *all* the tricks of the aerial photographer's trade. Habit covers the world around us like varnish; there is nothing as invisible as a monument in a public square. Concealed in every serious photographic endeavor is the attempt to scratch off or at least to scratch at this patina of habit, to make the world as new as on the day of Creation.

In this attempt the aerial photographer has an advantage over his earthbound colleagues—the advantage of altitude. Even close to three thousand hours of photo flight in chartered small aircraft fail to diminish my amazement at how dramatically the world changes when seen with the eagle's eyes. To be sure, oblique views are of no great interest to me; they offer little more than one can glimpse from a steeple or spire. Only a perpendicular view exhaustively deals with the potential of elevation; this perspective alone both alienates and concentrates, allowing a visually exciting tight-rope walk between information and abstraction.

For my work I generally rent small, single-engine airplanes—with a pilot, please. My aeronautical ambition has always been limited to the intention of one day attending an emergency landing class. Every time I am assigned a seventy-year-old pilot I firmly resolve finally to turn this intention into fact. Among single-engine aircraft, I prefer high-wing Cessnas, models 150 to 210. For flights over open water and for aerial photography in the mountains, I favor two engines: for example, a Britten-Norman Islander. On special occasions I have even chartered airliners, flying as the sole passenger between their scheduled flights. I allow myself the expensive comfort of a helicopter only rarely—over big cities, or sports events, or both, as in the New York City Marathon.

Requirements for rental are a door that can be removed or a window that can be fully opened. Pressurized aircraft are out of the question. I lean out during the flight. It is a drafty method, but it guarantees a nearly perpendicular downward view without expensive technical precautions and complicated flight ma-neuvers. After twenty years of such improvisation I can sing a song about the powers of persuasion sometimes required to convince a pilot to strip his plane to its skeleton. And by now my insurance company is quite familiar with the refrain: gone with the wind . . . a camera body over the Sahara, an exposure meter over the Great Barrier Reef, a wide-angle lens over the Cape of Good Hope.

What occasionally slides off my knees during a steep bank and hits the ground was part of my 35-mm equipment. From the air I work with lenses of focal lengths ranging from twenty to two hundred millimeters. I shun zoom lenses for lack of sharpness. Vibrations caused by the airplane, the slipstream, and occasional turbulence all restrict the use of telephoto lenses longer than two hundred millimeters. Use of a wide-angle lens depends on the field of vision—that is, on the type of airplane: landing gear, struts, and wing tips are usually unwanted elements in a picture.

I take up to ten loaded camera bodies on board to save expensive flying time, as a body can be changed more quickly than film. I do not have much patience with automatic cameras; in aerial work, they generally give incorrect exposure, unless you override them manually. I use filters only occasionally, sometimes a polarizing filter to reduce reflections on water.

The most important accessory is the motor drive. Motorized transport of film tremendously facilitates composition of a picture, which must be accomplished in split seconds. In solving some tricky aerographical problems the motor drive is even indispensable. I am

thinking, for example, about images that adhere strictly to the central axis and that are therefore killed by the slightest deviation from the ideal composition. Such photographs almost always fail with manual film winding because during the fly-by the shutter is habitually released too soon or too late.

Before take-off I lock the focus ring at infinity with tape, which relieves me of the job of controlling focus when the airstream makes my eyes water; after all, depth of field is not one of the worries of an aerial photographer. I normally expose at 1/500 of a second; longer exposures greatly increase the risk of blurring. In poor light conditions I have, however, made do with 1/60 of a second without the help of a gyroscopic stabilizer—provided that the discovery was right in front of the airplane's nose and could be photographed in the direction of the flight, so that angular velocity remained low.

I prefer altitudes between one and five thousand feet. Quite often, poor visibility and sometimes the airplane's operating ceiling do not allow higher altitudes. There is seldom a compelling reason for very low flying, but sometimes pilots itch to show off their flying abilities. They will brush the ears of standing corn and the white crests of waves with the plane's landing gear. Such daring frightens me.

To complete the list of my equipment: a silk hood and cold-weather mask; silk gloves to operate the camera in freezing air. I never travel without a Phillips-head screwdriver to free the window latch on a Cessna. But for this screwdriver on my pocketknife, I would have had to miss many an early morning flight; at this time of day mechanics at small airports are still

asleep. I always carry a roll of adhesive tape in my bag. In the newer Cessnas, particularly those with retractable landing gear, the uplift no longer forces the open window firmly against the wing. It limps at a half-open position, no doubt because of sound aerodynamic laws. I therefore tape the window to the underside of the wing before take-off.

In many older Cessnas one sits too low to face almost straight downward, as I desire. That is why a pillow should also be part of my baggage. But such foresight is really overdoing it a bit: a telephone directory is just as handy. Anyway, I have spent many hours of my life sitting on the Yellow Pages for Manhattan and other of the world's metropolises.

A word about the rental of the plane. It pays to drive long distances and to charter the aircraft near the target or the search area of the flight. This saves expensive flying time; but above all, if the outbound or return flight is short, one gains for shooting those priceless first or last minutes of a day, when the rising or setting sun reveals the chosen site in all its glory. An added advantage of local rental is the pilot's knowledge of the area. And it even protects you against meteorological surprises, since the weather at the point of departure is not necessarily the same as that at the destination unless the two are close together.

I do not want to discourage would-be aerial photographers who cannot afford to rent an airplane. Wonderful pictures can be taken again and again on commercial flights. Admittedly, it is no longer simply a question of becoming friendly with the captain during a stopover and getting him to fly an extra round with

his DC-3 over a rock church in the Ethiopian highlands. Or to bring his Fokker-Friendship down in a nose dive from its cruising altitude to an advantageous camera position beside the mountain temples of Abu Simbel. I sorely miss the days when I was admitted to the cockpit and there could open a window, but I suspect that my fellow passengers on such improvised photo flights do not share my nostalgia. Often when I returned to my seat after such an adventure, feeling highly pleased with myself, my fellow passengers would be bent over their airsickness bags or at least looking the color of ripe avocados.

To take successful photographs from modern jet airplanes requires more luck than skill. The multi-paned windows—an outer and inner pane of acrylic glass for pressurization and an acoustic panel of plexiglass for noise reduction—drive every photographer to desperation. They cause color casts and blurring. Desperate as it may seem, obtaining a passable photograph is not completely hopeless, despite the handicap of the panes and panel. Certain atmospheric conditions and flight altitudes can yield reasonably sharp photographs, though the outcome is never completely predictable.

But then you can trust your luck, and if the occasion arises, even lend it a hand. On a scheduled flight from Chicago to New York on a sensationally clear spring day, I removed the noise-reduction panel. The DC-10 was packed, but no one paid any attention to what I was doing, not even my neighbor. The panel was a little loose to begin with, and I forced it out of its mount and let it slip gently to the floor. My enterprise was rewarded. Coming into New

York, the captain, in a holding pattern, circled a few times, and Manhattan seen through only two panes was the hoped-for feast for eyes and camera.

Friends who have heard this story wonder if it is a good idea to fly in the same jet with me. I can reassure them. The technical department of an airline that holds my aerographic discoveries in especially high regard went so far as to promise that, if I give them advance notice when I take a scheduled flight, they will remove the offending panel before takeoff, knowing that it puts a damper on photographers more than on the noise.

Many people think there is something inexcusably frivolous about my taking off into the blue when there is so much to be done on the ground. Admittedly, distance transforms an abomination into a visual bonanza. From the untidy and profane settlement growth that devours fields, forests, and meadows, the eyes, at jet altitudes, begin to distill a gratifying order from the chaos. The automobile junk yard in a natural setting, seen at ground level, assaults the eye; viewed even from a low-flying plane, it graduates into an appealing parti-colored design. Small wonder that there is no shortage of people to reproach me for not being committed to the ground, and to say I'm just, well, flighty. I have always defended myself with this: whoever goes into the air gains perspective, and perspective is a prerequisite of insight. In other words, whoever looks for beauty out of the blue need not run the risk of glossing things over; he can indeed bring about some good on the ground.

Perhaps I have only hoped this more than

really believed it, until recently, when I received substantial proofs—the second even weightier than the first—that insight does come from perspective. During a reconnaisance flight along the big bend in the Niger River, I had spotted a village in my viewfinder that was more beautiful than any I had ever seen in Africa (plate 62). A little later I spent many days in the border country between Mali and Niger searching on the ground for its location and name. It is called Labbézanga—and the inhabitants clearly remembered the plane that, in the euphoria of discovery, had circled above their heads seemingly for hours. At first my interest in them and the fact that I had had an airplane made the villagers suspicious of me. They took me for an agent of the government, which indeed wanted to move the village from the island in the Niger to the mainland, simply for administrative convenience; it had even threatened military action to enforce its will. Only with reluctance did the elders of the village come around to my point of view, that my pictures would promote their interest rather than those of the government.

At the beginning I flattered myself that I had given Labbézanga its photographic debut, but a search of all the relevant literature proved me wrong. The French colonial government had ordered an aerial view of the village in 1955. Since this experience, I have comforted myself with the thought that every Columbus has his Vikings, that a discovery becomes one only when it entails consequences.

My photograph had the most agreeable consequences imaginable for the inhabitants of Labbézanga. It was reproduced millions of

times in magazines and on posters, and today the government of Mali proudly draws the attention of foreign visitors to "the most beautiful village in Africa." There is no more talk of resettlement.

The image of Labbézanga helped to preserve the place. The aerial view of a farm near Pomeroy, in Washington state, even helped to bring about change. The farm (similar to the one in plate 105) demonstrated the ideal repertoire of erosion-preventing soil-management techniques, but besides being exemplary, it was also beautiful in a challenging, provocative way. I sent the aerial view to David Hein, an official of the Soil Conservation Service in neighboring Lewiston, Idaho, asking him for his informed and expert comments. David enlarged the photograph and pinned it up on his office wall. There it was noticed by Alex Schaub, a farmer who, until then, had stubbornly refused to do anything to save his run-down two-thousand-acre-farm. When he saw the photo, Alex told David that he and his service could do whatever they wanted "if you can make my farm look as fantastic as that."

David could and did. In only two years he bestowed upon the Schaub farm the zebra pattern of the model. Strip cropping on the contour, together with crop rotation, reduced soil loss from the previous high of 156 tons per year per acre to a tolerable four tons. Later David congratulated me as we flew over "my" surgically improved farm: "You've saved the country millions of tons of the best agricultural soil."

But, agreed: the lightness of that flighty Gerster only rarely carries so much weight.

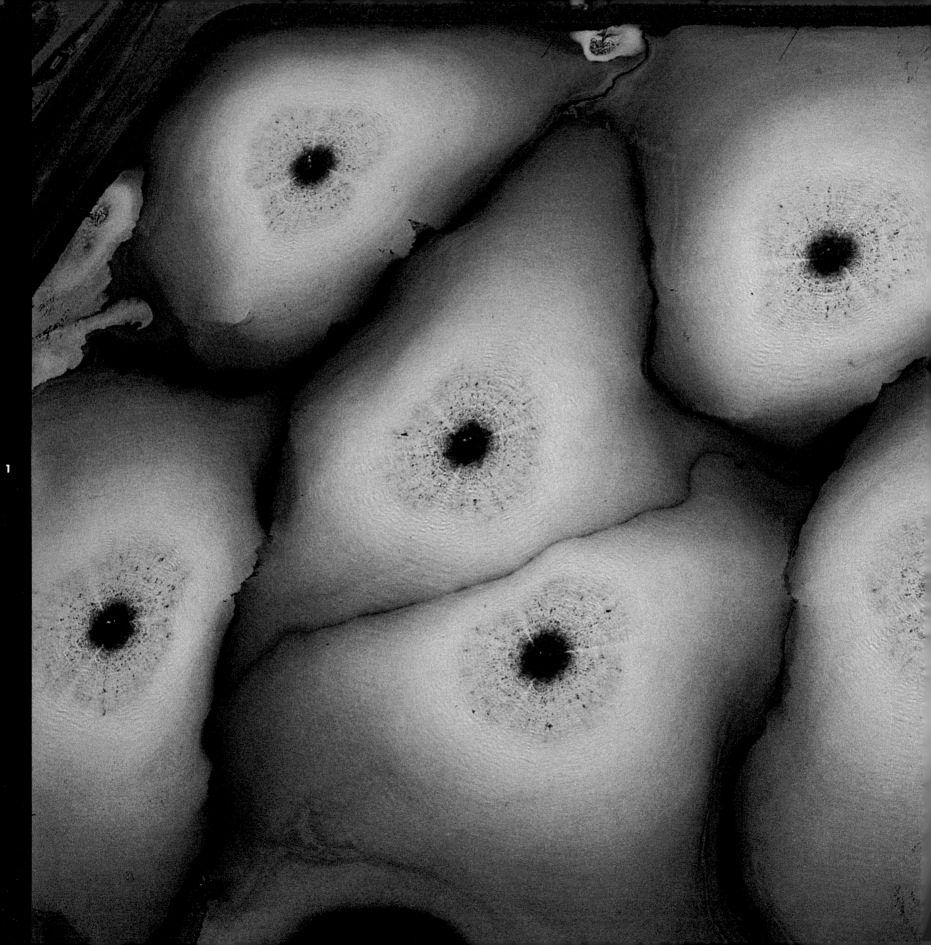

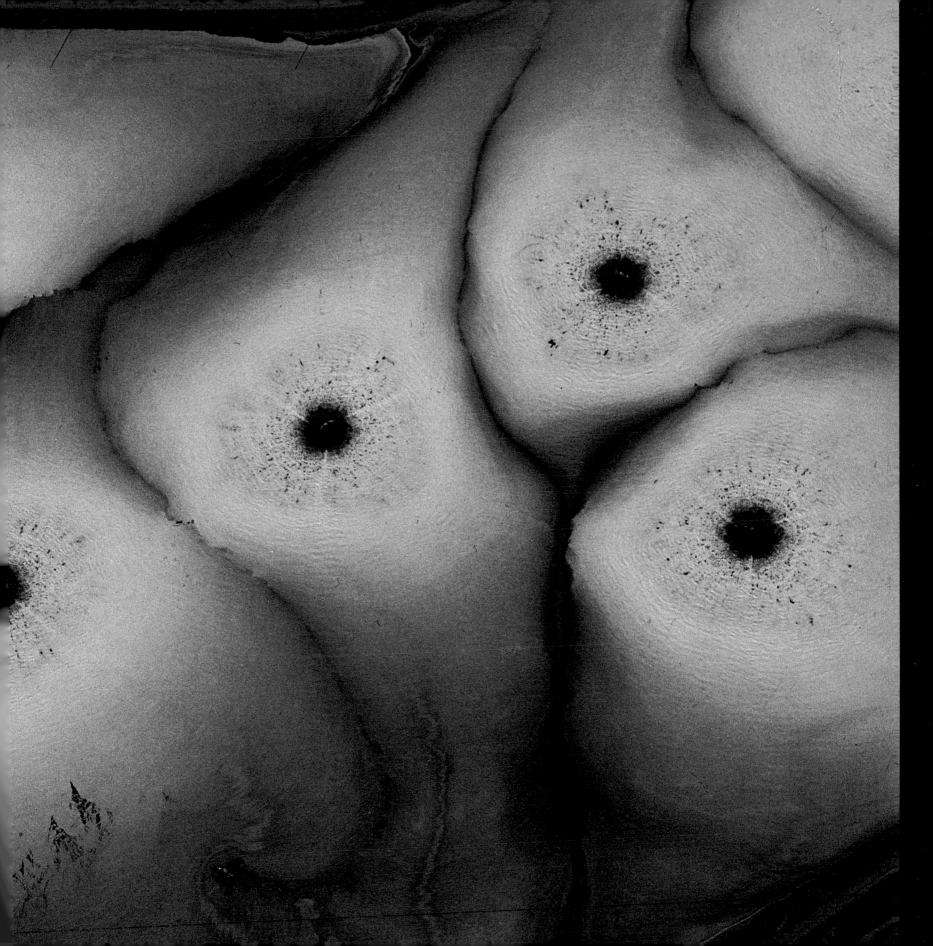

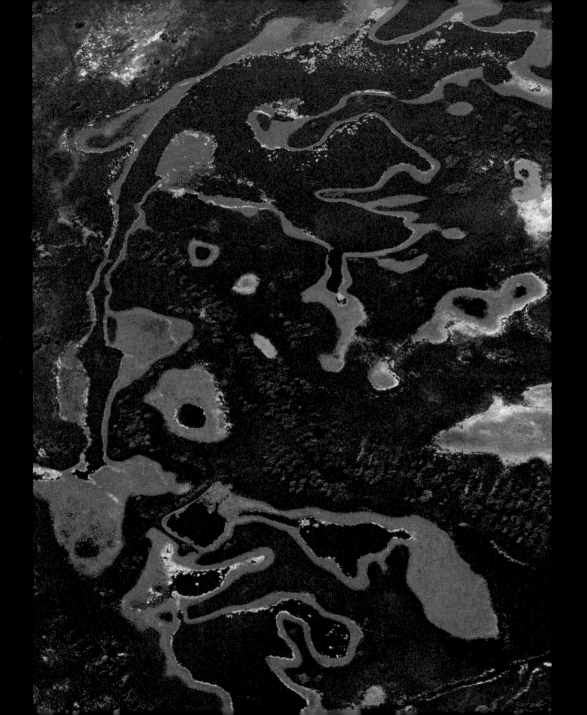

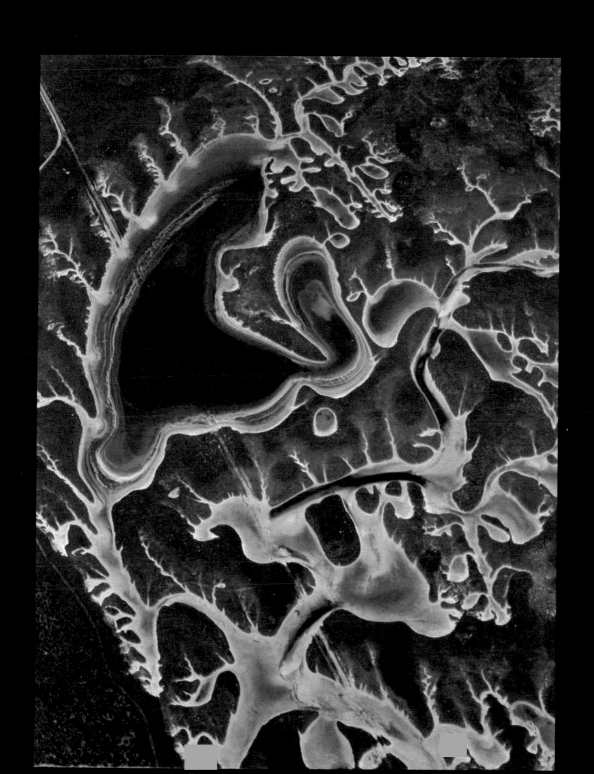

3

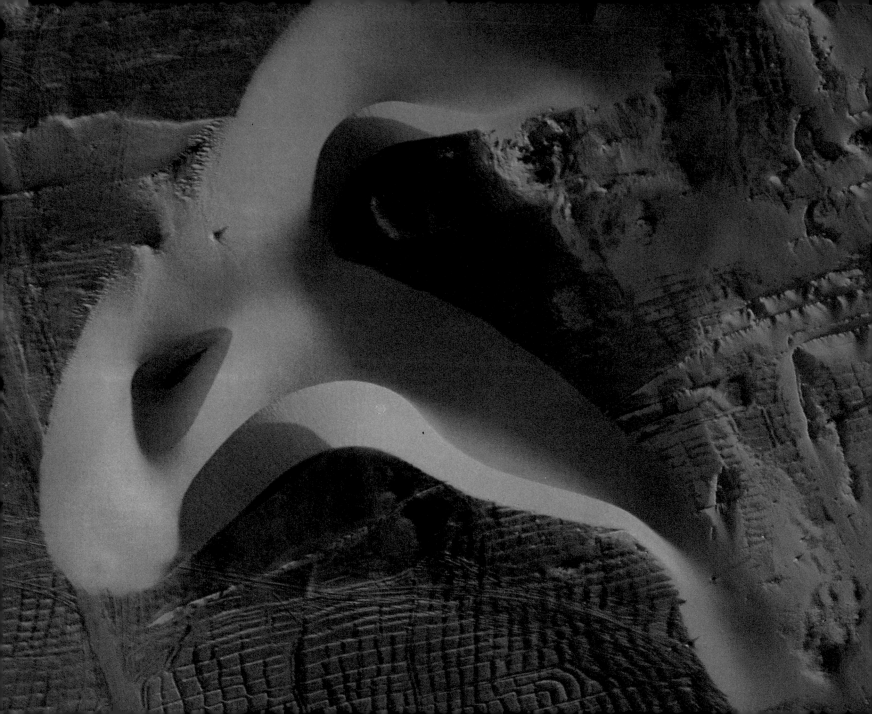

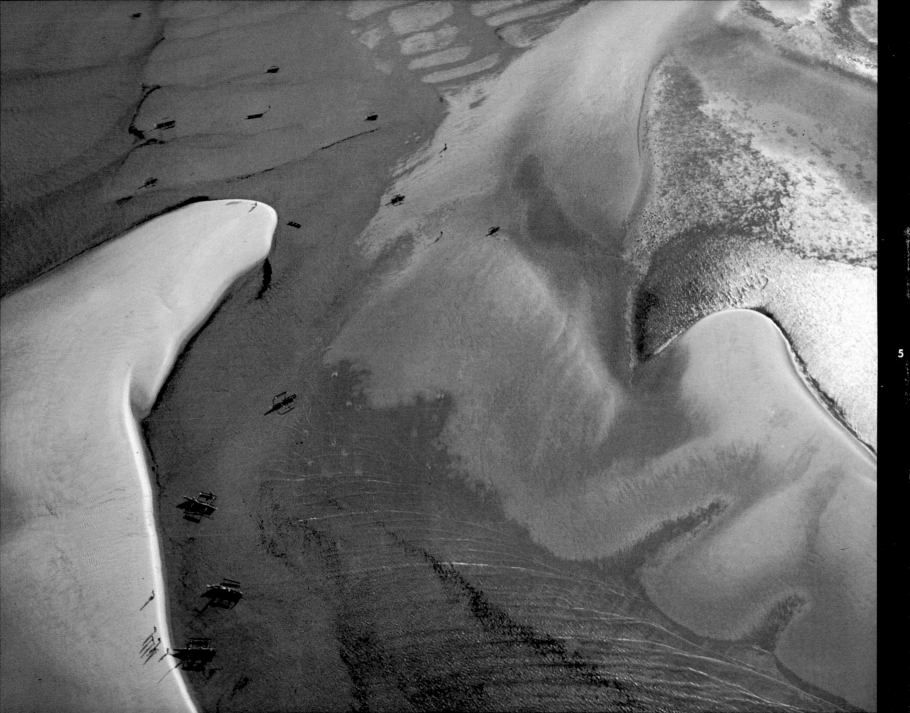

6

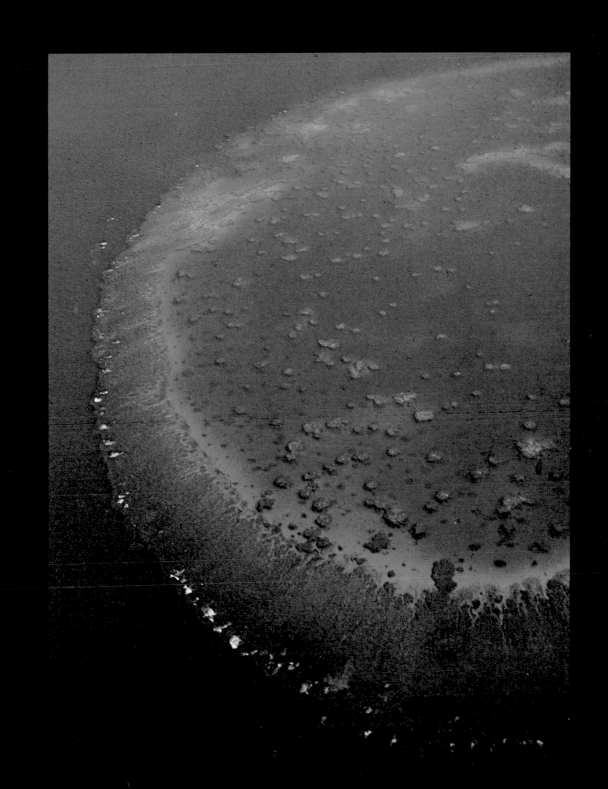

7

1 Waste-water purification plant at a pulp mill, Lewiston, Idaho. Floating ventilation turbines suck in polluted sludge from the bottom of a vast basin and spray it out, mixing it with oxygen, thereby stimulating the propagation and appetite of the bacteria and protozoa that decompose the organic residue in the waste water. European water purification specialists, who must clean waste water to higher specifications in much less space and in a much shorter time, are both envious and critical of this treatment. They consider one-step water purification—the ventilation and deposit of sludge in a single basin—medieval. The efficiency of the system is poor, and the water flushed into the river—here the Snake River—pollutes the lower course with salts. However, the method is cheap, requiring little supervision; and waste of land in the thinly populated continents of North and South America, where lagoons like this one close to pulp mills are the rule, is not yet causing headaches.

As long as manufacturers continue to break up wood with alkalines in a sulphate process, American pulp mills will remain stinkers of the worst kind. The awful stench of mercaptan met the airplane even high above the lagoon and dispelled any lustful thoughts. Feast your eyes, but hold your nose.

2 Flooded area in the Mompos Depression, Colombia. The San Jorge and Cauca rivers meet the Magdalena River in the Mompos Depression. During the rainy season in the highlands, the confluent rivers transform the lowlands into an ever-changing kaleidoscope of lakes and swamps. When the rivers return to their beds, huge herds of cattle, attracted by lush fields, wander in from the provinces of Córdoba and Bolívar. Today, the flooded area is judged to be useless for agriculture, but this was not always the case. The ridged pre-Columbian fields are obvious from the air. The Indians made flood-proof striplike fields by digging out earth and muck between them, and planted, depending on location, corn, manioc (similar to cassava), sweet potatoes, cocoa, and vegetables. It is possible that they occasionally used the depressions between the fields for fish and mussel farming. Extensive fields of this kind exist outside of Colombia in Mexico, Ecuador, Belize, Surinam, Bolivia, and Peru. It is not yet clear how old this method is, but it is certain that it was used by all cultures of old America at the time they entered recorded history. The Mayas, for example, were masters of the agricultural development of swamps by means of ridged fields. Many such fields are still cultivated today.

3 Pools at the northern edge of the Etosha Pan, Namibia. In the southern summer, water from sudden cloudbursts etches into the sandy earth of the Etosha Pan a filigree of drainage streams. Efflourescent salt accentuates rims and contours, blue and green algae inhabit and color the pools. If one is inclined to compare processes of nature with works of art, it looks as if Matisse or Miró had labored here, using land as his medium. Or, to compare nature with nature, the pools are reminiscent of thin cross-sections of certain mineral rocks. Quite a feast for the eyes—but not only that. At the first rains, more than a thousand elephants, attracted by the pools in the north, migrate across the borders of Etosha National Park and, among these pools, take a summer vacation from the tourists.

4 Wandering dune in Kharga Oasis, Egypt. The *barkhan,* a crescent of sand, creeps over the skeleton of earlier cultivation—abandoned irrigation canals and plots of land. They may have already been laid out here in the late pharaonic era, at the time of the invasion of the Persians or Alexander the Great. But it is also possible that they stem from early Christian times, when Kharga became the place of exile for heretical church fathers and patriarchs who had fallen from favor.

The *barkhan* is part of a column of dunes that advances across the 125-mile length of the oasis as inexorably as an armored invasion. The sand formation created by the hundreds of crescent-shaped dunes is known to the inhabitants of Kharga as *Ghard Abu Muharik,* "Father of Motion Dune." Whoever happens to be in its path waits patiently until the sand blows out of his house, if need be for generations. The father who abandoned his farmstead because the encroaching sand filled in his spring thanks Allah that at least his son may be able to return after the sand has gone. Though another *barkhan* will approach soon after that.

5 Low tide near Kundichi, Tanzania. The fisherman wait for high tide to float their beached outriggers.

6 Tidal gullies in the mud flats near Bandar Abbas on the Persian Gulf, Iran.

7 Coral reefs off Townsville, Queensland, Australia. They are part of the Great Barrier Reef that lies protectively along the northeastern coast of the island continent. Its distance from land varies from 16 to 186 miles, and it is 1,200 miles long. It is made up of numerous single reefs of circular, oval, horseshoe, and hook shapes. There is nothing like it among the living coral reefs of the world. Geologists assure us that there has never been a comparable creation of reef coral, even in this planet's earliest epochs.

In 1983, in order to preserve it, Australia proclaimed the Great Barrier Reef a marine park. Thus the coral can be more adequately defended against the most destructive assaults—scuba-diving tourists and fishermen using dynamite—as well as against ecological shortsightedness. On the other hand, the Marine Park Authority can do nothing against the forces of nature—earthquakes, cyclones, the incursion of fresh water (from rain during neap tide), and climatic adversity, which attacks the reef by warming up the seawater. The Park Authority is also defenseless against a prickly starfish, which feeds on the coral polyps. Periodically, the Crown of Thorns explosively increases in population and temporarily transforms the colorful coral gardens into a moonlike desert.

8

8 Waste-water purification lagoon along the Mississippi, north of Baton Rouge, Louisiana. Turbines artificially aerate industrial waste water. The resulting patterns suggest flowers, the innocence of which contrasts with the image in plate 1.

9. Rotting fruit near Homestead, Florida. Each little hill on the garbage heap is a truckload of culled pumpkins and tomatoes.

An attempt by European Community bureaucrats to put an end to the Common Market's agricultural surpluses added a new and inhuman phrase to our vocabulary—"market returns," an outrageously hypocritical term for destruction. In all fairness, the fruit shown here was not rejected in order to prop up the producer's price, but because its quality did not meet consumer demands.

10 Sand shoals in Moreton Bay, near Brisbane, Queensland, Australia. The sands, never completely dry even at low tide, are sculpted into constantly changing configurations by the gentle currents of the tides and by tropical whirlwinds, which occasionally churn them up.

Natural processes can suddenly tip from a predictable state toward an unpredictable one. A regular current abruptly becomes turbulent; order becomes disorder, anarchy, chaos. The behavior of sand in a flowing medium, whether water (plates 5, 50) or wind (plates 4, 51, 74, 85, 110), commands growing attention from chaos theorists.

"Chaos research" has become almost fasionable today, and theorists tend to believe that, in nature, order is the exception, chaos the rule. This discovery, however, can occasionally be reassuring—an EEG read-out of brain activity that shows completely regular, stongly periodic oscillations signals the approach of an epileptic seizure; whereas, during normal thought processes, an electroencephalograph registers a jagged curve. The more intelligent a person, the more intensely he thinks, the more chaotic the read-out. *Chaos is good for you.*

11 Waste-water purification plant near Baton Rouge, Louisiana. Plates 1 and 8 depict water-purification processes in which sludge is aerated by spraying it into the air; in the process shown here, hoses placed in the sludge aerate the bacteria and protozoa. Compressed air bubbles out from regularly placed holes in the hoses, a system that creates the patterns. The beauty of the purification plant takes one's breath away, but so does the smell.

12 Salt pans near Massawa, Ethiopia. Massive industrial production (plates 24, 29, 69, 123) is not the only salt-making method that creates fascinating visual patterns. In this photograph, the small commercial evaporation pans together give the impression of paint on an artist's palette. The salt producers of Massawa bring seawater into man-made troughs. The sun not only concentrates the brine, but also bleaches the harvested salt to an immaculate white.

13 The opal field at White Cliffs, New South Wales, Australia. In 1889, in the northwest corner of New South Wales, kangaroo hunters discovered opal-bearing rocks that either crop out or lie just below the surface. In the ten years that followed, the precious opals of White Cliffs became known throughout the world. But shortly after the turn of the century expenses outstripped profits. When the last miners left in 1915, their legacy was a landscape pock-marked by some fifty thousand shafts. Since then, professionals have tried many times to revive opal mining in White Cliffs, but today the fields belong mainly to the *fossickers*, or amateur treasure hunters. For a couple of dollars anyone can buy a ten-thousand-square-foot opal claim. The *fossicker* then sifts through for the nth time, occasionally even with success. In the excavated rubble, which previous miners considered barren and which they dumped around the mouth of the exploratory shafts, discoveries have been made. Or the *fossicker* digs a new tunnel at the bottom of the shaft. *Fossicking* is practically a national sport in Australia. People have come for a weekend and stayed the rest of their lives.

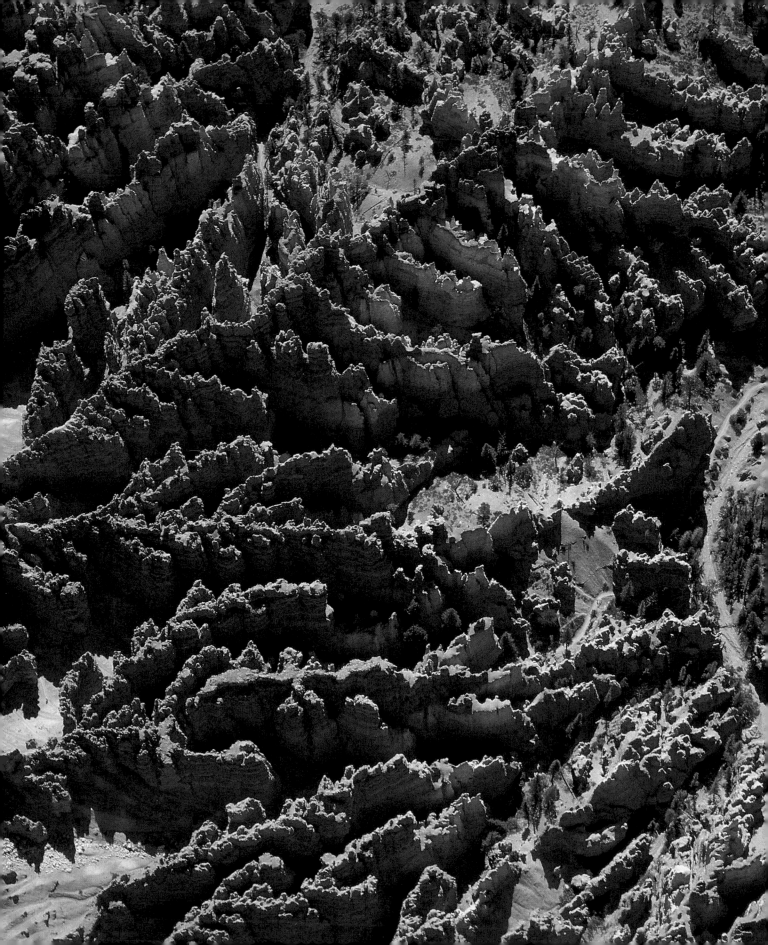

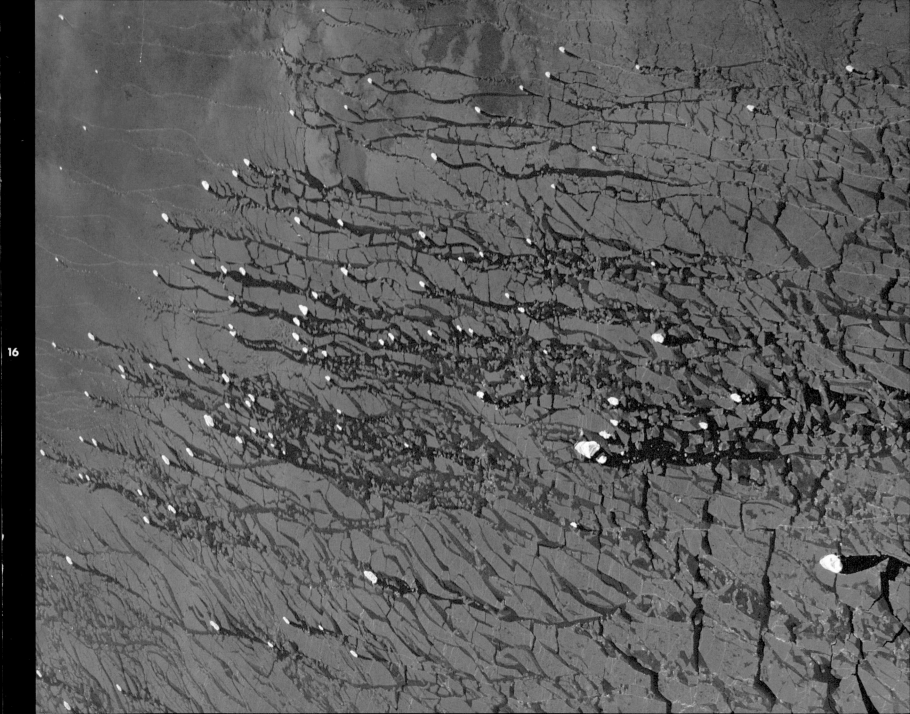

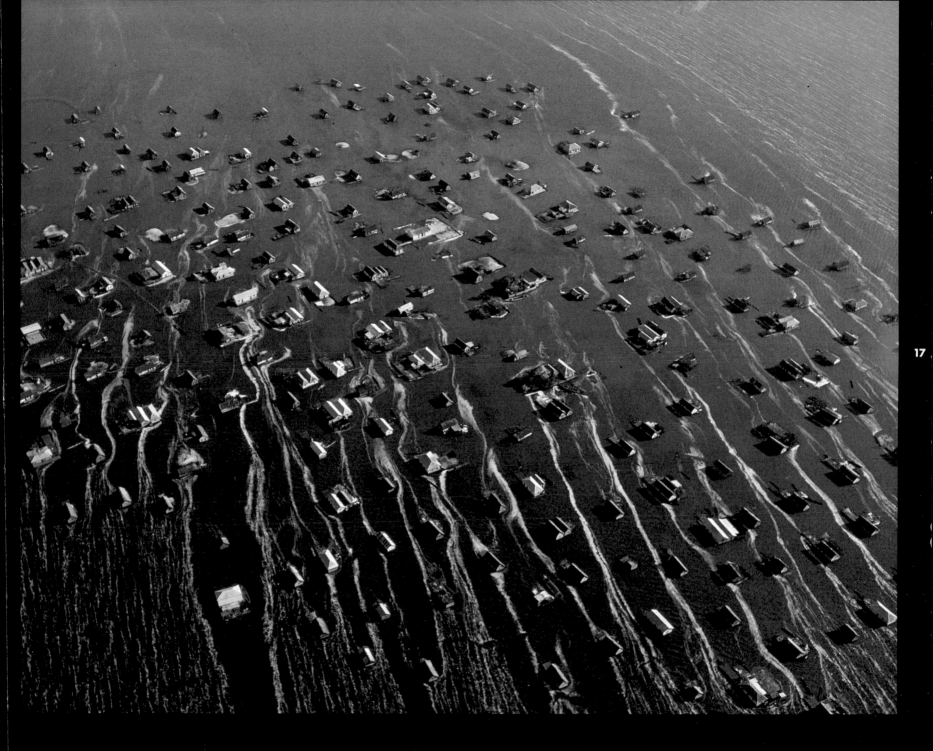

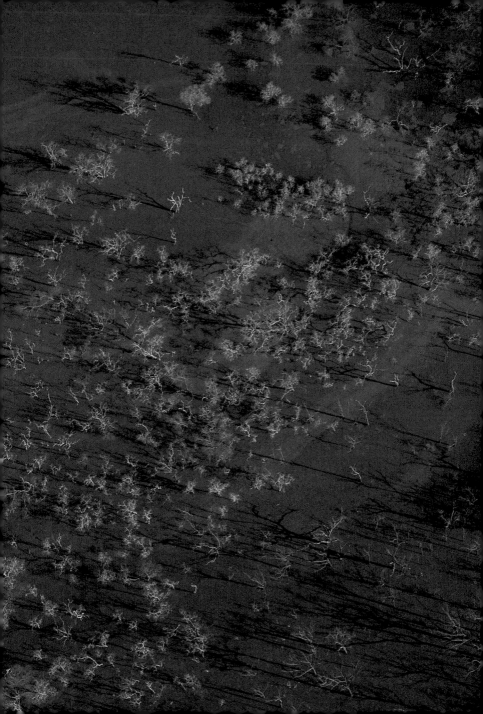

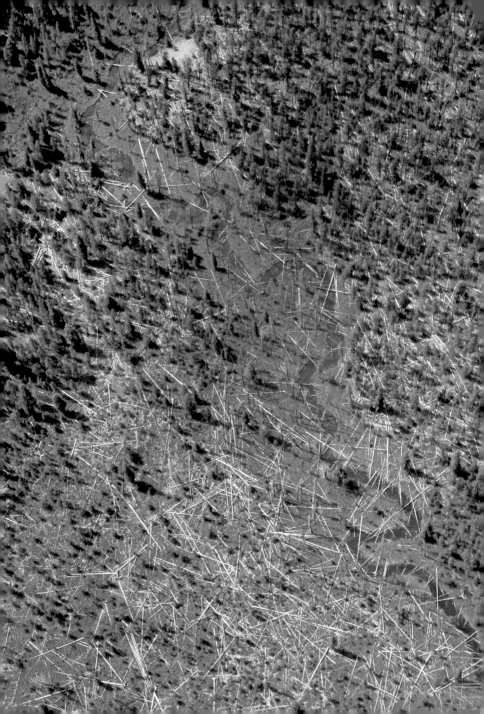

14 Bryce Canyon National Park, Utah. The man for whom this park was named did not make much of this miracle of weathering. The Mormon cattle breeder Ebenezer Bryce, who settled here in 1875, was annoyed by the wild, wondrous labyrinth of rocks—"a hell of a place to lose a cow."

To call this delicately sculptured work of weathering a "canyon" is misleading. More precisely, it is the end slope of a plateau of horizontally stratified sedimentary rock. For reasons not yet fully understood, there are zones in the sedimentary rock where joint planes run at right angles to the horizontal beds. In these clefts, the forces of weathering attack. Frosts and plant roots shatter the rock; water and chemicals in the air break down the cliffs. Rainwater and melting snow wash down the detritus of the weathering process and continue to chisel out the peaks and crags. Even their pigmentation is for the most part a product of weathering. The chemical decomposition of the rock produces red and yellow ferric oxide as well as the lavender and purple of manganese dioxide compounds.

15 Coral reefs off Abaco Island, Commonwealth of the Bahamas. The flatter part of the reef, which grows in uneven patches, gleams blue green.

16 Crystallizing soda on Lake Magadi, Kenya.

17 The fishing village of Nueva Venecia, Colombia. Lake dwellers founded this village during the middle of the last century in the Ciénaga Pajaral, part of an extensive system of communicating coastal swamps and lagoons in the Caribbean province of El Magdalena. The thirteen hundred inhabitants of Nueva Venecia make their living from fishing. The Ciénagas are Colombia's most productive fishing grounds. Even at high tide the water is less than a yard deep in many places, but gusting winds constantly agitate the water and thereby create the ideal living conditions for aquatic life. Here a storm beats the organically rich water to the consistency of egg white, blowing the foam in between the habitation islands of Nueva Venecia. The foam contains as a suspension living and dead plankton, microscopic algae, bacteria, nematodes, radiolaria, and the waste products of them all—a real biogenic froth.

18 Tree skeletons in the red mud of an alumina works near Gove, Australia. The red mud is the residue of alumina production and gets its color from iron oxide. It dries in collecting ponds and is put to limited use as an admixture in the production of pig iron, as well as in the chemical and construction industries.

19 Spruce trees snapped like matchsticks, Yellowstone National Park, Wyoming. Parasites, such as the pine bark beetle and the spruce bud worm, weakened the trees; beavers gnawed at them; snow and storms finally felled them. Volcanic warming of the ground (plate 119) is also a force of destruction to be reckoned with. It has begun to kill the forest in some parts of the park. For once, man is not responsible. The cyclical devastation by parasitic insects has been as much a part of Yellowstone National Park as its most famous landmark, Old Faithful. But man's acquittal in this case cannot justify his hypocritical I-told-you-so attitude in other instances of spoliation. A bumper-sticker I discovered in the park's parking lot carried this cynical message of asphalt ecology: "Save a tree—eat a beaver."

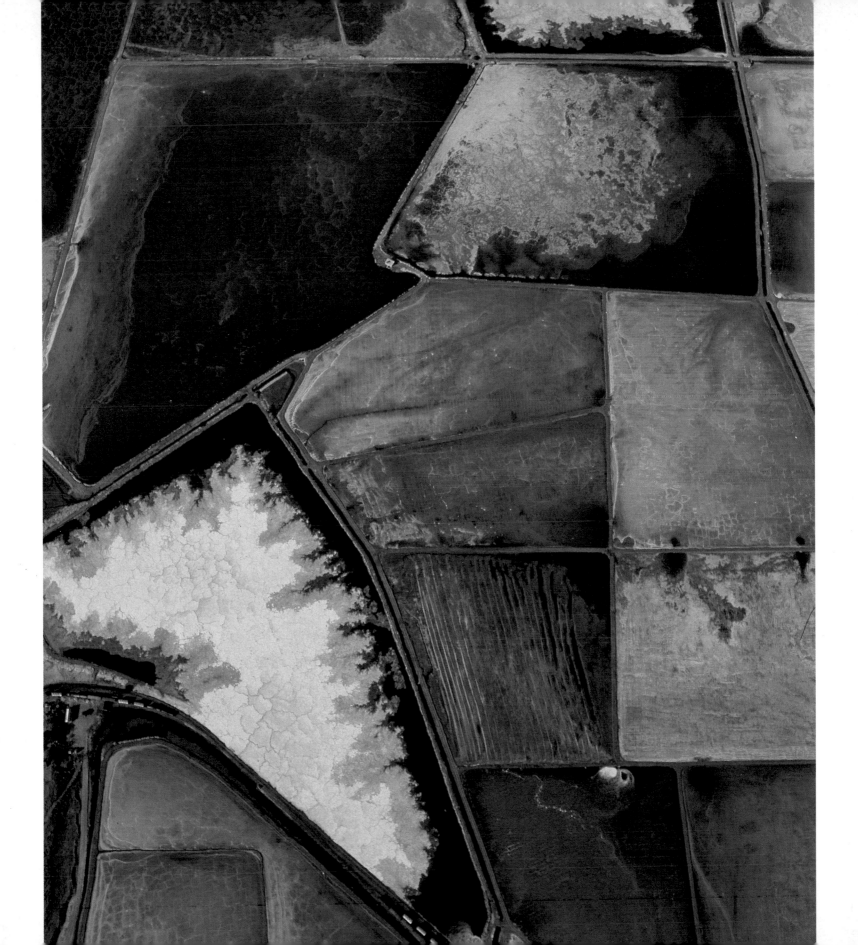

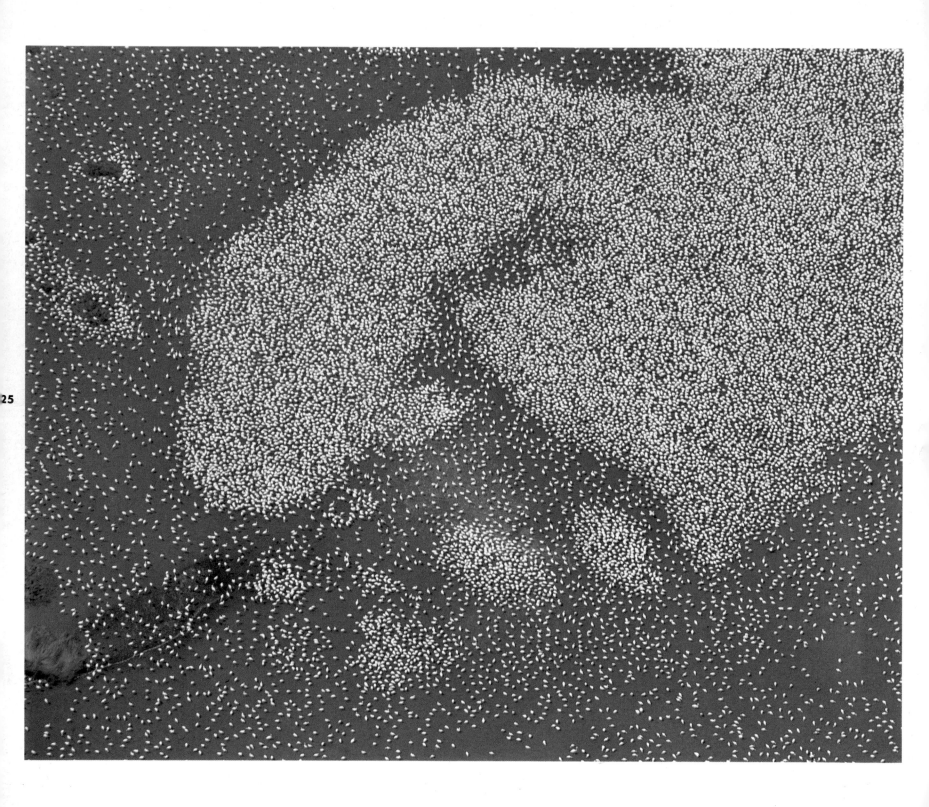

25

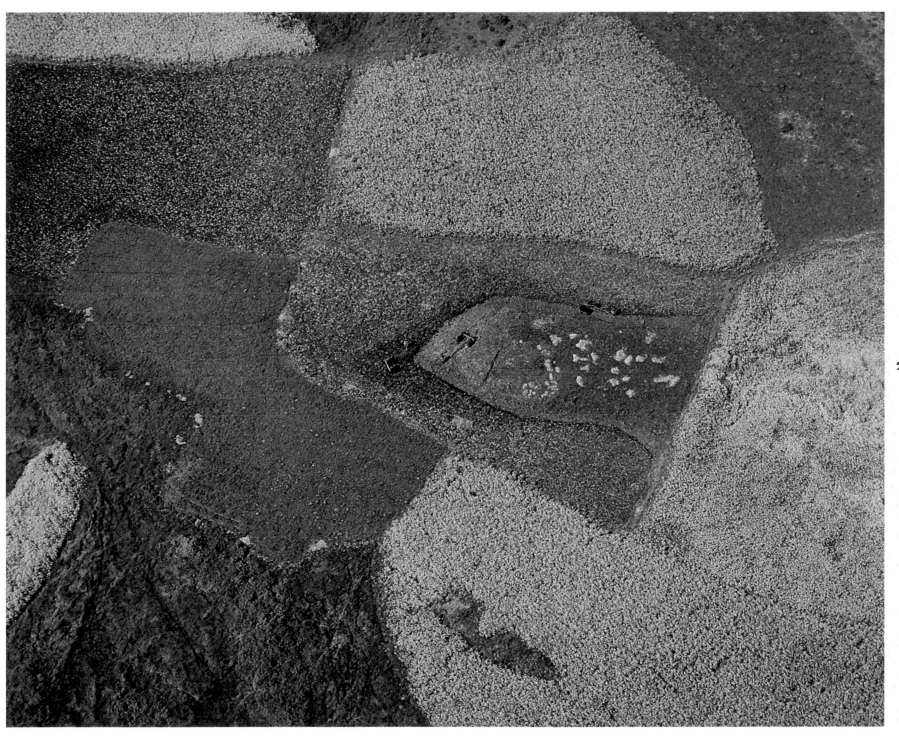

20 Rice cultivation near Semarang, central Java, Indonesia. The Javanese farmers make energetic, if not brilliant, use of the favorable location—which incorporates ash-rich fertile soil and the monsoon climate—to produce three harvests per year. The terraced fields at the foot and on the slopes of the volcano are colorfully resplendent throughout the year, as the rice harvests do not all ripen at the same time. Vegetables are grown in addition to rice.

21 Citrus groves near Morphou, Cyprus. This picture was taken at the beginning of the 1970s. Today the citrus orchards of the Mesaoria, the fertile transverse depression between the mountain ranges of this Mediterranean island, are practically history. Morphou now lies in the Turkish-occupied part of the island, and citrus growers are either denied access to their gardens or, if they live in the occupied zone, are no longer connected with their former, efficiently functioning marketing organizations. The difficulties of the citrus growers did not, however, begin with the political and military amputation. The increasing salt content of the irrigation water had already threatened their gardens, and reserves of ground water were steadily decreasing. The Mesaoria is, as its name indicates, a "land between mountains" and therefore lies in the rain shadow.

22 Irrigated fields near Yazd, Iran. The green belts surrounding Persian desert villages and towns provide cucumbers, pumpkins, celery, spinach, onions, radishes, and a newcomer—the tomato—as well as mint, parsley, leeks, dill, and basil. Without herbs there is no Persian cooking: *sabzeh*, "the green" part of every Persian meal, does more than just supply vitamins. For a desert people it symbolizes fertility and life itself. *Sabzeh*—on this day sprouted grain—is the high point of the New Year meal on March 21st.

23 Mosaic of fields near Bushehr, on the Persian Gulf, Iran. The dark brown plots are freshly plowed or harrowed. The light brown areas have probably been tilled several days before. Land waiting to be plowed or meant to lie fallow is very pale, almost white. A ground cover of grass or weeds flecks the fallow land with rust colors. Apparently these fields receive water from rain, as there are no irrigation canals. On the Persian Gulf, nonirrigated cultivation must withstand low precipitation and scorching heat. The farmers do, however, have an ally in the high humidity. This picture was taken in January, a cool and rainy month that is the most favorable time for cultivating the fields.

24 Salt gardens on Lake Magadi, East African Rift Valley, Kenya. The concessionaire who operates here produces mainly soda from the salt lake (plate 16). In a small area of the lake, common salt matures in concentrating and crystallizing ponds. The annual production of 44,000 tons is sufficient to cover Kenya's requirements for kitchen use, cattle raising, and such industries as cellulose, paper making, and tanning.

The sun gradually evaporates the lake's water in the concentrating ponds. In the crystallizing ponds, sodium chloride sheds unwanted impurities and forms a white crust on the surface. The salt producer is dependent both on the sun and on the help of salt-loving microorganisms in the brine. Algae, ciliates, and other unicellular organisms, bacteria, nematodes, and radiolaria carpet the evaporation ponds. This layer seals the ponds and, by coloring the brine, intensifies the absorption of sunshine, thereby accelerating evaporation.

The final concentrating ponds belong exclusively to red bacteria. When the pond turns dark red, the salt producer knows that his salt is almost ready for harvest.

25 Flamingos on Lake Bogoria, Kenya. More than half the estimated world population of six million flamingos lives on and around the soda lakes in the East African Rift Valley. Two varieties of flamingos wade, nest, and breed in the inhospitable alkaline waters other animals avoid: the small flamingo (*Phoeniconaias minor*) and, in far fewer numbers, the large, or common flamingo (*Phoenicopterus ruber*). The beaks of both are refined sieves, with which they can strain out the plentiful algae, tiny shrimp, and other small crustaceans, without drinking the poisonous salt solution. The plumage of the chicks is dirty white; only later does it become pink from the consumption of salt algae containing canthaxanthin, a coloring agent chemically related to vitamin A (plate 24). In a zoo flamingos pale with each molting if their diet does not include carrots, paprika, and/or a canthaxanthin preparation. Hot springs are responsible for the holes in the flamingo carpet.

26 Mosaic of fields in Lasta, Wollo, Ethiopia. At the end of October, after the height of the rainy season, *nug* fields still glow in the highlands, while an ox team is already breaking up the grain fields in the hope of a second harvest. *Nug (Guizotia abyssinica)*, a relative of our sunflower, is Ethiopia's most important oil-producing plant, whose fatty seeds yield a treasured cooking oil.

In precolonial times Ethiopia was the only area in tropical Africa that knew, besides the hoe, plow farming—part of the cultural heritage of South Arabian immigrants. But in a good year, even with the advantage of the plow, the Ethiopian farmer produces only five percent more food than his family consumes. Thus here—and not only here—hunger is less a problem of lean years than one of continually meager surplus in the fat ones. Catastrophes, crises, and kwashiorkor (endemic malnutrition) make for television drama and therefore mobilize our hearts and help. Chronically insufficient production, however, lacks immediacy and color. It at best engages our intellect. But not enough, so that our lack of imagination has nefarious consequences. Even in good faith, donor countries have repeatedly discriminated against the small farmers of the Third World. Emergency food supplies depress the prices local farmers receive for their produce. Also, agricultural development projects of industrial proportions push the poor onto marginal, erosion-threatened lands.

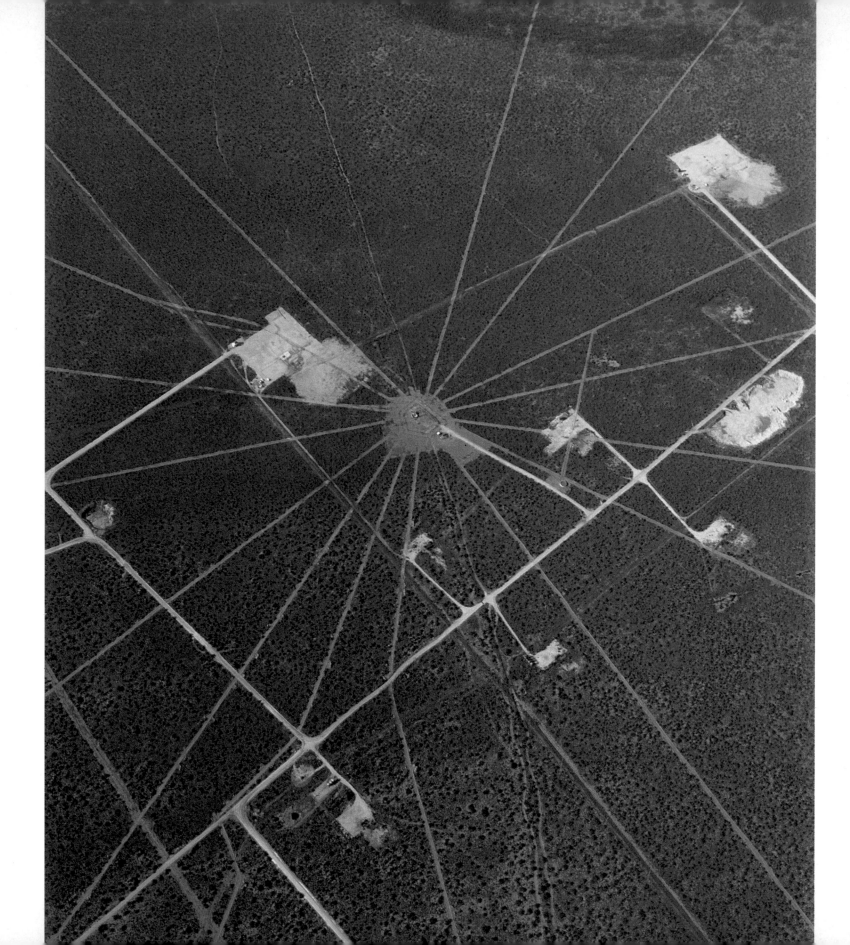

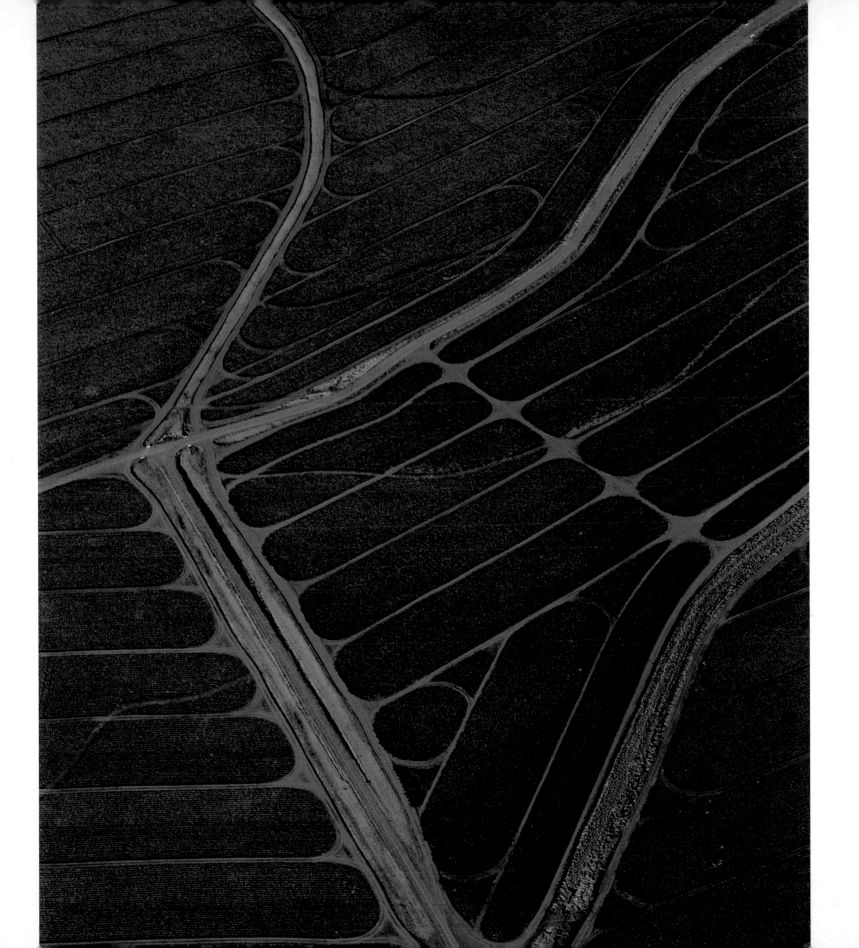

28

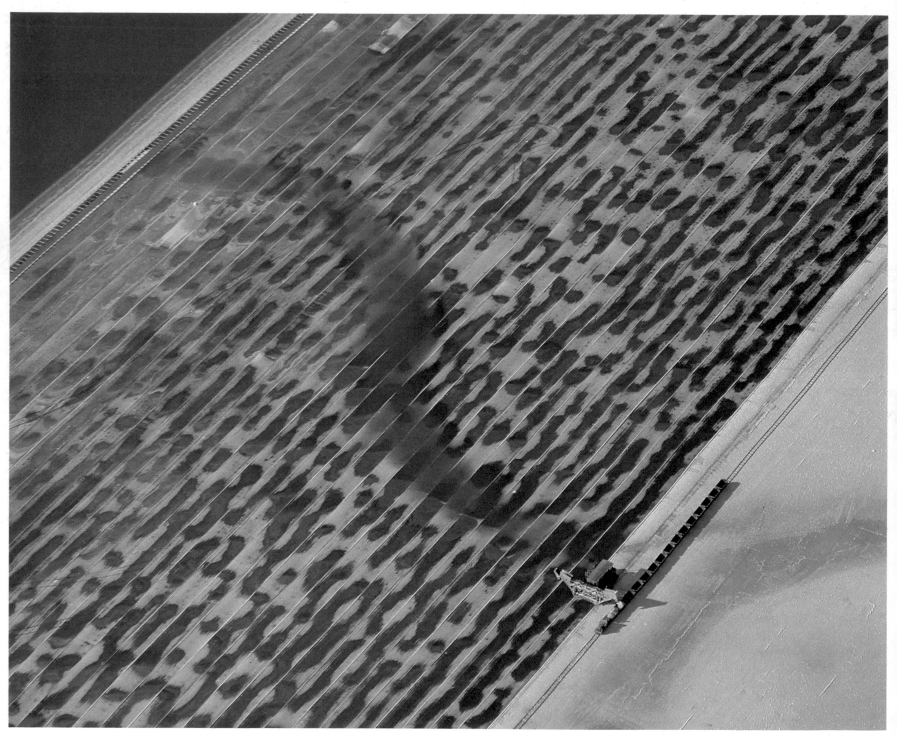

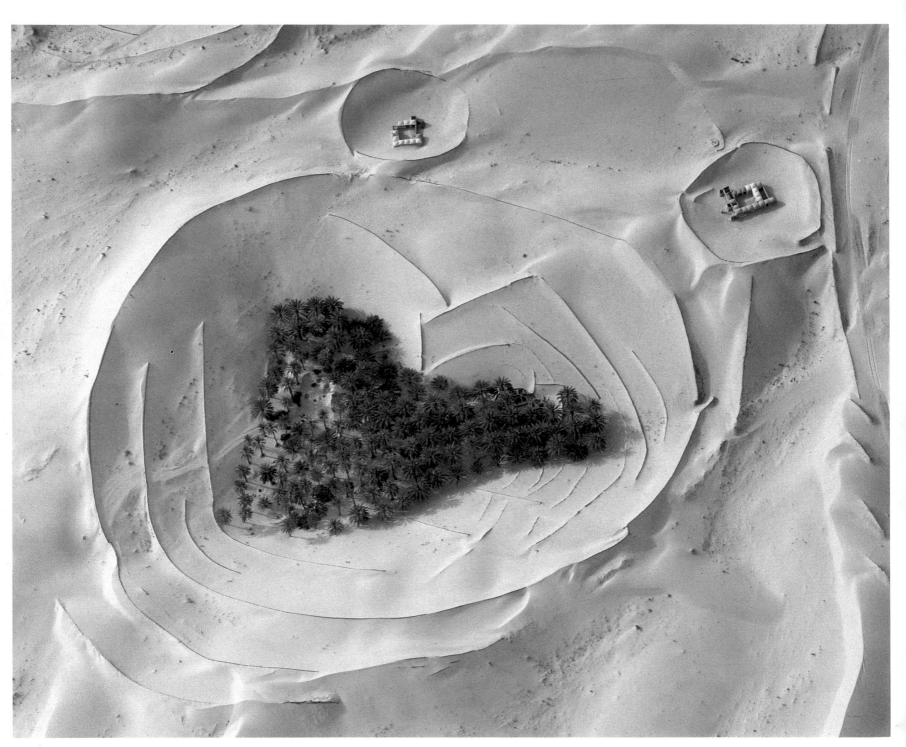

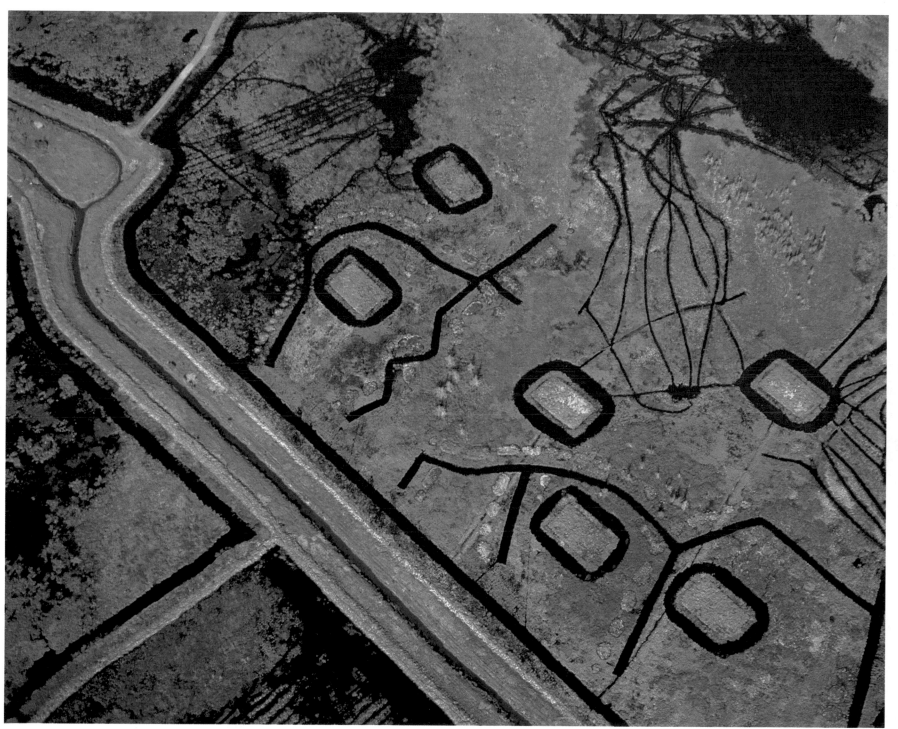

27 Cell grazing on an oil field near Wink, Texas. Rancher Mike Harrison rotates his herd among fifteen slices of a circular pasture. Every three days the cattle are moved on to the neighboring pasture sector. The cattle crossing passes through the middle of the circle, where the animals habitually go to drink. The electric fences separating the sectors are run cheaply on solar power.

An oil field with pumping stations and access roads overlays the spoked pasture land. The wheel pattern of such cell-grazing installations could become as common in American cattle country as the use of center-pivot irrigation now is throughout the semi-arid agricultural regions of the Southwest (plate 72). The temporary disadvantages of such systems—initial fall in herd productivity, high investment costs—are adequately balanced by long-term gains: pasture, untrampled during 340 days of each year, improves in quality and quantity.

In 1876 and 1883 the state legislature bequeathed two million acres of land to the University of Texas to promote higher education. One may wonder what Texas thought of universities at that time, as the land was practically worthless. But this changed in 1923, when oil was discovered.

Mike Harrison leased the land from the university; the oil industry pays the university for damage caused by its operations, and the university, in turn, pays its leaseholder, with the proviso that the money be spent on improving the pasture.

28 Pineapple plantation on Lanai, Hawaii. Operational optimization determines the graphics of the plantation: each field is twice as wide as the arm of the sprinkler truck (for spreading fertilizer and pesticides) and the conveyor belt of the harvester. The rounded corners match the turning radius of the vehicles. Roads and gutters additionally pattern the reddish brown clay soil. Hawaii's pineapple growers follow a three-year cycle. The first harvest takes place in the second year, the second in the third, and then the plants are plowed under. The processing facilities—for sliced pineapple and canned pineapple juice—operate only a few weeks in the summer. The time of the harvest is therefore planned exactly.

The pineapples ripen after eighteen or twenty-four months, depending on whether the plants are grown from root suckers or from "crowns," the leaf tops of the pseudocarp. Planning may be made even more exact by spraying the crop with ethylene to end the growing period and induce fructification. Those opposed to the introduction of such chemicals should note that ripe fruit gives off the same gas naturally. An apple sealed in a plastic bag with a pineapple plant induces the same process.

29 Salt harvest in San Francisco Bay, California. Traversing the crystallizing ponds, a harvester on Caterpillar tracks removes exactly five-and-a-half inches of salt from the mud flats and loads it onto the conveyor belt. Leftover brine, red with bacterial growth, collects in the deepest parts of the ponds.

The salt gardens on the United States Pacific coast produce about one million tons of common salt each year. Only a fraction of this ends up as table salt. Most of the sodium chloride is harvested for industry, where it is used as a raw material in the production of plastics, chemical solvents, pesticides, and weed killers. Demand, precipitously increased by technical innovations, is met by a supply that is practically inexhaustible; common salt circulates through the veins of any industrial society bent on growth; its consumption is one of the gauges of industrial society's success. The automobile is by far the most ravenous salt consumer, with a yearly per-car consumption ten times higher than human per-head requirements. One should therefore take the assertion that salt is not only a fuel of industry but also a measure of civilization *cum grano salis*.

30 A manor house near Badajoz, Extremadura, Spain. The lord of the manor raises fighting bulls.

31 Palm gardens in the "Souf," a group of oases hollowed out from the Sahara, Algeria. The inhabitants of the Souf take advantage of a unique river that trickles underground. Because water does not come to them in the form of rain, they go, together with the palms, to the water. They plant the trees on the bottoms of man-made craters of various shapes, sizes, and depths in order that the roots of the trees dip into the hidden water. The water flows constantly and keeps the roots from rotting as they would in standing water. The palm growers use staggered palm-leaf fences to protect the main basins and the neighboring smaller craters— which contain their domed houses— against blowing sand. They periodically change the position of the fences according to prevailing winds.

32 Nesting and brooding islands for waterfowl near Germantown, New Brunswick, Canada. Swans, geese, and especially ducks, as well as pied-billed coots, bitterns, and black terns invade these artificial ponds and islands in early spring. The availability of open water, for courtship and pairing, and islands, for nesting and breeding (free from raccoons and skunks), is apparently the main attraction for the birds. In 1973, before the transformation of the swamp, there were only thirteen breeding pairs of four species of water birds, while now there are one-hundred-fifty pairs per year. Up to twelve species occupy the same island, but birds that do not breed in colonies do not tolerate on the island another pair of their own kind.

Wetlands inscribed with mysterious signs like those on the Germantown marsh are nowadays a common sight across Canada. Ducks Unlimited, an organization of United States hunters and conservationists, finances the creation and improvement of these wetland sanctuaries. It manages marshes and bogs to protect and improve stopovers along the migration routes of water-fowl, not only to promote an increase in the bird population for the birds' sake, but also to serve the wants of hunters.

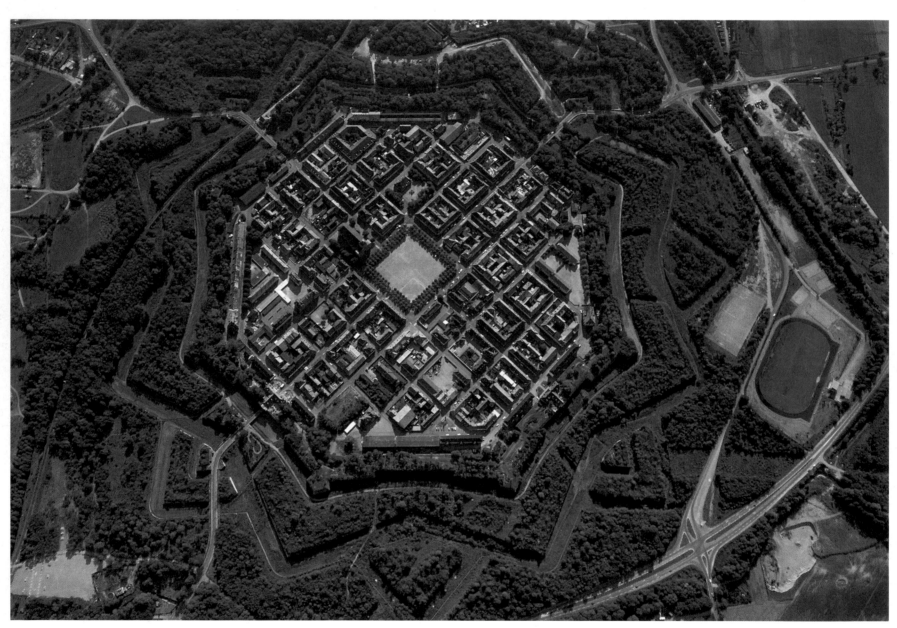

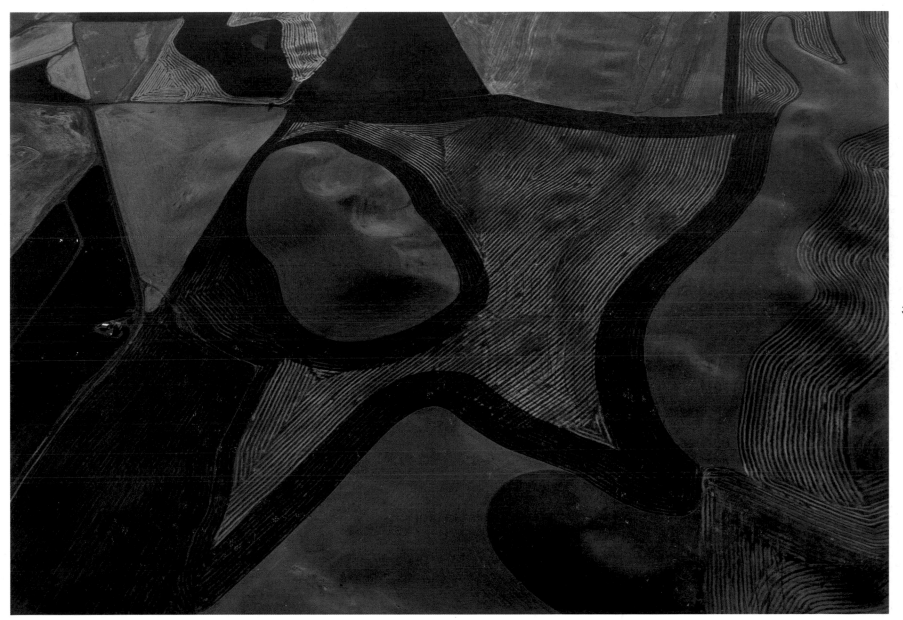

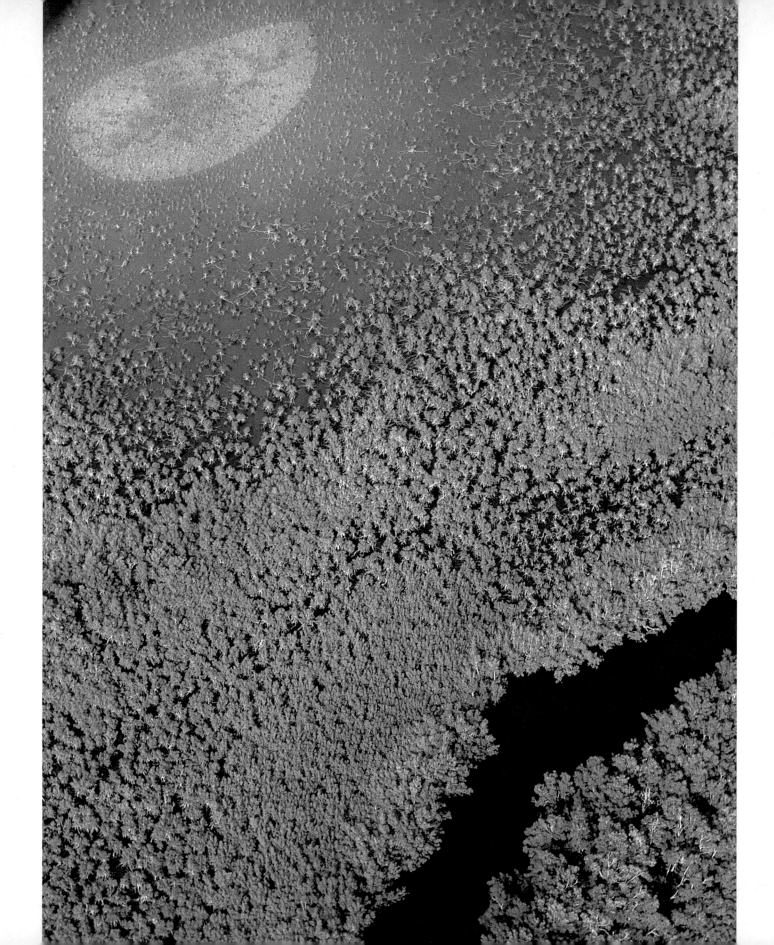

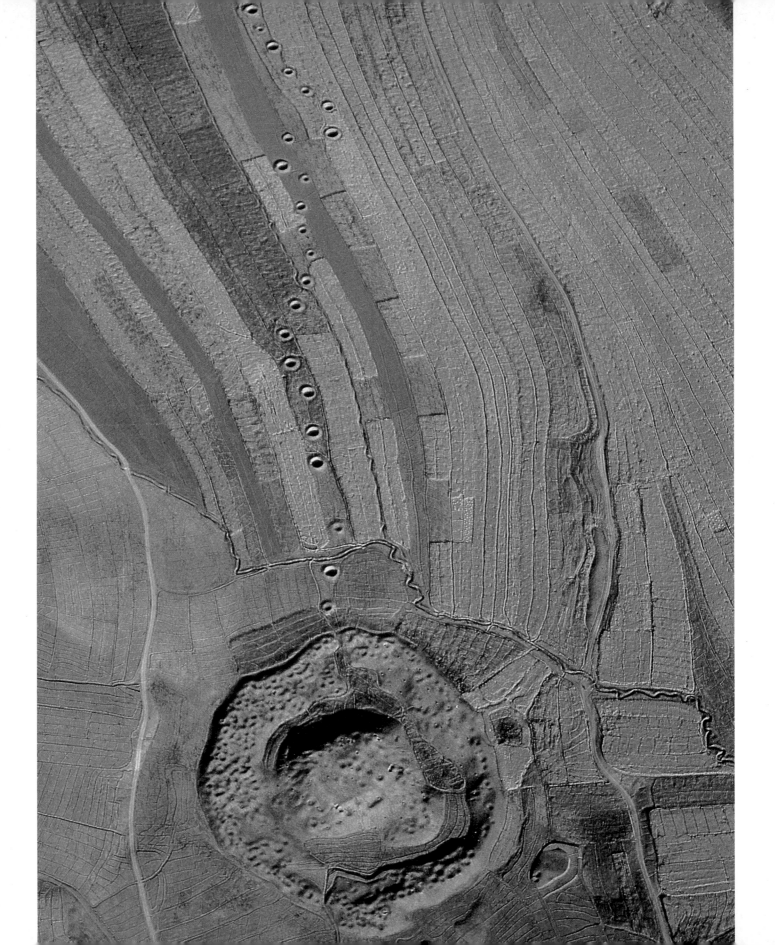

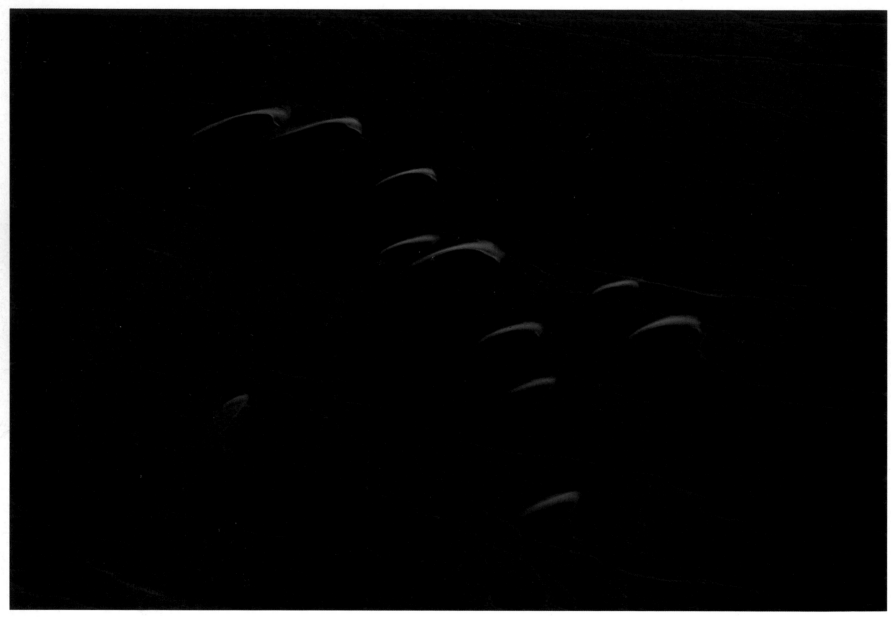

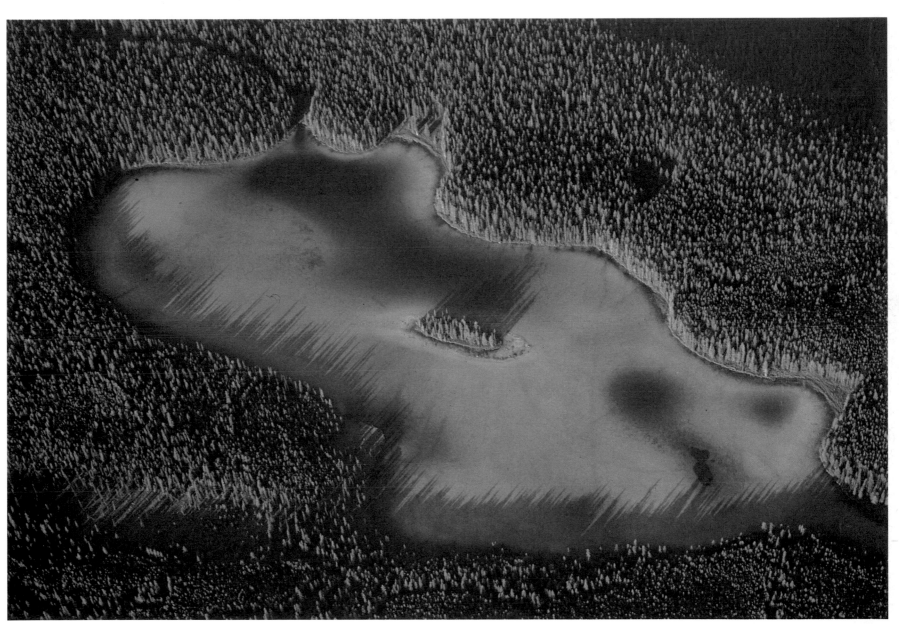

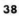

33 Neuf-Brisach, Département Haut-Rhin, France. The French fortification engineer Sébastien Le Prestre de Vauban planned and built Neuf-Brisach between 1699 and 1713. The city, fortified by two eight-sided works, is practically a textbook model of a bastioned fortress. As regards the interior works, curtains almost one thousand feet long connect eight bastioned towers, each protected by counterguards and tenailles. The semilunes of the exterior works are equipped with redoubts. It is no wonder that to describe a fortress of the early eighteenth century, one must borrow so many terms rooted in the French language, for the art of fortification and siege as practiced by Vauban dominated his time as well as much fortress architecture of subsequent eras. As a city, Neuf-Brisach is as plain and functional as a chess board. Vauban was good with figures. He liked to count and recount; statisticians honor him as one of the founding fathers of their science. He led thirty-five seiges, built thirty-three fortified cities and towns, and rehabilitated an additional three hundred forts. In addition to this impressive record, he proved to have civil courage. With his published demand for fairness in taxation, he fell from favor with the Sun King, Louis XIV.

34 Farm near Palouse, Washington. Wheat gilds the picture, freshly threshed dry peas weave silver threads, fallow land adds the black, and grass the green. The farmer has begun to break up the earth with a chisel plow and to mix the pea straw lightly with the loosened soil. This "stubble mulching" protects the land against the dreaded winter rains and frosts. Plowing the stubble under, as formerly practiced, is now frowned upon as a cause of erosion.

35 Mangroves in the Niger Delta, Nigeria. This is the largest river delta in Africa, vaster even than that of the more famous Nile—and the complexity of this swampy wilderness at the mouth of the river is unique on earth. The tides rule a belt of swamp, up to twenty-five miles wide. Twice a day the swamps are flooded, and twice a day the water subsequently recedes. These salt swamps are the realm of the mangroves, a wonder of adaptation to extreme living conditions. The prop roots of the red mangrove *(Rhizophora racemosa)*—almost all Nigerian mangroves belong to this genus—are intertwined in the impenetrable mazes above the muddy ground. Mangroves thin out and almost disappear if the location becomes either too salty or insufficiently so. The latter seems to be the case in the photograph, as the brownish hump of land is not normally reached by the tide.

36 Irrigated wheat fields near Hamadan, Iran. Long, cold winters and hot, dry summers torture the heartland of the former Median Kingdom. Plentiful water from melting snow makes the area one of Iran's most important agricultural regions despite yearly temperature excesses. Intense sunshine during the short growing season allows even a second harvest. After grain, fodder crops are usually planted.

The picture calls to mind a comet. The head, which pulls the ripe fields behind it like a tail, is a *tepe,* one of those artificial hills that are now almost a natural feature of the Iranian landscape. In these *tepes* civilizations and centuries are pasted together: layer upon layer of clay buildings. Treasure hunters have rifled and riddled this *tepe,* the interior mound as well as circular walls. Once again archaeologists will have to make do with the crumbs that have fallen from the table of their more piratical colleagues. The holes in the ground are the shaft openings of a *qanat,* a horizontal well. *Qanats* tap the ground water in the alluvial fans at the foot of the mountains and lead the water along the natural incline toward the surface.

37 Wandering dunes in the Atacama Desert, Chile. The wasteland between the coastal *cordillera* and the Andes holds the world record for dryness. Here rain is an exception, more often expected in vain than occurring; sometimes it does not rain for decades. In the harbor town of Iquique, the coastal fog, the *camanchaca* brings some humidity in winter. Elders remember the last "flood" with a shiver of pleasure, even though the sensational event happened a generation ago. It drizzled an entire day, and houses even became wet on the inside. Not such a surprising occurrence, as no one had ever troubled to repair a damaged roof. There seemed no reason for it.

The deep furrows marring the desert's countenance show, however, that, in earlier times, water ran frequently. As far as local precipitation is concerned, "earlier" goes back more than ten thousand years. Archaeologists, at any rate, have discovered a hill of organic waste on the surface that was perfectly preserved after thousands of years of exposure. The erosion is rather the work of the so-called *avenidas de agua,* streams that fan out from the foot of the mountains, spreading some green over the desert after unusually high precipitation in the Andes. But in historical times even those events have become increasingly rare.

38 A forest lake in Banff National Park, Alberta, Canada. Melted snow and a spring feed the lake. Water level varies with the seasons, though the lake is always shallow, and its shoals glimmer greenly, as if from too much algae. This, however, is not the case; the lake is completely healthy and balanced ecologically; it has pleasantly diversified plant and animal life, which makes it popular with anglers and with the grebes that nest there. The small island, covered by white spruce like the lakeshore, gives the sixteen-hundred-foot body of water its name, Island Lake.

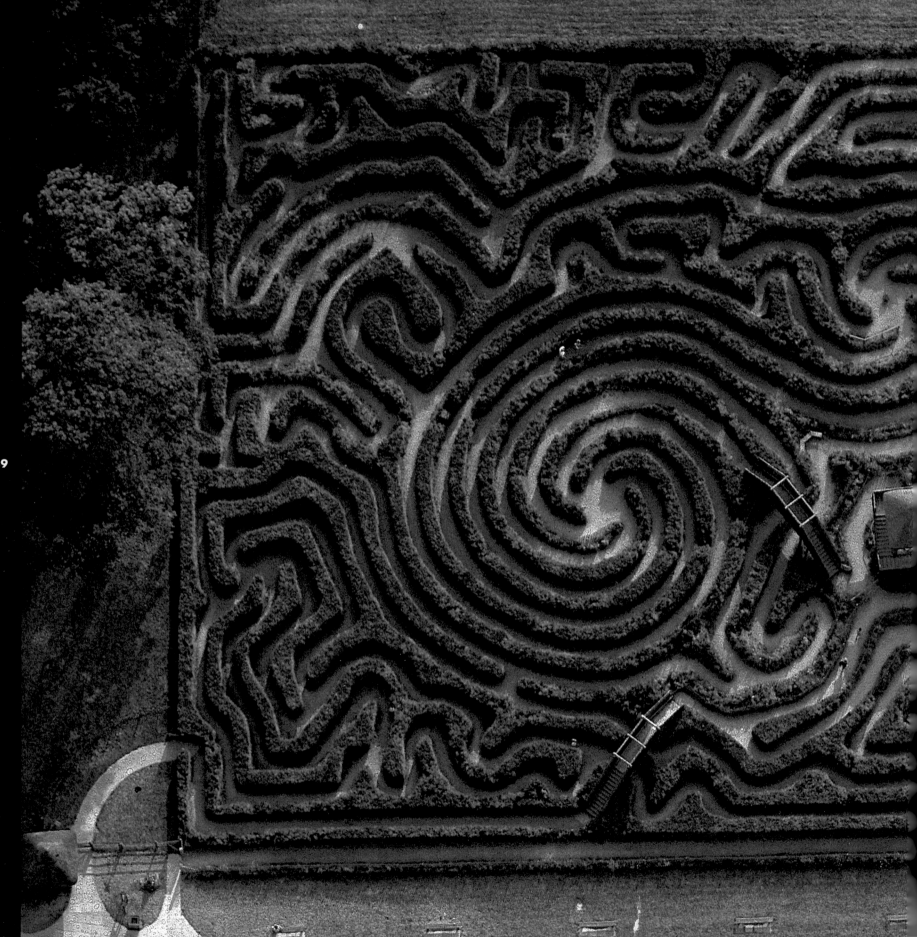

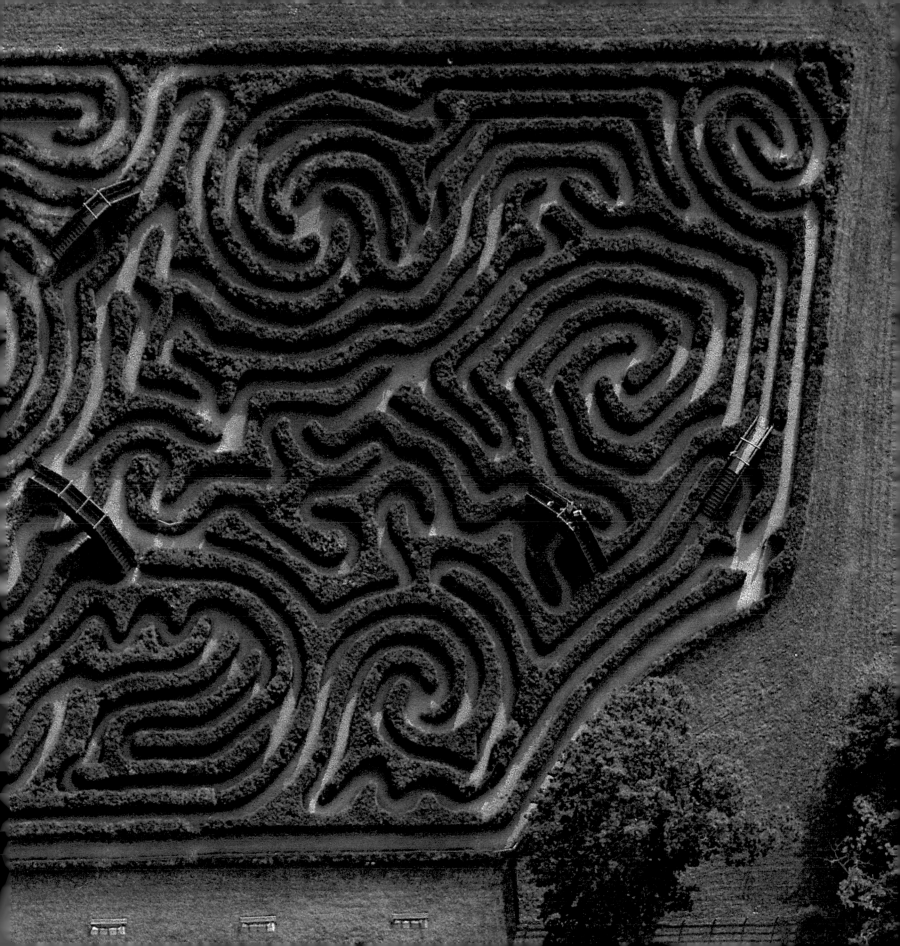

40

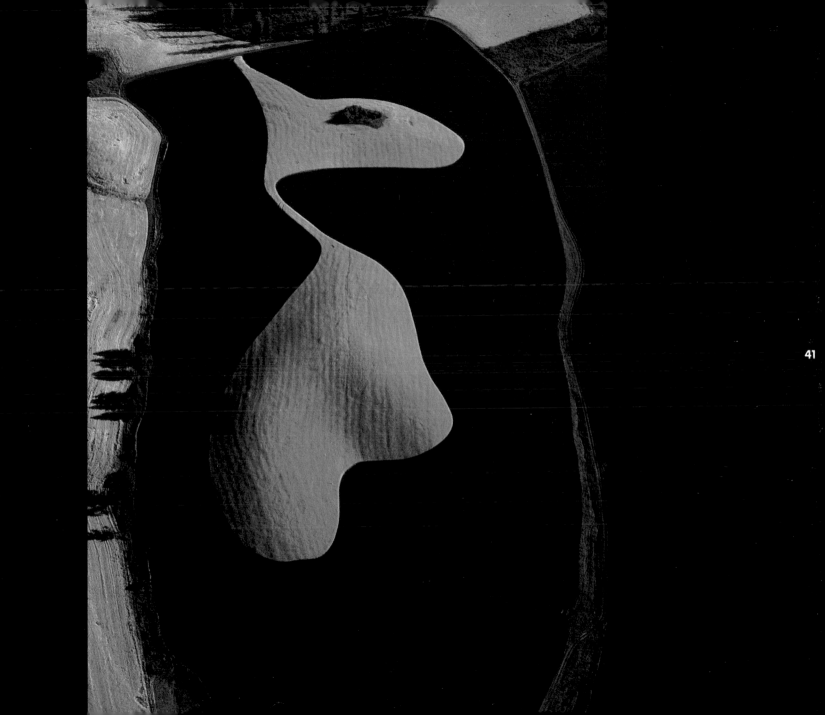

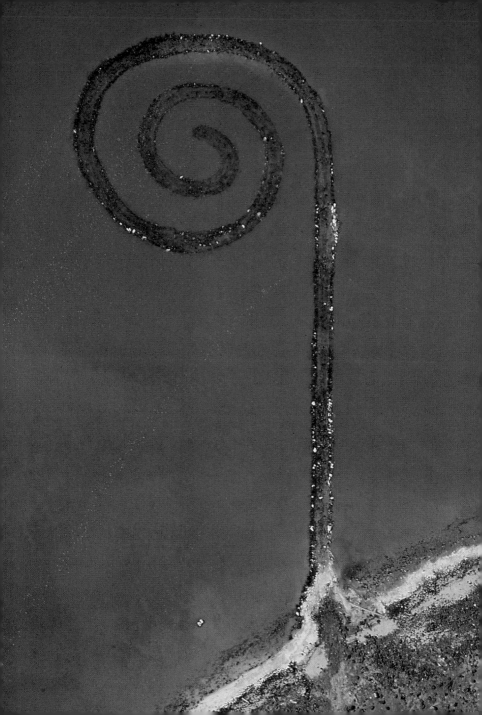

44

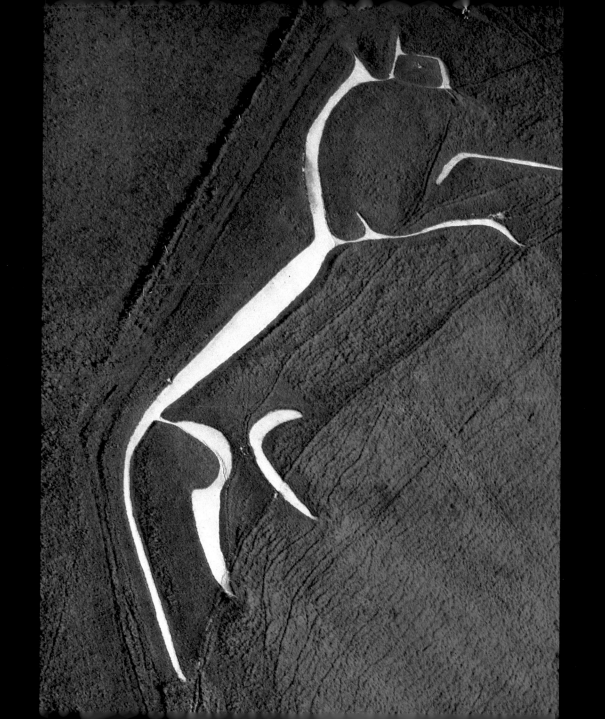

39 The maze at Longleat House (see plate 82), Wiltshire, England. In the 374-by-171-foot hedge maze, 16,180 yew trees line 1.6 miles of paths. There is no larger labyrinth anywhere. Six wooden bridges give it a touch of vivid three-dimensionality—a distant echo of the three-thousand room Egyptian labyrinth mentioned by Herodotus.

Rock musician Greg Bright caused a worldwide sensation with his labyrinth designs. His success flourished in a time fluctuating between psychedelic confusion and clarity, and in 1975 the secretive labyrinth king was commissioned by the lord of the manor to design this maze. Shortly after his "coronation" at Longleat, Bright abdicated and registered at a university as a student of philosophy. Certainly a worthy exile—since earliest times labyrinths have symbolized self-discovery and the search for meaning in life.

Since Greg Bright's work, England has developed a labyrinth mania. In 1984 alone, ten new ones were built. At least one, however, has since been closed, as an alarming number of visitors could not find their way out. In Longleat, emergency stations prevent "the euphoria of confusion" (Bright's phrase) from suddenly turning into panic. In addition, a labyrinth patrol looks for lost people every evening.

40 Madame Lisa in the grass, near Alamo, California. During three December days, using pegs and strings, Will Ashford transferred the outlines of the Gioconda onto a grassy slope above Interstate 680. Finally he inscribed the 200-by-140 foot image with temporarily invisible "ink": nitrogen fertilizer. Lusher and darker-growing grass brought the drawing out in the spring. As an exposed image gradually appears on photographic paper in the developing bath, a world-famous lady slowly began to smile at passing motorists out of the left corner of her mouth.
Rain and sun developed her enigmatic expression. In the early summer that universally known smile withered and yellowed—to the satisfaction of the state police. Ashford and the Highway Patrol had divergent views of his grass women (he later "fertilized" Marilyn Monroe on the same slope), which caused commuters greatly to extend their thirty-seven-second view (assuming travel at the legal speed limit) by parking on the shoulder or median.

I do not know any other living fertilizer artist, but Ashford does have a precursor. In the eighteenth century the inventive Benjamin Franklin convinced his neighbors of the growth-inducing properties of lime by fertilizing a field with huge letters: THIS HAS BEEN PLASTERED.

41 Wheat, ready for harvest, near Lewiston, Idaho. The dark loess soil on a fallow summer field dramatically surrounds the rabbit-shaped field created by the golden winter wheat. How does such an "agro-icon" come into being? Only the farmer knows, and I could not find his address. Perhaps he used only the most elevated parts of his field and removed the rest from production in order to collect government subsidies for reducing cultivated land.

42 *Spiral Jetty* by Robert Smithson, in the Great Salt Lake, Utah. Born in 1938, land artist Robert Smithson built this spiral jetty in 1970 on a plot of land he had leased for twenty years. He recorded the amount of material he dumped into the lake to construct the jetty, 440 feet long by 15 feet wide: 6,600 tons of basalt blocks and riparian rubble from the shoreline—292 truckloads in all. The mysterious signal at the northern end of the lake is of late permanently flooded, as the mean annual water level has risen. At more normal levels the jetty is left dry, the blocks encrusted with white salt crystals when the lake shrinks with summer evaporation. At the same time, the redness of the water deepens; the increased salinity promotes the explosive growth of red algae and bacteria. The photo does not do full justice to the artist's intention. The value of the creation as a sign or signal was secondary to the experience Smithson had walking along the spiral from the outside to the center—the rapids and whirls of the irreversible vortex motion of life converging ever more quickly toward the point of the final truth: death. In 1973, while he was searching from the air above Texas for a suitable location for a new work—a spiral ramp—Smithson's plane crashed, and the artist was killed.

43 Strip farming on the contour, near Canton, Ohio. The farmer's objective here was stopping soil erosion rather than creating land art. That is why the strip fields—one of corn and the other a mixture of grass and legumes—cling to the contours of the land, with corn the crowning point on the hilltop. The type of crop, the machines used, the gradient, and the type of soil all determine the width of the strips. When the farmer rotates crops he makes sure that row crops are not grown twice on neighboring fields—for example, soy beans beside corn—because such coexistence would promote erosion. By planting corn beside a close-growing crop like grass or clover, as is the norm in this part of Ohio, the farmer husbands the soil. Mind you, the corn is also fed to the cattle, an extravagant and circuitous method of food production, objectionable from the standpoint of energy expenditure and for being hard on the soil.

44 The Giant of Cerro Unitas in the Atacama Desert, Chile. The 325-foot-tall slope figure on Cerro Unitas was created by removing rubble. The image may be a thousand years old or more, but its further life expectancy is short. It lies on a practice range of the Chilean air force, where this gargantuan being is used as a target.

The slope figure belongs to the mysterious picture book of the western foothills of the Andes, the most famous pages of which are the ground drawings of Nazca in Peru, more than six hundred miles north of the Atacama giant. Opinion as to the meaning of the Nazca earth images is divided, and no one has seriously speculated on the Giant of Cerro Unitas.

45 The White Horse of Uffington, Berkshire, England. Its total length is 360 feet. In the hills of southern England some prehistoric artist drew by removing sods from the grass cover, which clings to the chalky hills like a skin, baring the underlying rock. The horse on the edge of the Berkshire Downs should be seen together with Uffington Castle, an Iron Age fort atop the hill directly above the horse. In addition, similar stylized drawings of horses on Iron Age Celtic coins suggest that the Uffington Horse is two thousand years old. Archetype of all other white horses on the Downs, it is the most revered of the English turf pictures. A fourteenth-century treatise on the wonders of Britain ranks it second only to Stonehenge. A fence now protects the horse from souvenir hunters as well as those in search of good fortune—it is said that whoever spins around, blindfolded, three times in the horse's eye has good luck in store for him.

The horses in chalk are clearly visible from the air: maps used by pilots record them as landmarks. During the Second World War the British Ministry of War ordered that they be obscured. Beginning in 1940, green paint, turfs, and twigs camouflaged them from German airmen.

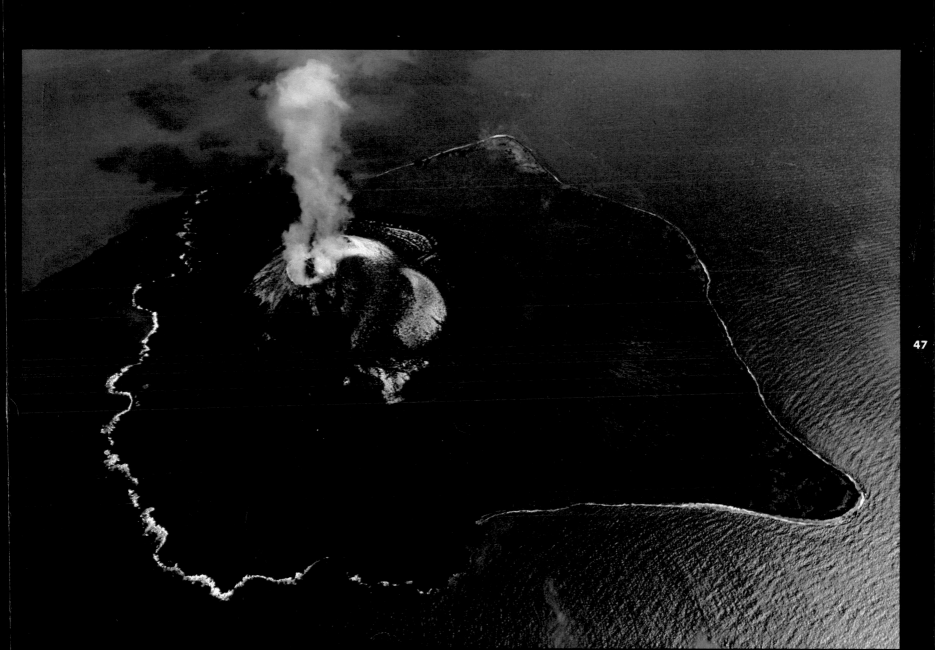

49

50

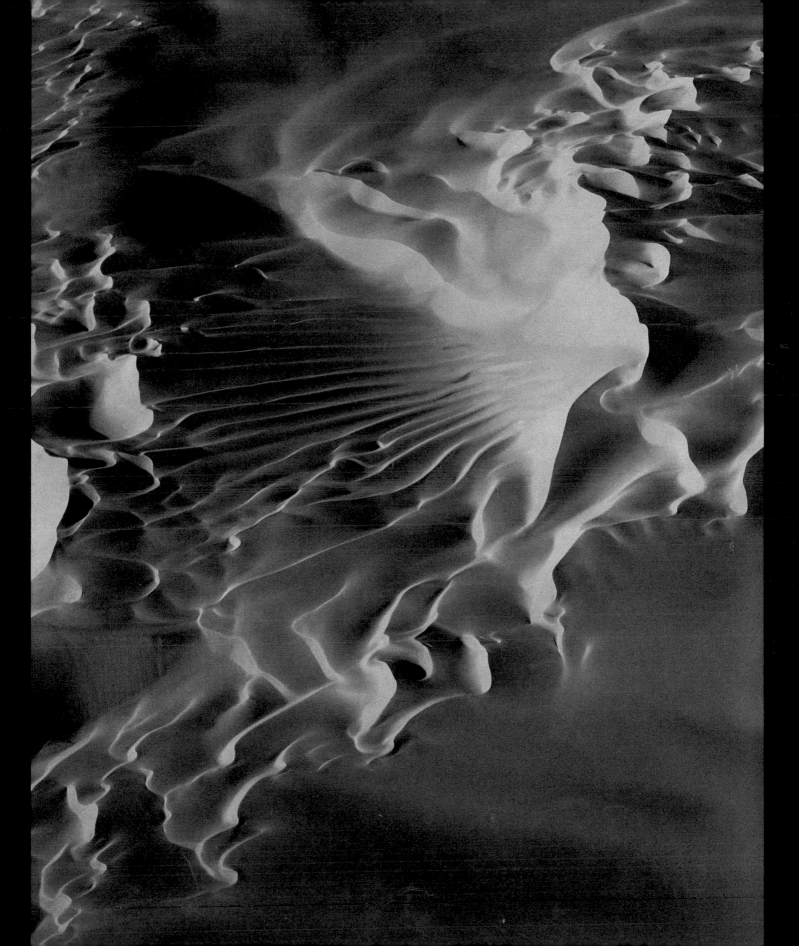

46 One of the *Surrounded Islands* by Christo, in Biscayne Bay, Florida. The Bulgarian exile began his career as a wrapping artist. He first got talked about when he draped a curtain across a Colorado valley between two mountain peaks, and he became famous for a fence that ran for twenty-four miles through the rolling hills of California. In 1983 he tried his hand at framing. For ten days in May eleven mangrove- and spruce-covered islets in the lagoon between Miami and Miami Beach were fitted out in dresses of Christo's design. Surrounded by 6.5 million square feet of fluorescent frangipani polypropylene webbing, the islands emerged as gigantic water lilies or, the better to express Christo's showmanship, as ballerinas with flying tutus. For this "irresponsible, irrational, poetic gesture" (Christo's description of the *Surrounded Islands* project), the artist spent 3.2 million dollars—mind you, out of his own pocket. Almost a tenth of the amount went to consultants and to court costs and lawyers' fees; conservationists, concerned about the welfare of the manatees and birds in the lagoon, fought Christo's island flowers until the last minute.

47 Anak Krakatoa, in the Sunda Straits, Indonesia. The volcanic island of Krakatoa exploded on August 27, 1883, at 9:58 a.m. The bang traveled as far as central Australia, but it failed adequately to alarm the local inhabitants, since a thick cloud of ash muffled it for them. *Tsunamis*, or tidal waves, up to 130 feet high, devastated the coasts of Java and Sumatra, killing 36,000. For years the stratosphere, polluted with dust and ash, gave the whole world "wrathful sunsets" (Tennyson) and lowered temperatures. Krakatoa made research history: for the first time our planet was not only understood as an interconnected system of air, land, and water, but was essentially experienced as such. On its one hundredth anniversary, the catastrophe of Krakatoa became frighteningly real as a small-scale model of the apocalypse of a nuclear winter that might be brought about by the soot and dust of burning cities. Incidentally, the creators of the first atom bomb secretly took two books on Krakatoa along to Los Alamos.

From the caldera there arises, like the Phoenix from the ashes of self-immolation, a new volcanic cone—Anak Krakatoa, "child of Krakatoa." By this time the child has matured into an island almost a mile across, but will have to go on growing if it is to replace what substance "Father Krakatoa" blew away on that August day.

48 Gosses Bluff, near Alice Springs, Australia. The circular mountain, three miles in diameter, was believed to be an ancient volcanic crater, or what a hundred million years of erosion left of it. But since 1966, gravity measurements, radiometric, seismic, and magnetic investigations, as well as test drillings have suggested that Gosses Bluff is an "astrobleme," an impact crater caused by a giant meteorite or even a comet. Indeed, some Apollo astronauts, training, used the crater as a moon on earth. The crater's extraterrestrial origin was confirmed by the recent discovery of chemical and mechanical changes in the rocks caused by a shock wave. Gosses Bluff is among the most impressive scars inflicted upon the earth by the cannonade from space, as it has barely healed.

Possibly the bombardment was wholly or partly responsible for the mass extinction of animal and plant life (for example, the death of the dinosaurs) that in intervals every thirty to fifty million years altered the evolution of life. The periods of increased incidence of meteoritic hits correspond with the breaks interrupting the course of evolution. The force of the meteoritic impacts, according to a new hypothesis, raised clouds of dust that blocked out sunlight for thousands of years and sentenced many life forms to a freezing death. And so might run the apocalyptic scenario that could result from a nuclear exchange.

49 Williamson Reef in the Lau archipelago, Fiji. The coral reef surrounds a lagoon, suggestive of an atoll, but, as is not the case with a classical atoll, there was never a volcano at the lagoon's present site. Due to the sinking of the land, a low-lying island simply dropped out of sight and left its fringing reef behind. In length, Williamson Reef is barely a mile-and-a-quarter from one outer edge to the other.

50 Trail of sand behind a cay on the Great Bahama Bank, Commonwealth of the Bahamas. A chain of submarine mountain rises to peaks and forms three thousand islands and cays—that is, crags, coral reefs, and sandbanks barely above high-tide level. On the mountain plateaus, just a few yards below the surface of the Atlantic, the tides and currents play with the loose sand.

51 Drifted sand near Pisco, Peru. The creations emerging from the most transitory of elements, wind and sand, invite contemplation of the interplay between freedom and law. Viewed thus, they can be called "beautiful," if only we dared to cut summarily across aesthetic tangles. And in this same respect, as halfway points between chaos and order, they are certainly "interesting." Geographers, physicists, mathematicians, and geomorphologists from many countries are now studying the dunes. The Peruvian coastal desert is a preferred area of study particularly for American researchers.

The motivation for a comparative desert science is not of this world. When the first images radioed back by Viking I of its landing site on Mars formed on a screen in California, a geologist broke the tension when he jokingly asked where the camels were—so evocatively did the Martian scenery resemble the earth's rocky and sandy deserts. The attempt to describe the sand drifts on our neighboring planets exactly—mathematically and physically— has resulted in another, though unpleasant discovery: how very little we know about dune formation on earth.

53

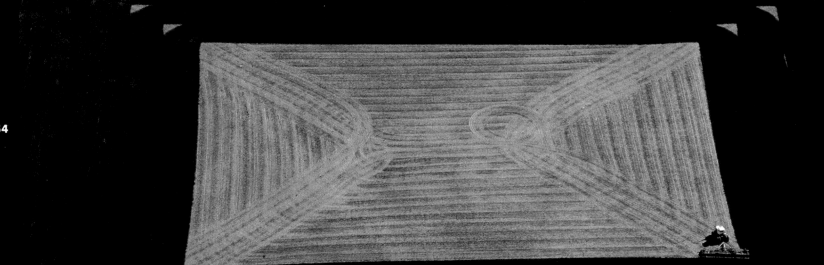

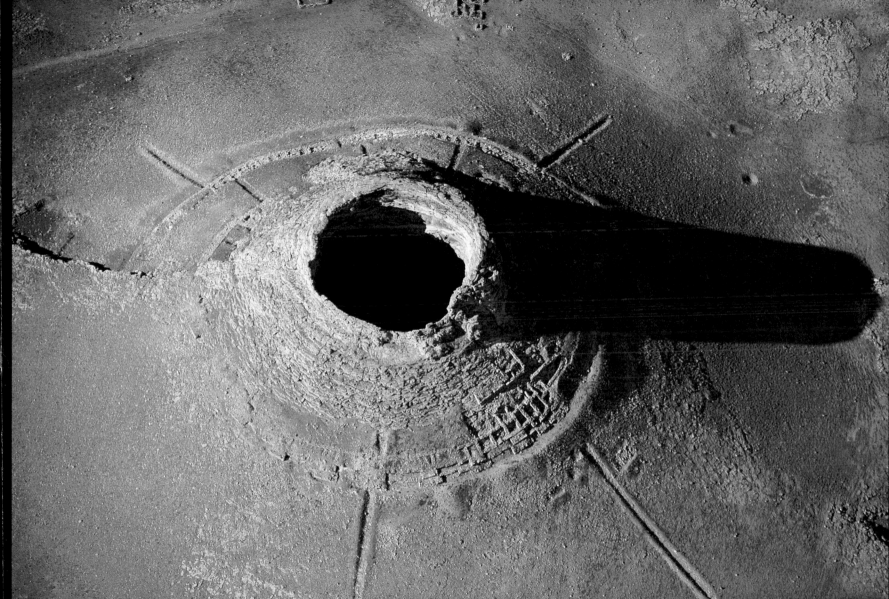

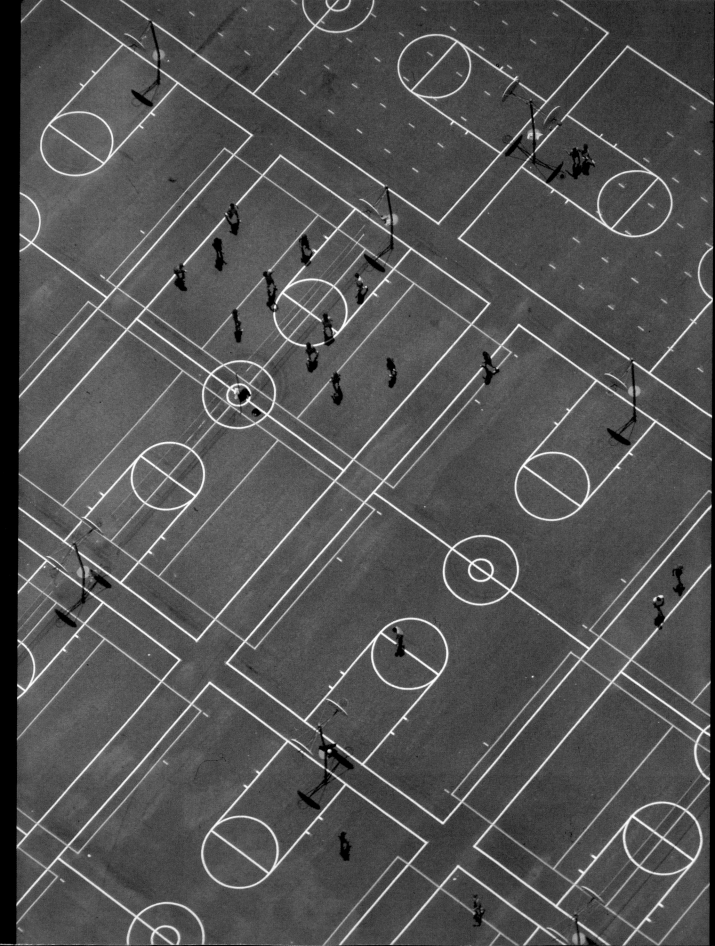

52 High-tension tower and *ipé* tree in a field near Piracicaba, São Paulo, Brazil. The yellow *ipé* is the national tree of Brazil. What is it in such a seemingly innocent image—a juxtaposition of nature and technology, electrical energy and a tree—that sends a galvanic shock along our skin? Maybe it is that such juxtaposition in many places and all too frequently has become conflict.

53 A road in the jungle of Mato Grosso, Brazil. This is part of twelve thousand miles of road that Brazil bulldozed through the bush and forest in order to open up and colonize Amazonia and the Mato Grosso.

The aerial view of this road partakes of the rousing imagery associated with a time of change—and that, therefore, does not always rouse the same feelings. It has not been that long since one's heart beat faster at the thought of the pioneers who blazed such trails through the jungle; now it stops. Even for some Brazilians this dream road has become a nightmare. The last primeval expanse on earth, the most abundant oxygen and fresh-water reservoir on the planet, and a genetic treasure trove that has yet to be investigated completely trembles under tires and Caterpillar tracks. And as if ecological irrationality were not enough, colonization has now degenerated into insidious colonialism as "civilization" brutally rolls over the Indians living in the forest.

54 A field quadrangle near Dubbo, New South Wales, Australia. In June, the southern hemisphere's midwinter month, the farmer prepares his field with a cultivator, a machine that loosens the soil, splits the clods, and simultaneously destroys weeds. He tills the field from the outside toward the center. Thanks to articulated steering, the tractor can turn at a right angle. (Turning without articulated steering increases the danger of soil compaction.) At the end, the farmer adds the diagonals, driving back and forth across the right-angle turns of his previous runs.

55 The Zendan-e Suleiman ("Solomon's Prison"), in a high valley, Azerbaijan Province, Iran. A gaseous spring built up the 330-foot-high mountain cone with calcium deposits. The nearly circular 230-foot-wide crater of the cone originally contained a lake. As early as the eighth century B.C. the Zendan had a shrine on the upper edge. A wreath of rooms below the terrace where the cult was celebrated presumably prevented the profane from reaching the holy lake. As the lake receded, the place of worship was probably transferred to a second mountain cone nearby, the Takht-e Suleiman ("Solomon's Throne"). For intermittent periods, the Zendan changed its function to that of an armed settlement, partly fortified, also at the foot of the hill. Local legend later connected the spring's cone with King Solomon. Today the inhabitants avoid the Zendan as the haunt of evil spirits.

The priests of the shrine apparently had thrown sacrificial offerings into the crater lake. For some time archaeologists had burned to clean out this prehistoric piggy bank. They were helped into it by German miners, who tunneled to the bottom of the former lake. But the cache, whatever it is, resisted the attack of pickaxes and shovels: the formation of sinter has thoroughly petrified the contents.

56 Volleyball and basketball players at a high school near Santa Barbara, California. A ball is just dropping into the basket. The lines on the ground define the bounds and divide the court according to the game: yellow for volleyball, white for basketball.

57 Hot-air balloons before a mass ascent at Albuquerque, New Mexico. The air above Albuquerque has a fairly high "iron content," which is how the not-too-daring young men in their flying baskets refer to a sky crowded with airplane traffic to and from the busy municipal airport and nearby Air Force base. But the cool morning hours, blessed by mild winds and unlimited visibility, make up for this—and the civilian and military flight controllers occasionally show some sympathy by demanding that a piece of iron make a detour. The annual October meeting of the hot-air balloonists in Albuquerque is therefore unrivaled in number of participants. The two weekends that frame the meet become fiestas. Hissing burners simultaneously swell the nylon envelopes; in a spectacular mass ascent, the whole armada floats away, like so many colored easter eggs.

Albuquerque lays claim to the title of world ballooning capital. After all, as early as 1882, the city went without gas for two days to allow a fellow citizen to go up in a Charlière. In recent times the city's balloonists spoiled its inhabitants with their record-breaking performances. Three Albuquerqueans crossed the Atlantic in a balloon. One of them, Maxie Anderson, later drifted nonstop over North America, and the other two, Ben Abruzzo and Larry Newman, conquered the Pacific. Anderson and Abruzzo aspired to a hat trick—to balloon around the world. But both died in flying accidents.

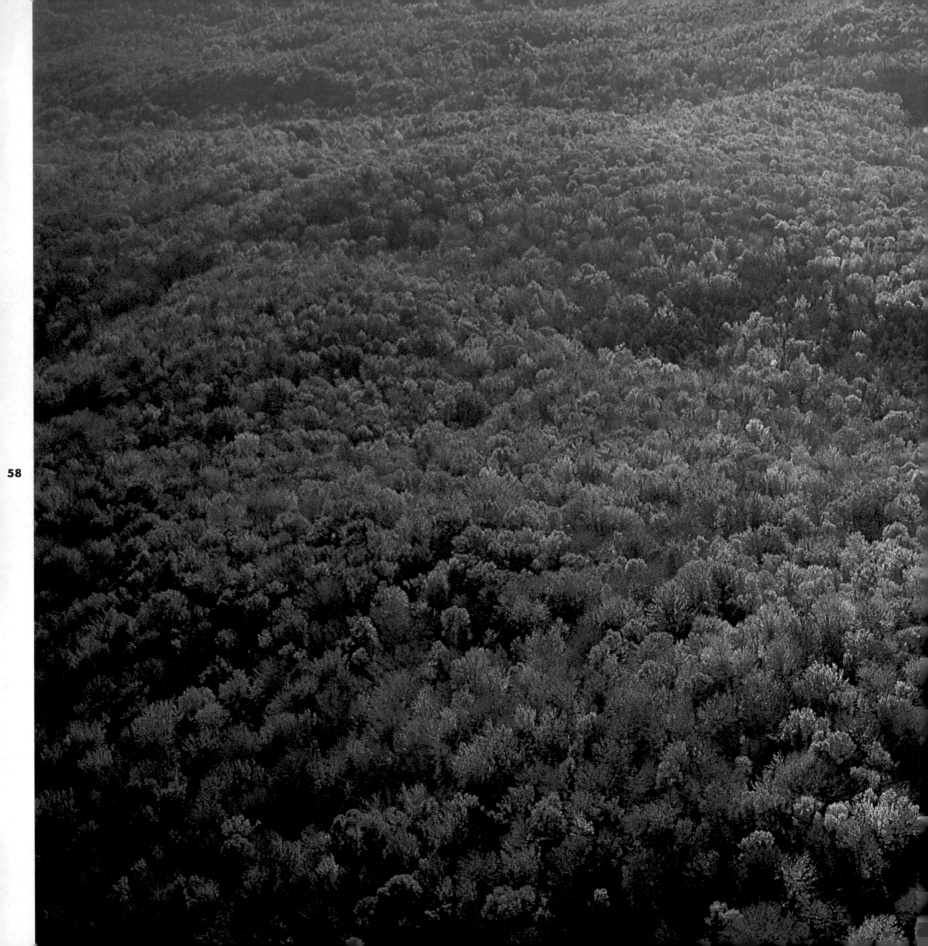

58

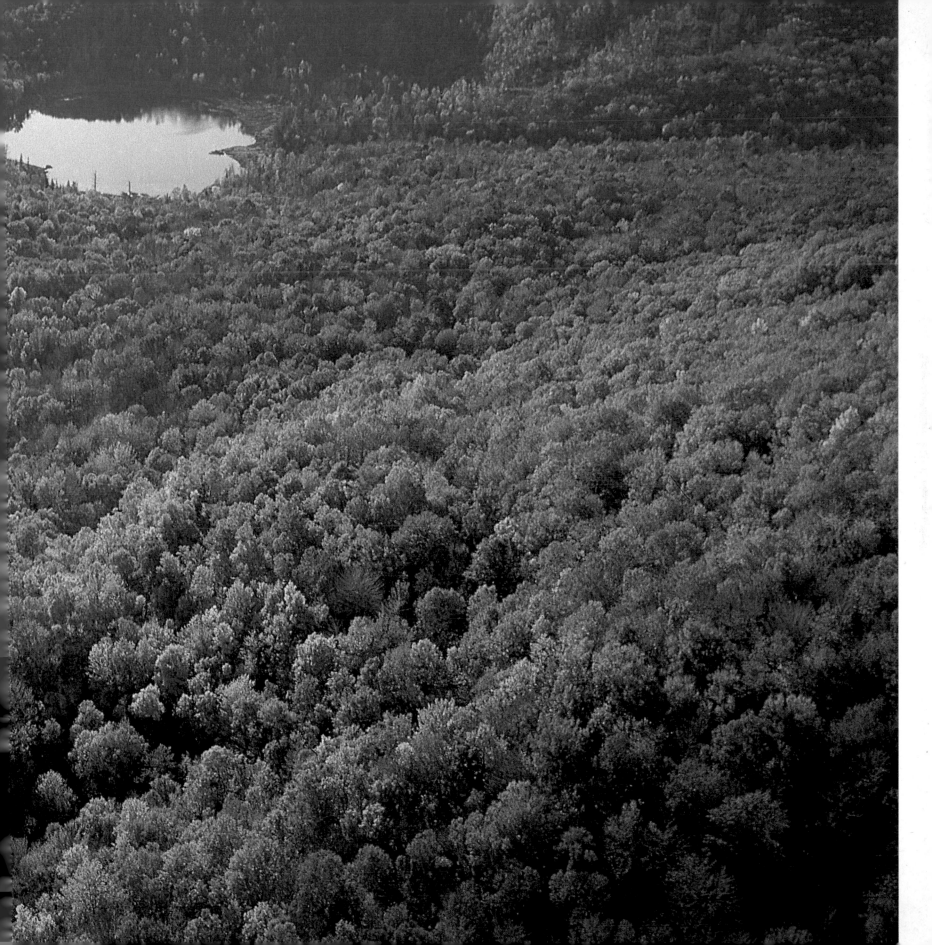

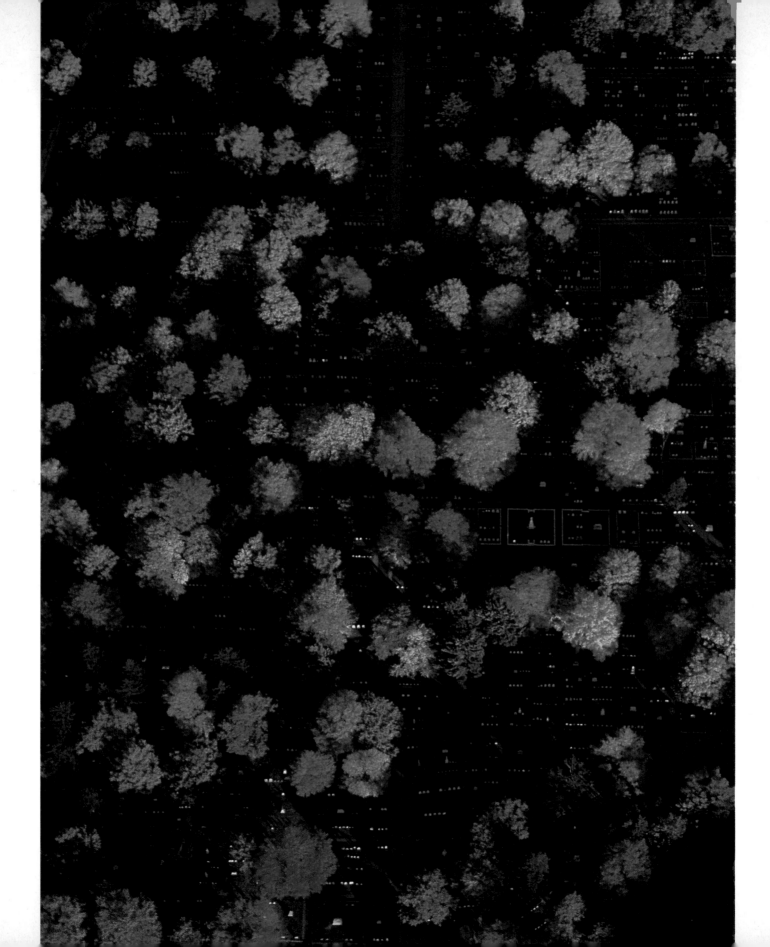

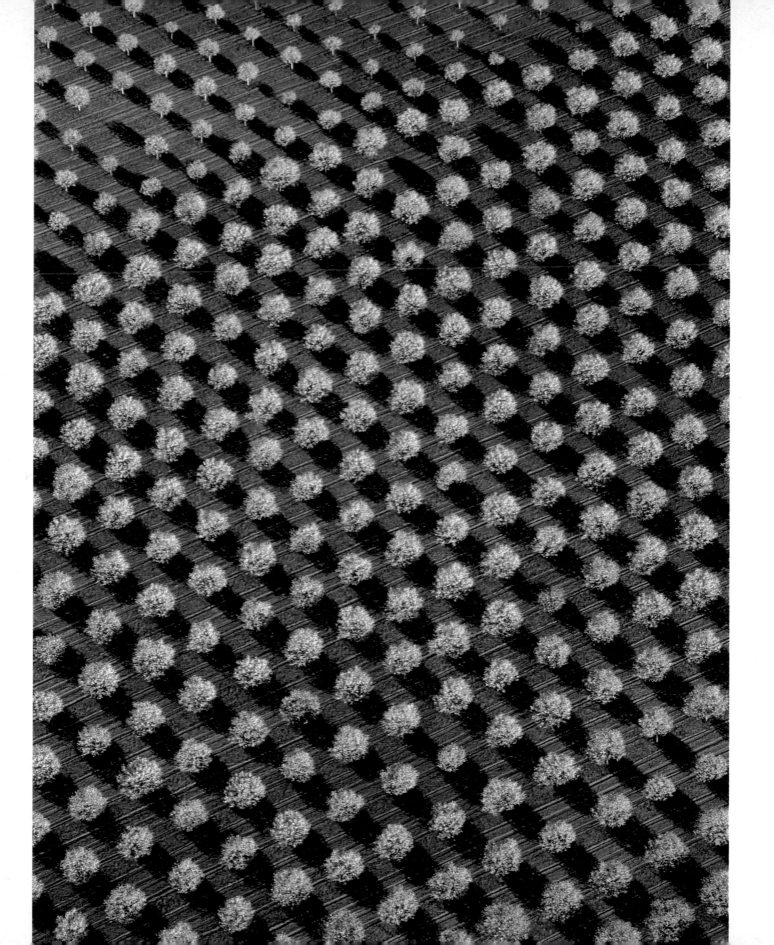

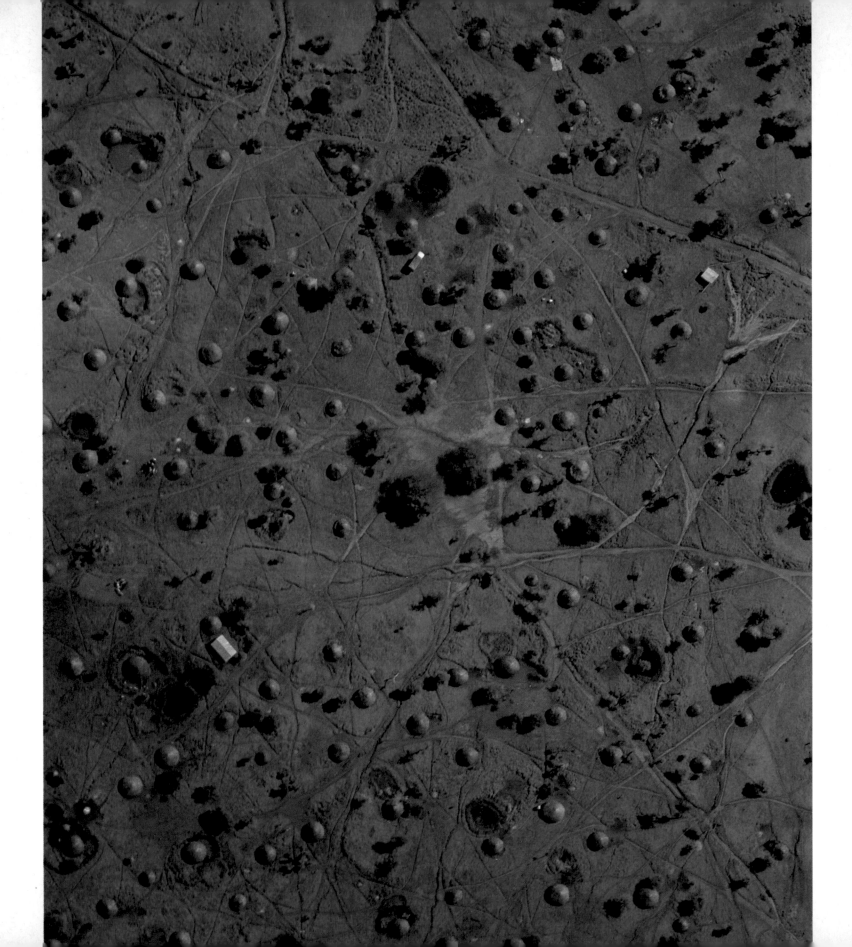

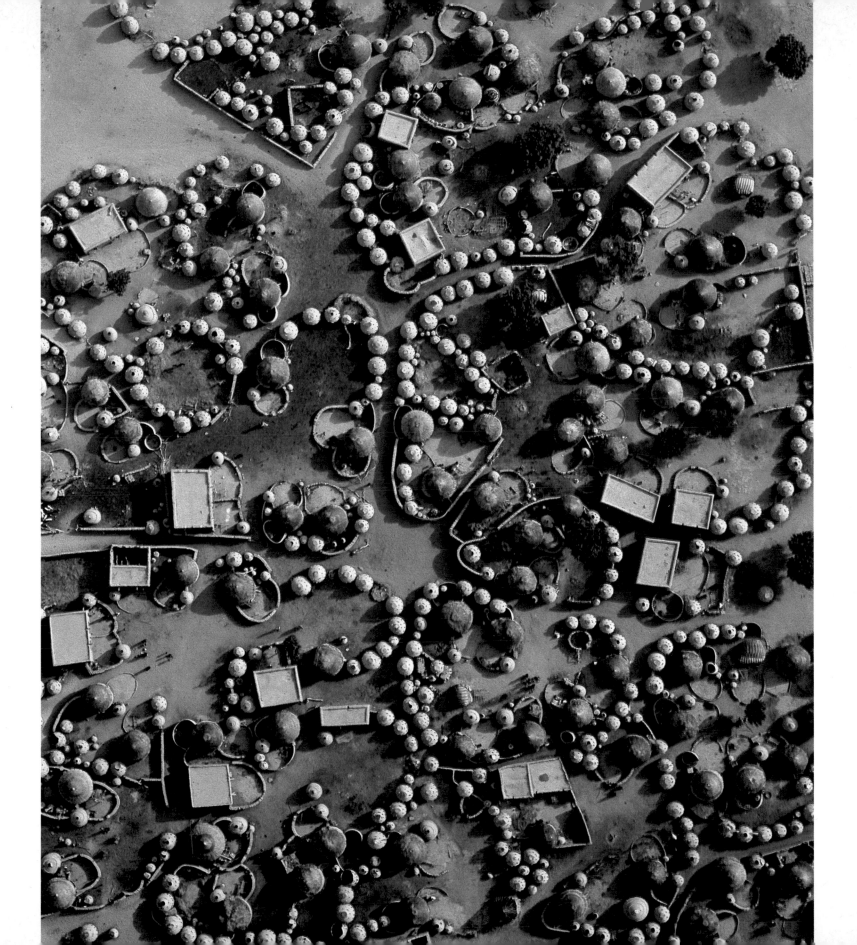

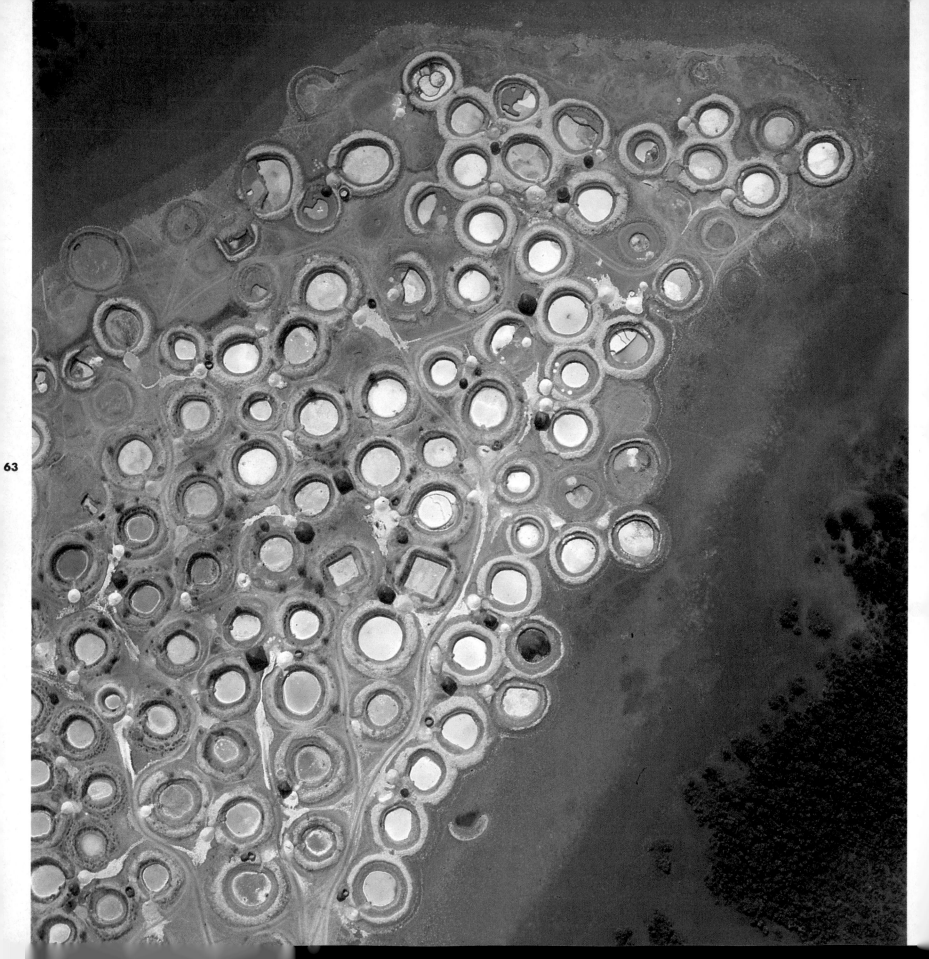

58 Autumn forest near St. Johnsbury, Vermont. When the V-formations of passing migrating Canada geese appear in the sky, the colored foliage creeps southward, blazing like a fire without flames. In the deciduous forests of New England there are an especially large number of tree species that produce red pigments (anthocyanes) from the sugar in the leaves. Furthermore, Indian Summer presents the most favorable weather for the development of anthocyanes. Following the first frost, sunny days restart the chlorophyll factory in the leaves, but at the same time cold nights prevent the newly created sugars from moving from the leaf to the tree. By comparison, the October palette of European deciduous forests is less spectacular. What is called in Europe the "Old Wives' Summer" lacks bite. And glaciation during the last Ice Age wiped out a number of deciduous trees in Europe that survived in North America by moving south. These include many species of oak and maple, including the superstar of New England's autumn forests, the sugar maple. But now man is completing in America what the Ice Age glaciers had been unable to do: acid rain and heavy metals threaten the forests of New England, too, and among the deciduous trees, the sugar maple in particular seems to be a preferred victim.

59 Cemetery, Portsmouth, New Hampshire, in the riotous colors of New England autumn. The sugar maple often has both gold and carmine leaves, yellow on the shaded side, red on the sunny. Once, the original inhabitants of North America knew exactly why the deciduous forests of the Northeast turned blood red during Indian Summer: the Great Hunter had killed the Great Bear, and his blood dripped down onto the mountains and valleys. This rapture of colors is completely without purpose; today researchers investigating the shedding of leaves and their color changes are agreed on this point. The autumnal transformations bring no benefit to the individual tree or to the species as a whole. The turning leaves are an episode of farewell said with grace and beauty, a gesture aglow with useless radiance.

60 Cherry trees in blossom near Benton Harbor, Michigan. These trees will bear tart cherries, used primarily for pies and pie fillings. Michigan is the most important producer of tart cherries in the United States. Rationalization, as opposed to European scattered planting of standard trees, forces intensive cultivation of sturdy, easily cared-for dwarf trees. Ten days before the harvest the cherries are sprayed with a growth accelerator to promote their abscission. The harvester, or "cherry shaker," thereafter has an easier job. Subjected to the harvester's repeated sharp blows, the tree rains down its fruit after a few seconds. The varying heights of the trees in the picture are due to approximately a three-year age difference among them. Wet spots rip holes here and there in the rigid order of the plantation. Cherry trees are highly sensitive to moisture build-up or an excessively high ground-water level. In normal years, the proximity of Lake Michigan is an invaluable advantage, as the waters of the lake store up heat and prevent frosts.

Radio and television broadcasters breathlessly report on peak color—the high point of the autumn color change in the New England forests—and mobilize vast caravans of cars from the metropolises. The fuss about cherry-blossom time in Michigan is more subdued, but its high point is, if possible, even more transient. Like youth's dream of a first love destined to last a lifetime, it comes alive, in some years, on a single April day.

61 A scattered village between Lake Natron and Serengeti, Tanzania. The inhabitants have covered the open ground between the huts and houses with a network of paths that say a great deal about their relation to each other—loners have no trails leading to their doors. Communication researchers, social scientists, and ethnologists today make a detailed study of the trails that man, as much a trampler as any hoofed animal, has left upon the earth.

62 The village of Labbézanga, on an island in the Niger River, Mali. The granaries wind through the village like strings of beads. In them, millet and rice keep for up to three years, though in the recent past, during the seemingly endless droughts, the harvest has rarely been sufficient to maintain full capacity. The amphora-shaped mud containers, some as high as the houses, are filled and emptied through an opening at the top. Stone slabs and fragments, jutting out from the body of the granaries like spikes, make them easier to climb. The villagers, settled, non-nomadic members of the Songhai tribe, live mainly in the traditional round mud huts with domed thatched roofs. In Labbézanga, however, terrace-roofed square houses of Islamic-Arabic origin are on the increase. Owning one boosts a family's social standing.

I have explained in the introduction why I felt like Columbus when I found Labbézanga. Beyond being "the most beautiful village in Africa," it is also, according to the cyberneticist Frederic Vester, a shining example of an interconnected system. For the unassuming Labbézangans almost too much praise.

63 Salt pans near Foundiougne, Senegal. After the torrential November and December rains, the inhabitants dig circular basins in the estuary and swampy delta of the Saloum River and pile the excavated earth around their rims. At the next spring tide, the sea, only a few miles away, pours brackish water into the basins through gaps in the humped edge. When the tide goes out the salt farmers plug the gap. The sun sucks up the water in a few months and leaves the salt behind. The harvest can be repeated three times before the next major rains.

64 Fish traps in Laguna de Bay, Luzon, Philippines. Not only the arrow-shaped trap, with a creel at the pointed end, lies in wait for the fish. The free-floating circular carpets of water hyacinths lure milkfish and tilapias, which seek refuge from the sun or come to feed—and often end up in the net. Fishermen in outrigger canoes regularly visit these islands of vegetation on the edge of the lagoon and collect their catch. Today Laguna de Bay, the largest fresh-water lake on Luzon, is a large and highly productive aquatic farm.

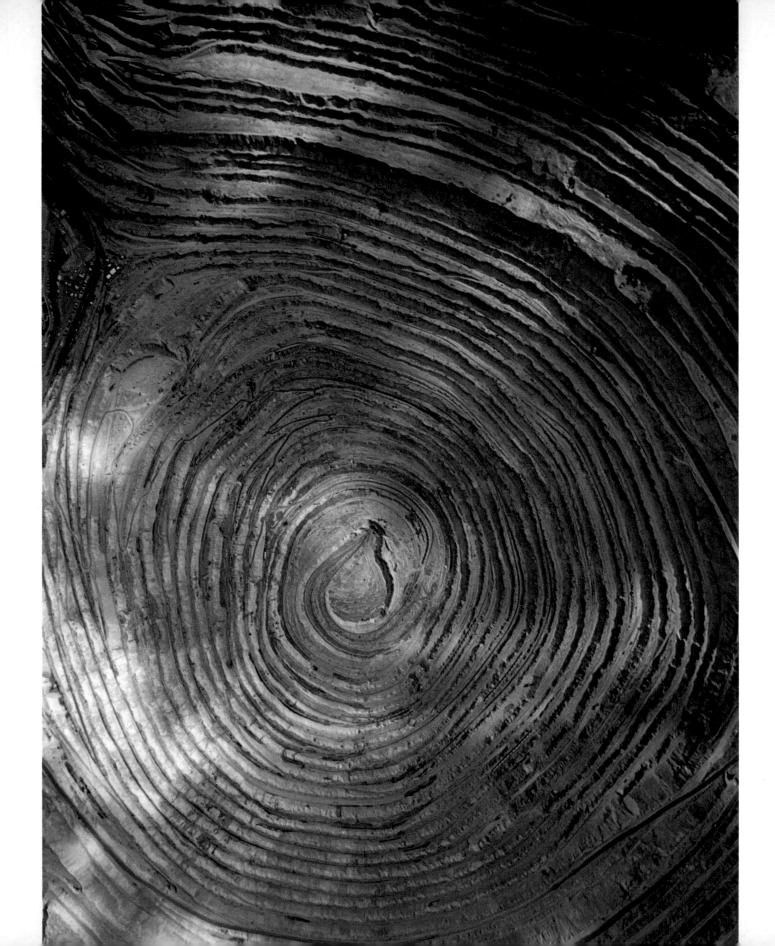

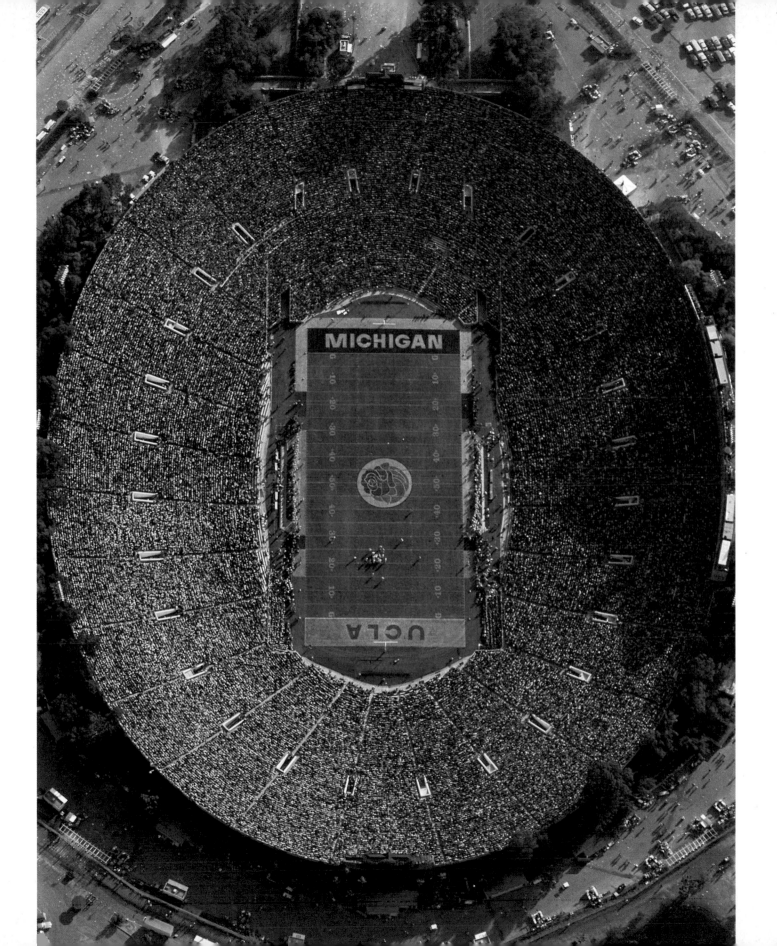

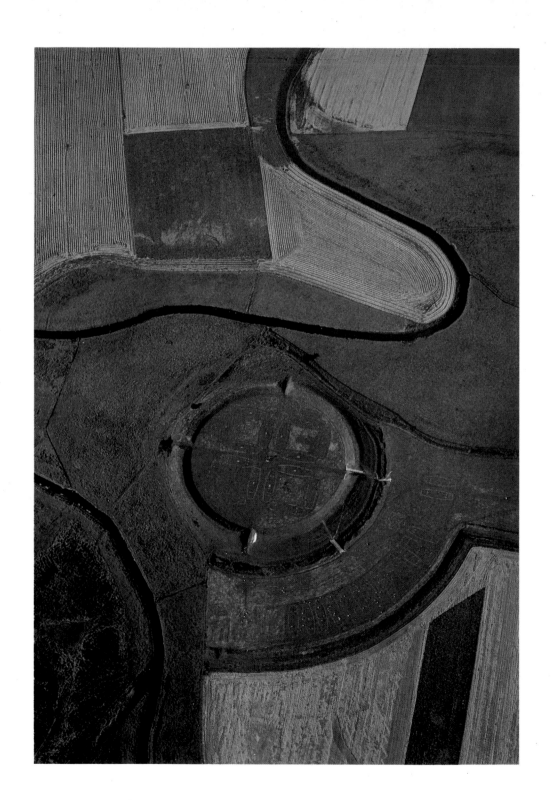

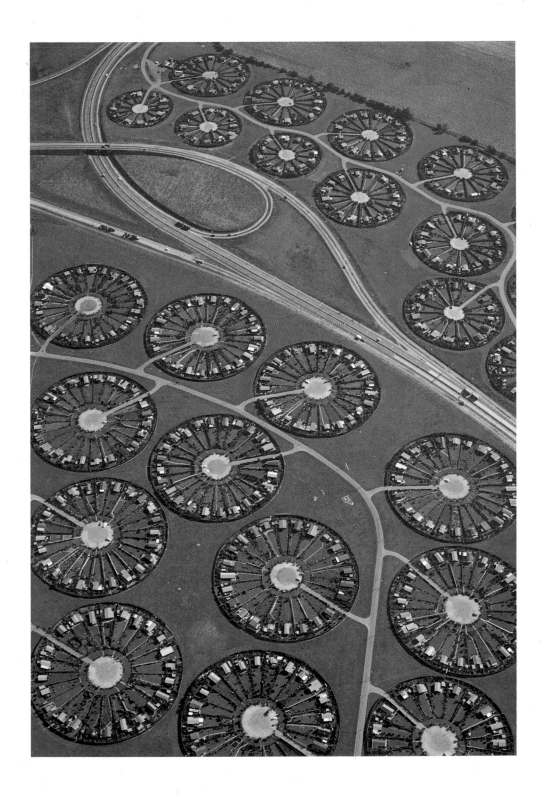

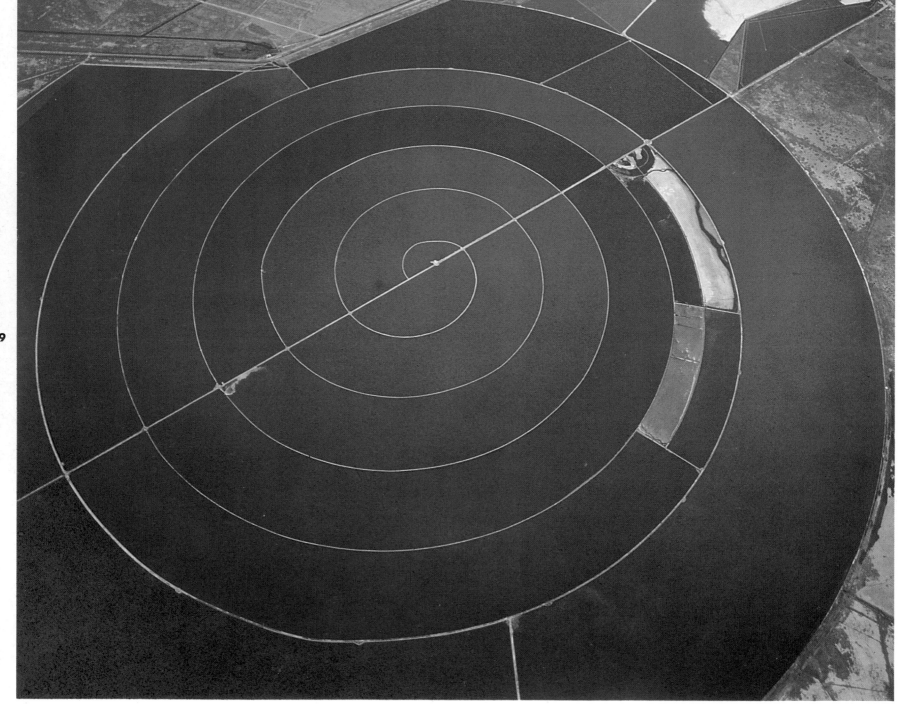

65 Bingham Canyon Mine, Utah. This is not only the oldest and largest open-pit copper mine, it is the biggest mining operation ever. More copper has come from this mine than from anywhere else. The greatest man-made excavation, the material from digging the Panama Canal would fit into it five times over. In short, it is the most spectacular mine on the planet. It is 2.5 miles long and 2,600 feet deep. In winter, snow falls on its rim while it is raining at the bottom. On the banks, up to 50 feet high and 120 feet wide, ore cars and dump trucks come and go. The handling capacity can exceed 638,000 tons in a record day, an all-time world production high. Since 1904 almost 5 billion tons of rock have been removed from the mine and 12.7 million tons of raw copper have been extracted from the ore.

The gigantic amphitheater and the gargantuan loading and transport equipment are a result of the very low copper content of the ore and the unfavorable ratio of ore to country rock. The extraction of huge amounts of ore and extreme sophistication in dressing have compensated for these shortcomings until very recently; in the spring of 1985 the mine was shut down for an indefinite time, perhaps permanently.

66 Football game in Pasadena, California. The traditional New Year's Day game brought 104,991 spectators to the Rose Bowl.

Meanwhile, not far from the stadium, in the city of Pasadena, pens squiggle and scrawl on continuous charts, recording tremors and quakes day in and day out. Hundreds of seismometers ceaselessly feed the seismological station of the California Institute of Technology with data from all of southern California. The time bomb of a great earthquake ticks away underground. Geophysicists believe that the southern part of the San Andreas Fault will give out in the next quarter-century, presumably with catastrophic results for Los Angeles and its satellite cities. At zero hour, when the big one makes the pens jump off the recording drum, the emergency planners hope at least for an empty stadium.

67 Viking base camp, Trelleborg, near Slagelse, on Zealand, Denmark. A circular rampart with an interior radius of 223 feet and an exterior radius of 282 feet encloses the main fortress. The circle deviates from geometric perfection by an inch or so. This accuracy is easy to achieve simply by rotating a rope around a central stake. But the interior partitioning proves that masters at handling surveyor's rods and pegs were at work. A crossroads, corresponding to the four gates, divides up the inner circle. In each quarter-circle quadrant four boat-shaped elliptical buildings surrounded the square courtyard. The circular encampment possessed an outer fortress, whose buildings, also boat shaped, were radially coordinated with the main installation. When Trelleborg was established it still had direct access to the sea and was presumably garrisoned by an army corps. Under Sweyn Forkbeard (986–1014) the Vikings later built more of these round defense works with troop barracks. The mathematical rigor they demanded of their layouts reveals something of the spirit of the Viking military instructors.

The circular city, divided into quadrants by an intersection, is a venerable city plan, nearly an urban mandala (plate 73). In the layout of the Viking fortress this archetypal city plan seems to be concentrated down to a single symbol pregnant with meaning.

68 Summer houses in Brøndbyvester, Denmark. The summer and weekend colonies near Copenhagen appear like clusters of blossom on the stem of the highway. In the center of every cluster is the parking lot, a sort of perversion of the classic wagon-protected "laager." With the barricades created by their houses and gardens, residents defend their cars. The municipality has leased the land to the Danish Allotment House Society to build the settlements. After a maximum of thirty years the lease expires, and the area must be returned to the community in good order. The houses may be used full time in the summer but only on weekends in the winter.

69 The evaporation spiral El Caracol ("The Snail"), near Mexico City. With the aid of sunshine, the Texcoco soda works concentrates the brine extracted from underground. The brine, following a downward gradient, flows some twenty miles to the center of the spiral, doubling in salinity along the way. The concentration takes half a year. From the middle of the spiral it is pumped into the factory on the shore, where soda and common salt are obtained from it.

The Snail lies on the bed of what was Texcoco Lake, one of five lakes in the High Valley of Mexico that, at the time of the Spanish arrival, still flowed together into one body of water during the rainy season, forming the Aztec "Lake of the Moon." Today, during the dry season, Texcoco Lake is a hot, bleak dustpan; it turns swampy during the rainy season. The sun's great powers of evaporation, together with the fact that the lake once occupied the lowest part of the basin, account for the richness of the salt deposit.

70 Solar One, the largest solar power station of its type, Mojave Desert, near Barstow, California. Reflecting and beaming sunshine, 1,818 mirror systems ("heliostats") heat a boiler poised on a 298-foot-high tower. At the base of the tower are a steam turbine, electrical generator, heat exchanger, thermal storage unit, and control facilities. The electrical output is rated at ten megawatts. The collector field of sun-tracking heliostats is elliptical, with 578 heliostats in both southern quadrants and 1,240 in both northern quadrants—a difference necessary because the power station is not at the equator and so the sunlight it receives is not distributed equally. To follow the sun's course, the heliostats are maneuverable around two axes. Every couple of seconds a computer calculates the position of the sun, based on the time of year and the day, and adjusts the heliostats accordingly. In case of an emergency, such as a storm warning, the heliostats return swiftly to a protected position, mirrored surfaces pointing downward. The energy of the surplus steam is stored. If a cloud switches off the sunlight, the power station withdraws some energy for steam production from its thermal storage. The same thing happens when the sun sets. Despite the prodigious technical achievement of Solar One, even enthusiasts entertain doubts. The electricity it generates is obscenely expensive. And then there is also the unfavorable "harvesting factor." During its planned life expectancy the power station will produce barely half of the energy expended in the manufacture of the materials (steel, concrete, glass) used to build it.

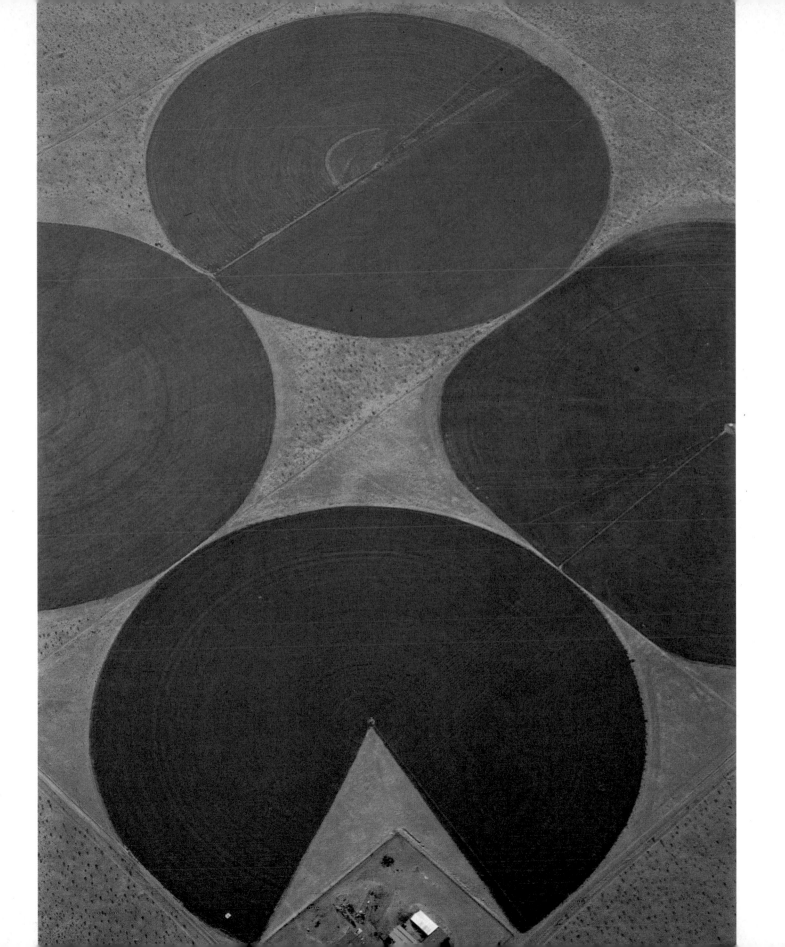

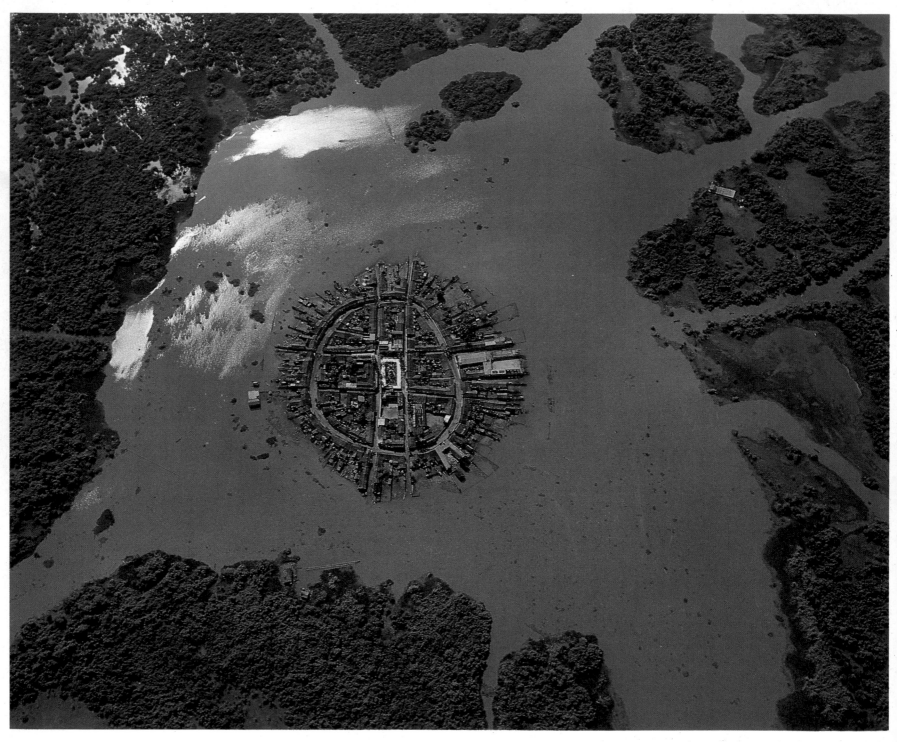

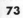

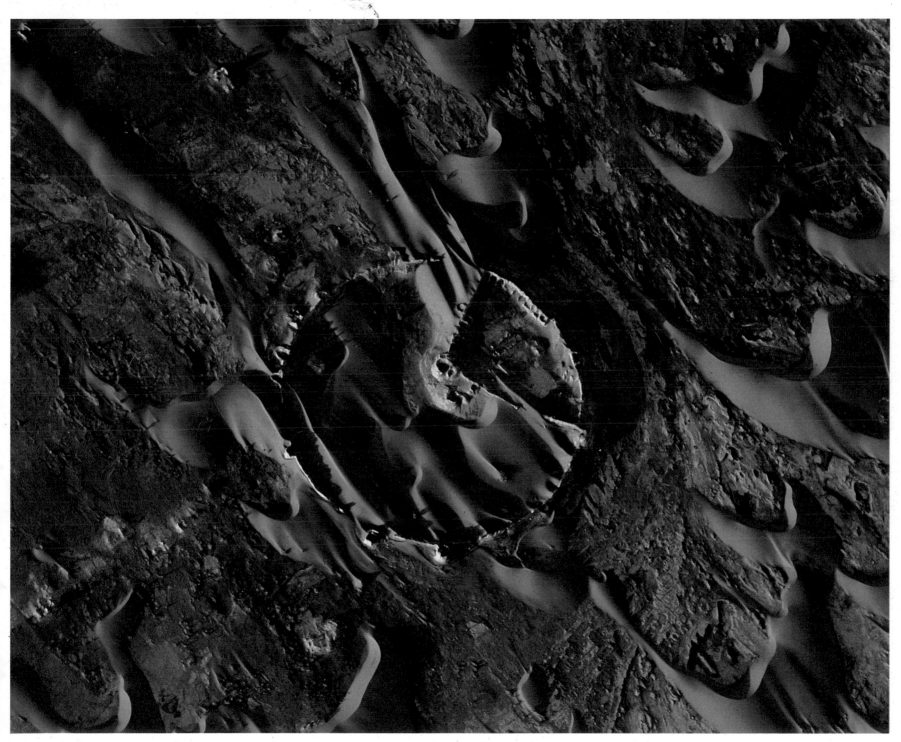

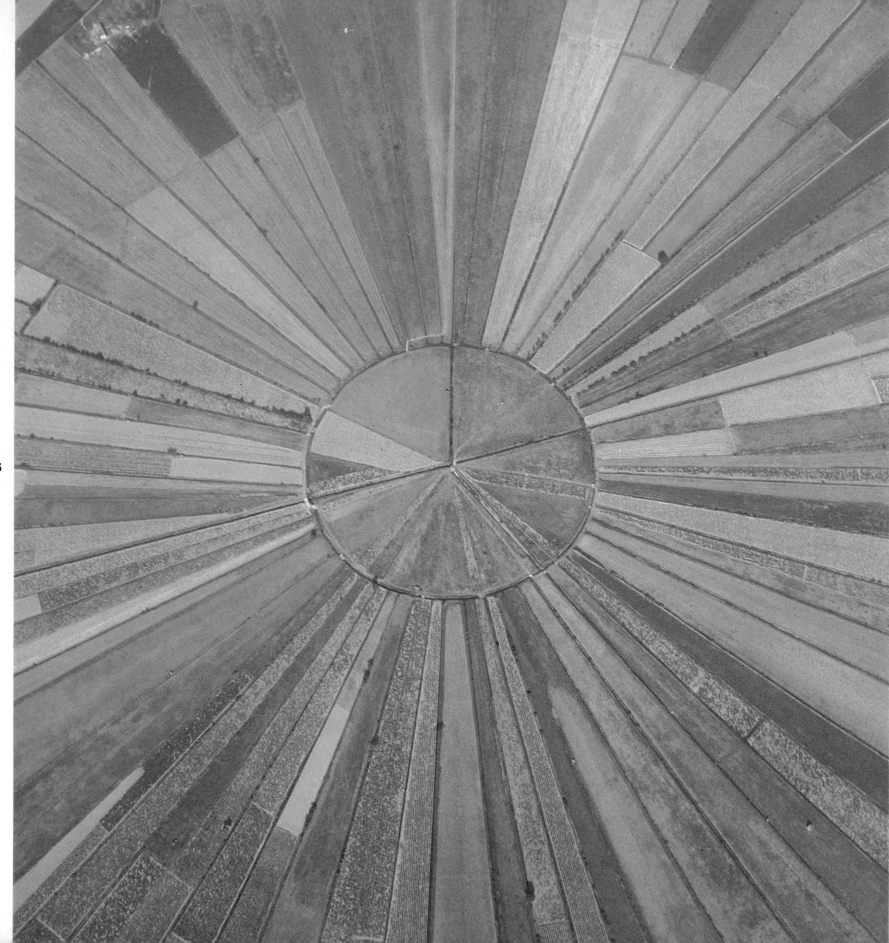

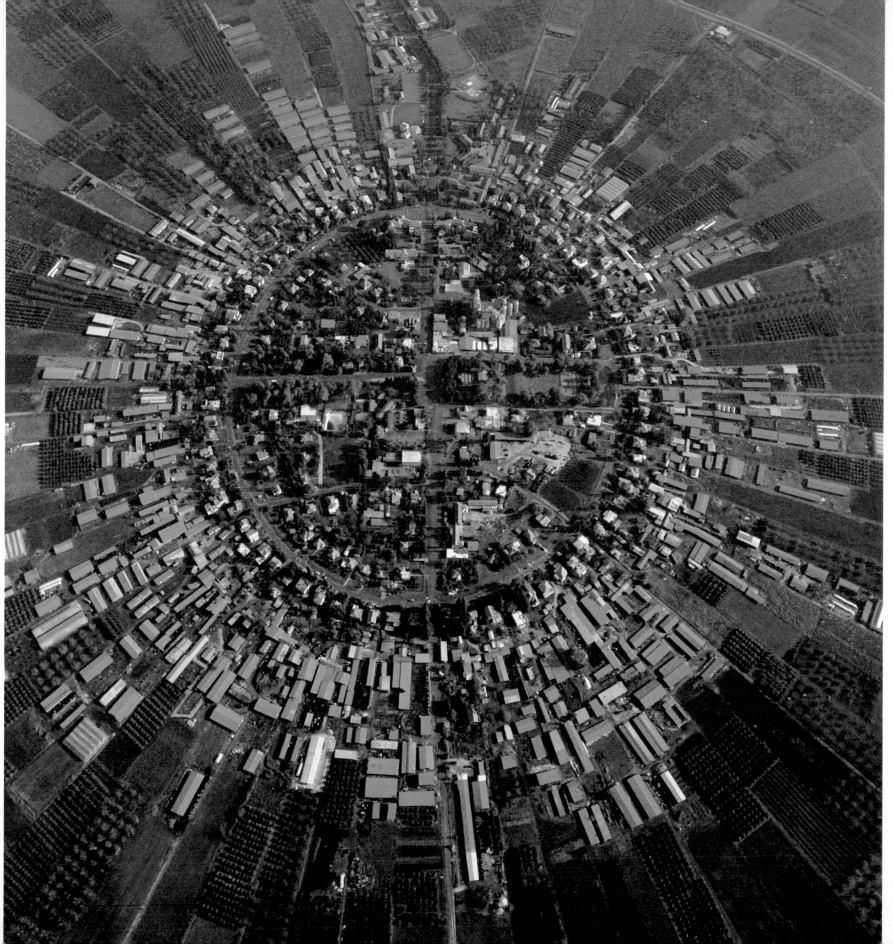

71 A garden crater near Timbuktu, Mali. The beds for pumpkins, tomatoes, onions, and chewing tobacco seem to lie on the banks of an amphitheater that descends to the water hole. The plants are watered by hand with buckets made of goat skin. The well taps one of the underground rivers branching out under the desert from the Niger, which flows about six miles away. The water level in the well varies seasonally, in accordance with the level of the parent river. At flood time, in a normal year the Niger fills the water hole up to the edge of the lowest garden bed, until it resembles a small lake. But during the almost fifteen years of the Sahel drought, the river has left the gardeners (members of the Songhai tribe) in the lurch again and again.

72 Center-pivot irrigators near Yuma, Arizona. Alfalfa, which can be cut as often as nine times a year, grows on the circular 143-acre fields. The swivel arm of the irrigation carousel—known as a center-pivot irrigator in technical jargon—moves at any desired speed. It can also be programmed to leave out a sector if, for example, the circle encloses an obstacle such as a house. Newer systems even succeed in squaring a circle. In the "dead" corners, unreached by older systems, an additional limb of the swivel arm folds out temporarily and waters the square almost completely.

The center-pivot irrigator, patented in 1952, is an important feature in the look of American agricultural land. However, agronomists and soil experts do not regard the green oases in the dry lands with unalloyed happiness. Center-pivot irrigators are water intensive. Where fossil ground water is "mined," the systems might pump too much water too quickly and soon deplete the aquifer. And a further reservation: the cross-country mobility of the many-jointed swivel arm tempts farmers to cultivate steep slopes, resulting in devastating soil erosion. Outside of North America, there are still other side effects to consider. In South Africa, for example, center-pivot irrigators have turned out to be ideal winter quarters for migratory locusts.

73 The town and island of Mexcaltitán, Nayarit, Mexico, in a lagoon on the Pacific coast. The shallow waters teem with crabs, shrimp, and fish, the main food supply and principal source of income for the 2,000 inhabitants. The settlement on the island dates far back into precolonial, pre-Spanish times. Some researchers even tend to equate Mexcaltitán with Aztlan, the original homeland of the Aztecs, or "the people from Aztlan," before they moved to their historical territories in the High Valley of Mexico. Aztec legends about the origin and wandering of the tribe tell of an island in the middle of an inland lake, a paradise for fishermen and hunters of waterfowl. It is a fact that the memory of moon worship, Central America's oldest cult, tenaciously lives on in the small town, and that its inhabitants today remain inbued with the mystical and mythical significance of the circular town. To them, Mexcaltitán is the center of the universe. The cross formed by the four main streets inside the ring road that encloses the town mirrors the division of the heavens into the "four corners of the world."

Although they believe themselves firmly anchored in the cosmos, the inhabitants have toyed with the idea of building a bridge or causeway to moor the island to the mainland—purely as a favor to nonsporting visitors who do not want to get their feet wet in leaky boats—but the government has prohibited the project.

74 Qaleh-e Gird ("Round Fortress"), Sistan Desert, Iran. The construction is probably of Islamic origin, but has not yet been investigated archaeologically. In this aerial view the bastions of the round wall—which afford flanking defense against attack—and an interior fortress situated close to the center stand out. The sector of the circular field, which is nearly sand-free, possibly accomodated the garrison. Wandering *barkhan* dunes (plate 4) alternately cover and uncover Qaleh-e Gird. Sistan is ruled by the "Wind of the 120 Days." Not without good reason, the oldest reports of wind motors for grinding corn and drawing water point to Sistan. The "Wind of the 120 Days" blows uninterruptedly from the northwest from the end of May until the end of September, often with hurricane force. With a speed of up to 125 miles per hour, it tirelessly propels the flying sand.

The idea of a round city as a mirror of the cosmos has been indigenous to the Iranian highlands since the first millenium B.C. Can one then claim for the Islamic latecomer a heavenly connection? One could, but one does not have to. Simple expediency sufficiently justifies the circular layout; by means of it, the shortest possible wall protects the greatest possible area.

75 The Star of Ensérune, Département Hérault, France. In 1247 three feudal lords, from the region of Montady, and the notary of Béziers obtained permission from the Archbishop of Narbonne, who was responsible for water resources, to drain the Etang de Montady and transform it into arable land. The rays of the pattern that resulted from this reclamation work are drainage ditches. The optical and technical aspects of the pattern thus contradict each other: the Star does not *radiate*, but *collects*. The drainage water flows down the gradient of the ditches into a collecting sump at the center. From there, a canal that cuts through the hill of Ensérune in an underground conduit leads the water into a neighboring *étang*, or shallow lake. A statute, unchanged since the thirteenth century, outlines the rights and duties of the owners of the reclaimed land. The *Syndicat Agricole* of Montady/Ensérune is the oldest in France and one of the oldest in Europe. The whole reclaimed area is slightly oval, a consequence of the terrain. Each single sector has been shaped wider or narrower so as to take this into account; each retains the same surface as a plot. On the total circular area of 1,235 acres in all are grown grapevines, tomatoes, corn, sorghum, and alfalfa.

76 The Moshav Nahalal, Israel. The farmers live on the outer circle of the settlement. Opposite them, on the other side of the circular street, one-and-a-quarter miles in circumference, live the members of the community involved in the service sector. In the center of the circle are the administration buildings and facilities jointly used by all the inhabitants. Israel's oldest moshav—a cooperative village of land-owning small farmers, as opposed to the property and production collectives of the kibbutz—accentuates the equality of its members with the meaningful symbolic shape of the circle (plates 67, 73); each Nahalali is the same distance from his field. The prospects of a cost-effective infrastructure and increased security also played a part in choosing a circular town plan. Today the Nahalalim raise mainly turkeys.

In 1921, showing off their pioneering spirit, the founders of the first moshav had chosen a swampy, malaria-infested location in the western Jezreel Valley. The toilsome drainage and road construction work was, however, contracted out to others, a blot on moshav ideology that still rankles the Nahalalim today. They agreed to the circular plan as proposed by the architect Richard Kaufmann only in 1922, after some hesitation because the circle blocks outward growth.

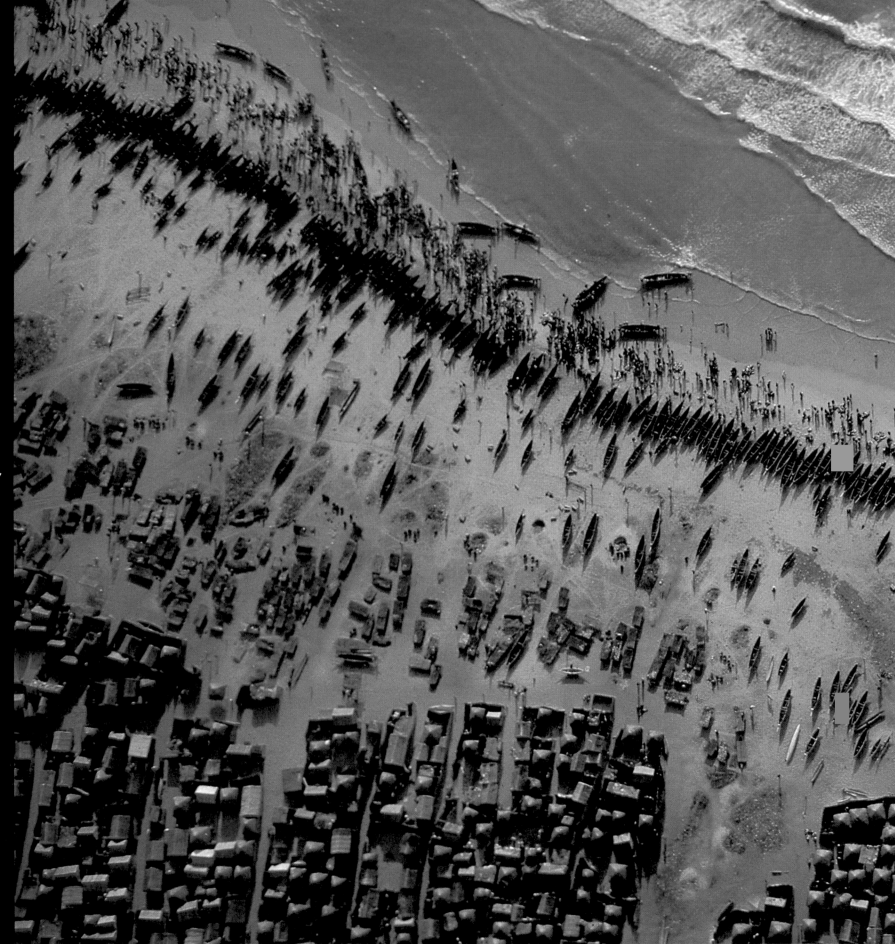

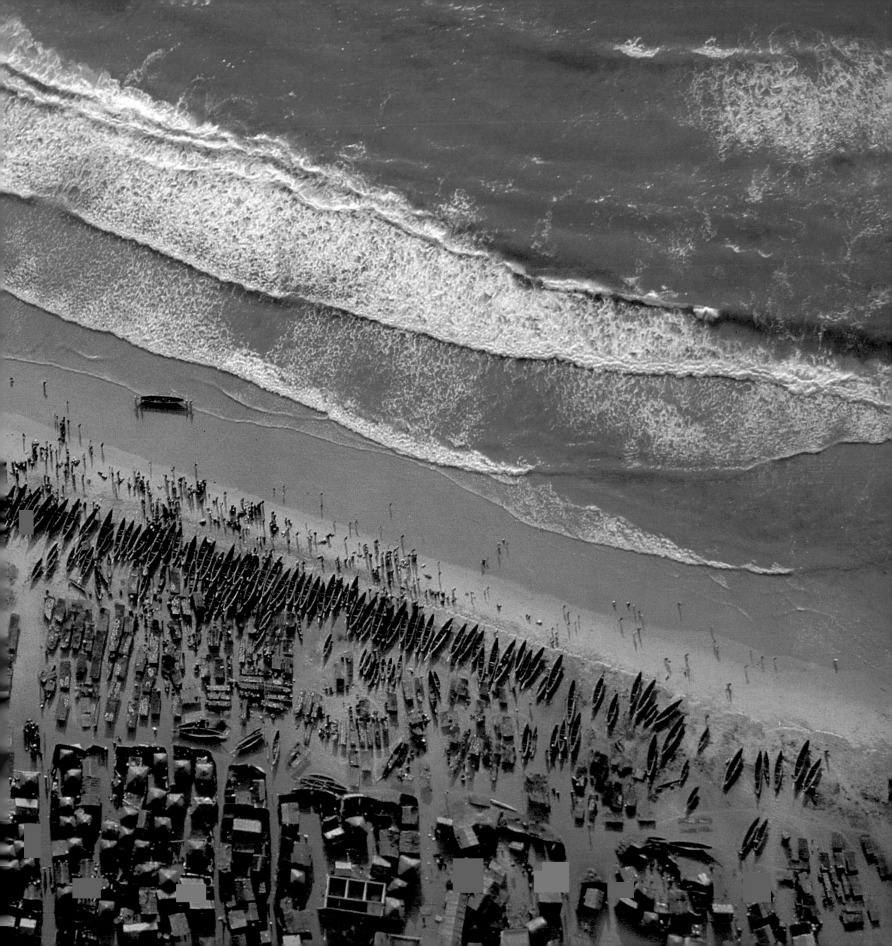

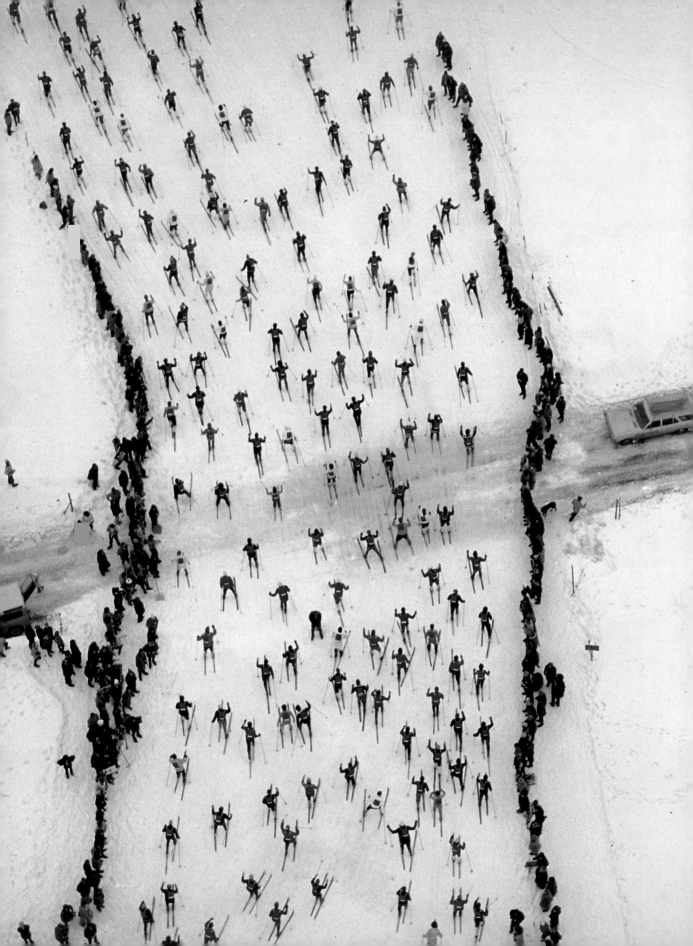

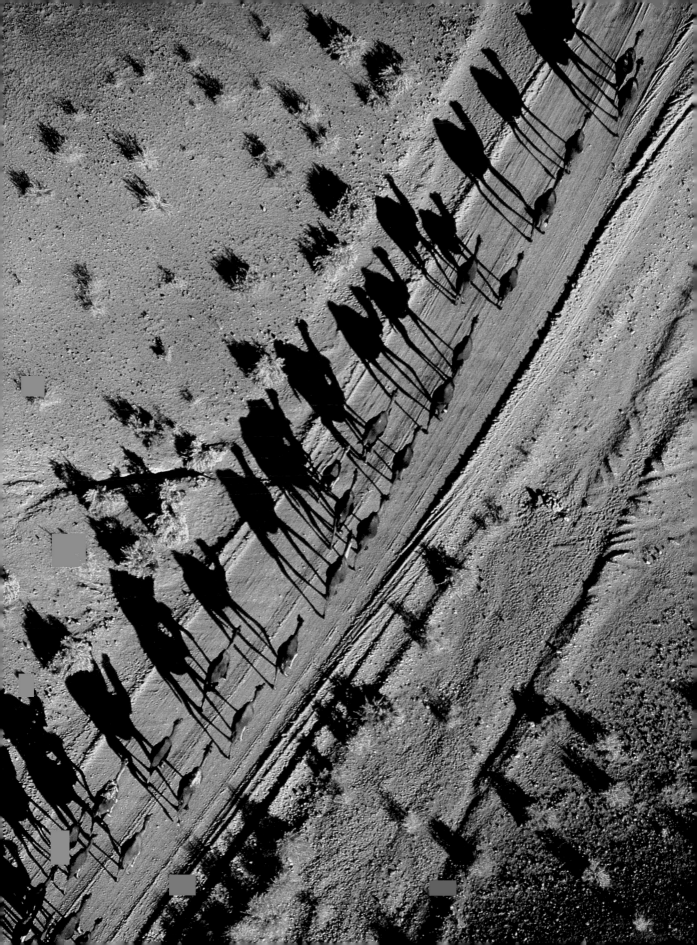

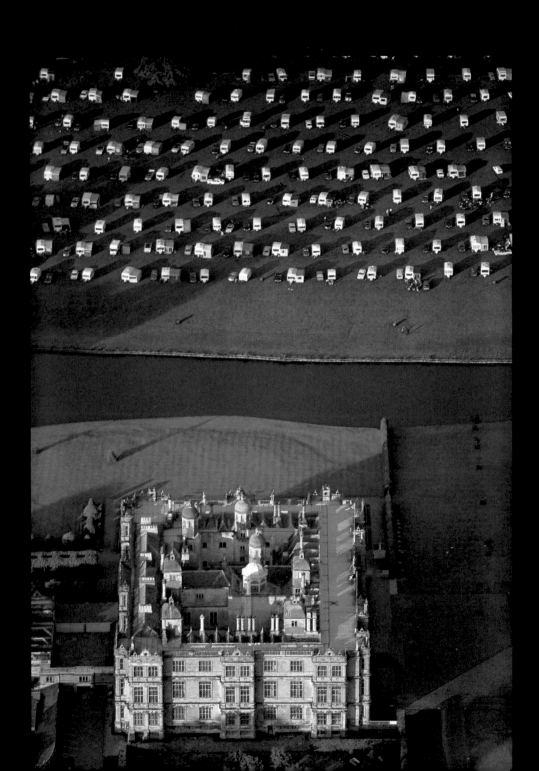

77 Cayar, north of Cap Vert, Senegal. From December to June the cold Canary current sweeps the Senegalese coast, particularly the stretch north of Cap Vert. With the help of trade winds, cold water wells up from great depths near the coast, yielding abundant fishing immediately beyond the barrier of foaming breakers. At this time of the year, everything in Cayar revolves around boats and fish. What is still the biggest fishing village on the West African Atlantic coast at the beginning of the year almost dies out by the middle. For the second half of the year, the fishermen move to the so-called Small Coast south of Cap Vert. Here the monsoon winds and warm equatorial waters that push away the Canary current once again provide them with a cornucopia of sea life, though of different species.

The skill of riding the waves in *pirogues* (the canoelike boats visible in the photograph) seems almost inborn in Senegalese fishermen. Nevertheless, every evening women and children, waiting on the beach for the men and their catch, anxiously watch their husbands, fathers, and sons negotiate the dangerous wall of surf. The coastal fishermen, almost all of whom are self-employed as small businessmen, are an enterprising class. They contribute greatly to Senegal's national income. The country's cattle breeders and peanut farmers, though, are not particularly grateful. They treat their fellow citizens of fishing fame arrogantly or even with open contempt.

78 Competitors in a cross-country ski marathon, in the Engadine, Switzerland. The road between Sils-Maria and Sils-Baselgia had to be prepared for the passing of the racers; by March it was partly clear of snow. The reproach directed against several European "people's races"—"Lots of people, little race"—certainly does not apply to the one in the Engadine. Lots of people, yes: there were 12,539 registered participants of both sexes in the record year of 1980. But also plenty of racing: the marathon test, over 26 miles long and 5,900 feet above sea level, is a strenuous affair. The organizers reasonably demand a medical certificate or equivalent from every competitor. There is no upper age limit—even an 85-year-old man has taken part. This ski fest has no losers: the very last arrival triumphs in a personal test of endurance and will-power. The best time so far (1983): 1 hour, 34 minutes, 8 seconds. It was attained with the new cross-country skating technique, the Finn step. The organizers of smaller races demand that their participants use the regular style, the diagonal step. They dislike skating on skis: it damages the cross-country courses as well as the ligaments and joints of the skiers. However, the organizers of the Engadine marathon do not at this time want to dictate any such rules—at least under normal snow conditions.

79 Caravan in Kerman Province, Iran. On this flight I meant to record a recent archaeological discovery, the Tepe Yahya. The dig had indicated that as early as the third millenium B.C. this part of the Iranian Highlands served as a turntable and entrepôt for trade among the Indus Valley, Mesopotamia, and the Persian Gulf. Even though the sighting of the caravan on the return flight from Tepe Yahya was incidental, the encounter did not seem out of place.

Even Alfred Edmund Brehm (1829–84), a German zoologist whose work on the life of animals earned him the nickname "Father of the Animals," derided the camel as "stubborn, bone-headed and dumb." In contrast, the Arab Bedouins have 2,000 words for it and praise its intelligence, loyalty, gentleness, and sensitivity. The one-humped camel, the dromedary, opened up the deserts and wastelands. It still has a future as a supplier of meat, milk, wool, and leather, but its days as a beast of burden and mount are numbered. It is no match for high-octane horsepower under the hood.

80 A freeway overpass under construction near Santa Barbara, California. Old carpets, thoroughly soaked at least once a day, keep the freshly concreted roadway moist. When concrete hardens, gravel and sand are bound to the cement, which undergoes a gradual chemical reaction. At this stage, water is needed, and heat is given off. In order to obtain good concrete, the builder protects it at this phase from loss of water and rapid cooling. Direct solar radiation and drafts of air damage new concrete, causing shrinkage cracks.

Years after having taken the photograph, I am still amazed at this super-scale Paul Klee. To be sure, construction specialists smile condescendingly at the California method. It is certainly picturesque, but very old-fashioned. In Europe, special mats, a Swiss development, have been adopted. They retain the heat generated as the concrete hardens and make it unnecessary to keep wetting the concrete. The new procedure is more economical, though less colorful, as the so-called Guritherm mats come only in green, brown, red, and white.

81 Automobile loading area on the River Meuse, near Waulsort, Belgium.

82 Two life-styles in Longleat, Wiltshire, England. Longleat House (built 1568–80), the ancestral home of the Marquis of Bath, is considered the most beautiful Elizabethan manor house in England—and the present inhabitant one of the most eccentric of English lords. He makes headlines with teddy-bear conventions and outlandish political opinions. He lures thousands of paying visitors with an amusement park, a safari land, and a huge labyrinth (plate 39). Faced with his tax bills and maintenance costs, the Lord regards even the campers and tent dwellers on his lawn with equanimity.

83 The roller coaster "Colossus" at Magic Mountain, an amusement park near Los Angeles, California. A colossus it certainly is—the ne plus ultra of wooden roller coasters. The double-tracked course is 4,250 feet long. The horror trip challenges passengers with two drops of 150 feet each; and eleven times in near weightlessness the stomach seems to take off on its own.

In the past few years the American thrill industry has raised its nerve-tickling and stomach-lurching potential. Roller coasters have always been around to create anatomical confusion, sending the stomach where the throat should be, but now, of course, with looping rides, it's a real head-over-heels proposition. "Colossus" gets by without any topsy-turviness, but it makes up for this lack by its size and its beauty as a construction of solid Douglas fir and long-leaf yellow pine. For roller coaster purists such beauty promises more delicious horror. The accompanying banging, rattling, grinding, and squeaking of the wooden coaster provide an additional dash of the spice of fear. That's why the first scream generally comes before the fall.

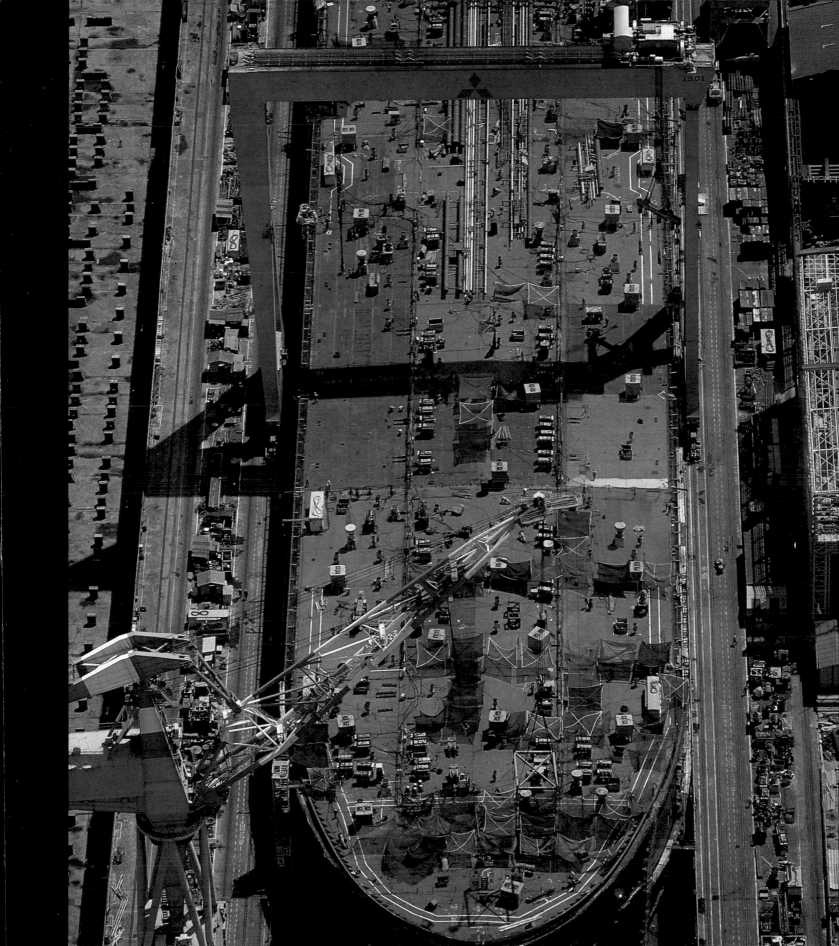

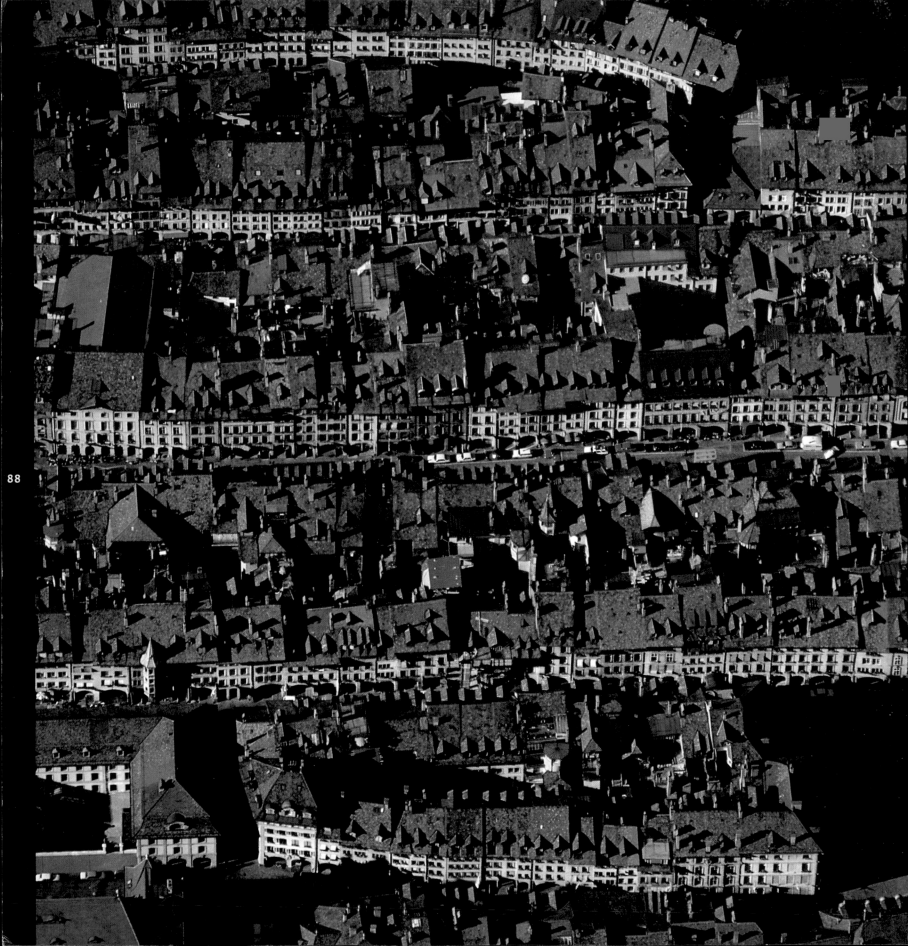

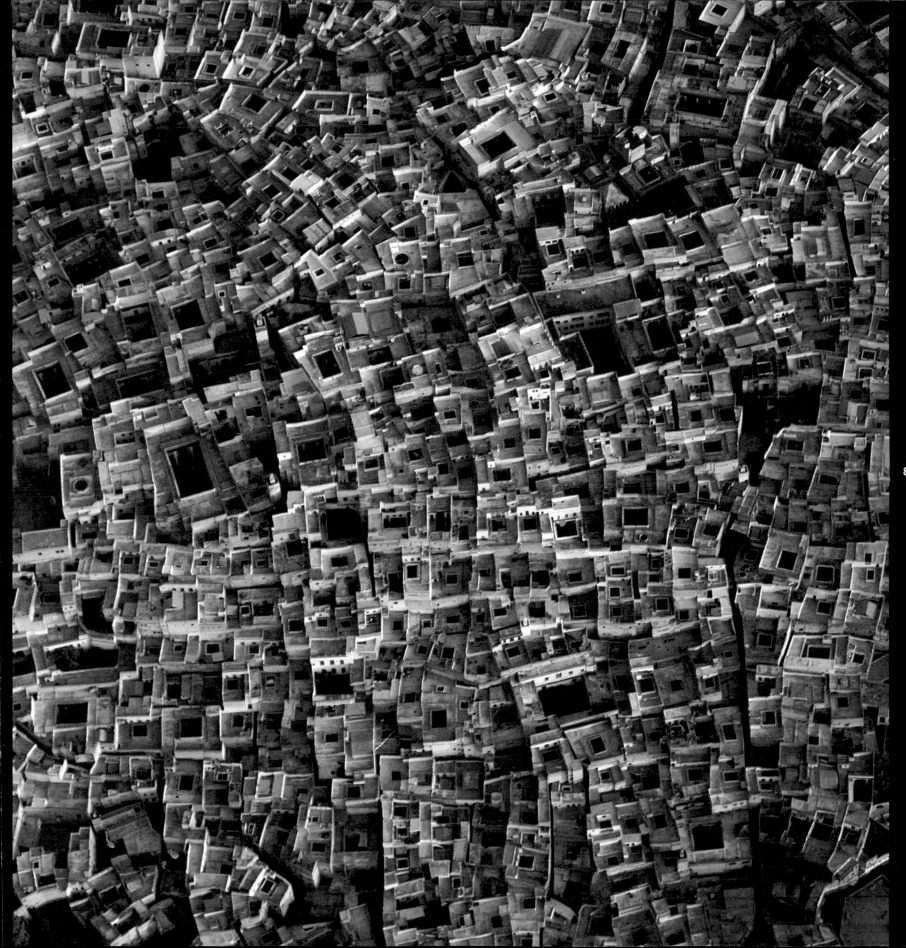

84 The port of Kali Baru, near Jakarta, Indonesia. Many small *prahus,* expelled from their hereditary port of Sunda Kelapa, anchor nowadays in Kali Baru. *Prahu* is the name applied to the hundreds of thousands of traditional wooden boats that fish along the Indonesian coasts and move most of the cargo in the island archipelago. The *prahu* fleet is presently being modernized; diesel engines replace sails. The bottom half of the picture is filled predominantly with fishing boats; in the upper are cargo vessels, most of them already fitted with motors. The freighters bring salt, dried fish, and coral, but mostly sawn timber and, for scaffolding, mangrove poles. Today Kali Baru has surpassed Sunda Kelapa as a freighting center—at a price. The vessels congest the harbor basin alarmingly. The development of the port facilities and the accompanying infrastructure, access roads and the like, has not kept pace with the growing number of ship movements and the freight tonnage they discharge. The harbor basin, littered with old wrecks like the obstacles on a steeplechase course, is shallow. No less shallow is the entry to the port. Big *prahus* more often that not run aground. During the western monsoon in January and February, the boats dance on the choppy water, bumping into each other in the badly protected basin. At that time of year, sometimes wind and waves block the entry to the port for days.

85 The wreck of the *Eduard Bohlen*, on the Diamond Coast, Namibia. The treacherous Atlantic coast of former German Southwest Africa, where sea and desert meet along nearly a thousand miles of shoreline, has always been a curse to shipping, probably since the time of the Phoenicians. Evidence of its malice is a large assortment of ship skeletons— some many decades old—which rot and rust in solitude. The *Eduard Bohlen*, a German ship, ran aground in Conception Bay between Swakopmund and Lüderitz in 1912. Unlucky ships like this are a lucky find for students of coastal accretion. Today the *Eduard Bohlen* lies more than a half-mile inland. The ocean constantly adds land to the Diamond Coast, the southern part of the Namibian Atlantic Shoreline; a northerly coastal drift spreads the sediment, including diamonds, that the Oranje River brings from the interior. Like no other wreck, the *Eduard Bohlen* makes the rapid growth of the coast conspicuous; its shadow of sand is an embryonic dune. However, worldwide, on balance, retreat far outstrips growth. Only a tenth of all coastlines under survey show land accretion.

86 Roofs of the collegiate church of Maria-Einsiedeln, Switzerland. The abbey of Maria-Einsiedeln is one of the most significant baroque monasteries in Europe. Benedictine monks built the first monastery in Einsiedeln in the tenth century. The pilgrimage church and the monastery, as they stand today, date back to the first half of the eighteenth century—the sixth successive structure on this site. During the eighteenth century, too, the forecourt was built, with arcades shaped like two open arms.

87 Construction of a supertanker in Nagasaki, Japan. The *Onyx* lies in the slipway, awaiting launch in a few weeks. The ship, 1,060 feet long, 177 feet wide, and 85 feet high, with a carrying capacity of 296,000 tons, belongs—in the jargon of tanker shipping—to the Very Large Crude Carrier (VLCC) category. She is an "oilephant," but not a "mammoth of the sea," an Ultra Large Crude Carrier, over 350,000 deadweight tons.

Since the first large tankers were built, they have been part of the stuff of contemporary nightmare. With the wreck of the *Amoco Cadiz*, the term "supertanker" seemed conclusively to be established as a dirty word in our vocabulary: in March, 1978, the *Amoco Cadiz* dumped its full load off the coast of Brittany. 245,300 tons of crude oil polluted 200 miles of beach and 5,800 square miles of ocean surface. The immediate effects of what is hitherto the biggest and most thoroughly investigated tanker accident were catastrophic enough: a massacre of waterfowl, oysters, fish, and algae. At the time, environmental experts feared long-term effects even more—for example, irreparable damage to France's most productive fishing grounds. However, these fears considerably underestimated the self-cleaning and self-healing powers of nature. Five years later specialists found hardly any traces of the ecological disaster.

88 The old city of Berne, Switzerland. It represents, in unequaled purity and maturity, the urban pattern of an axially structured town with a street market. In Berne the wider main street that served as a marketplace—Kramgasse and Gerechtigkeitsgasse, one of the most astonishing and congenial street spaces anywhere—is flanked by smaller streets running parallel to it. The eaves of the houses are aligned, and their gables form long rows. The upper stories of the houses protrude over the famous arcades. The citizens were permitted to build these arcades on the ground floor in front of their houses and to extend the house facade over them; the ground under the arcade, however, remains public property. Berne is one of a whole family of towns founded by the dynasty of the Zähringer on both sides of the Rhine. The urbanist Paul Hofer, leading authority on Berne, praises it as the "most compact and consistent creation of planners—in the twelfth century, at any rate."

As a masterpiece of medieval urban architecture, the old city of Berne is on the UNESCO World Heritage List.

89 The old city of Fez, Morocco. Fez, one of four Moroccan royal cities, has no late Roman past. It was founded, according to tradition, about the year 800—as an Islamic city. Fez soon became, and was for centuries, the first city of North Africa, its spiritual, economic, and scientific center, whose fame in the fifteenth century aroused even Europe's curiosity and greed. The jumble of living and working quarters, mixing markets and mosques, still makes it the epitome of an Islamic city. It reminded the Viennese poet Hugo von Hofmannsthal, its most sensitive portrayer, of the ornamental patterns of embroidered and entangled Arabic script and of a favorite of the Islamic bazaar: "so reticulated and so encapsulated and so inescapable, one would think one had stumbled into the heart of a pomegranate." The old city of Fez is Morocco's contribution to the UNESCO World Heritage List.

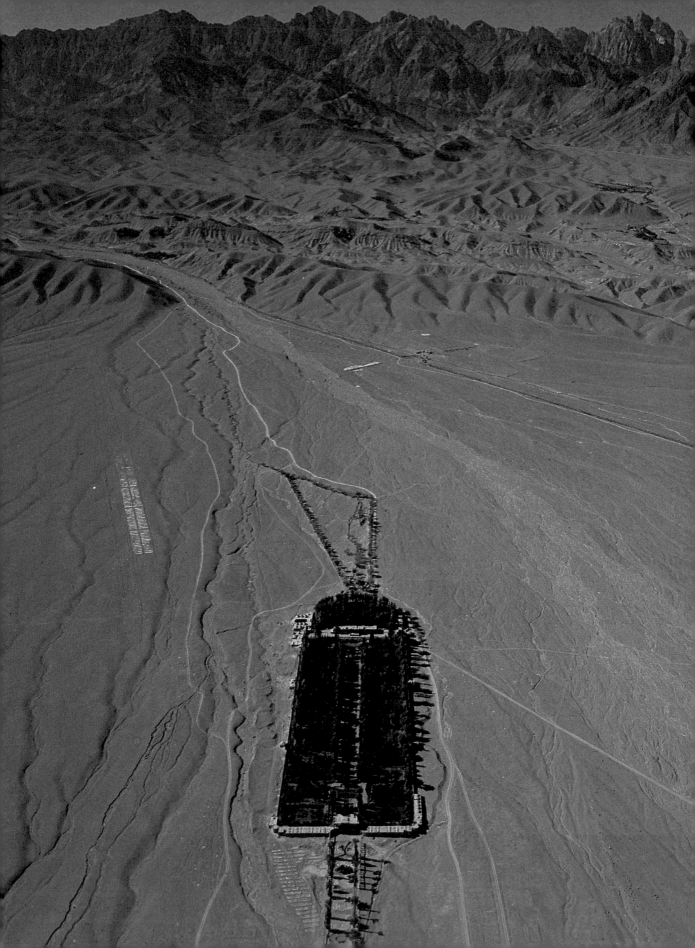

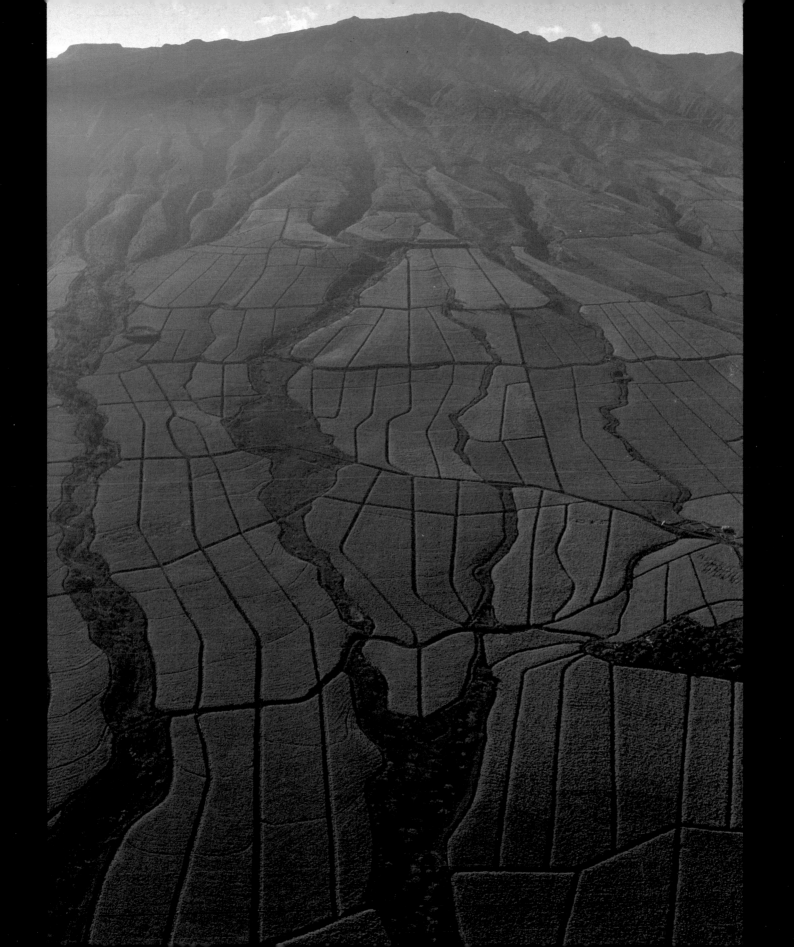

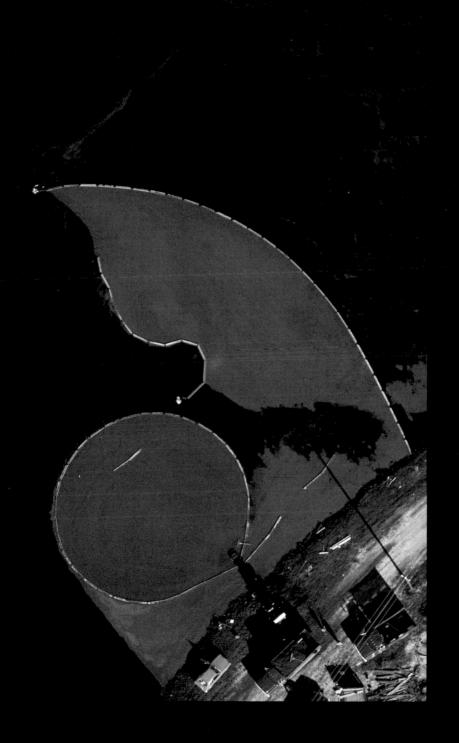

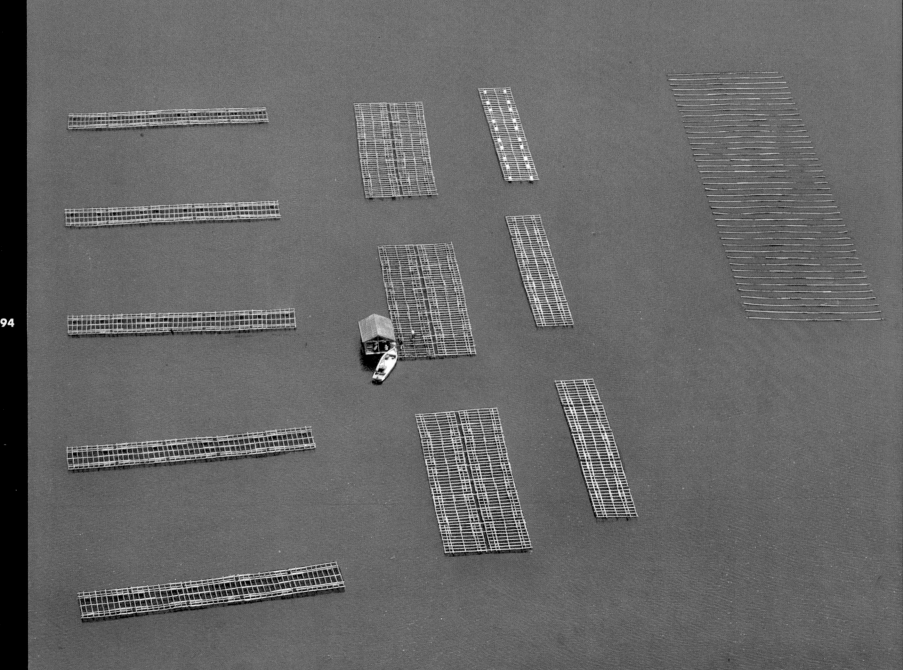

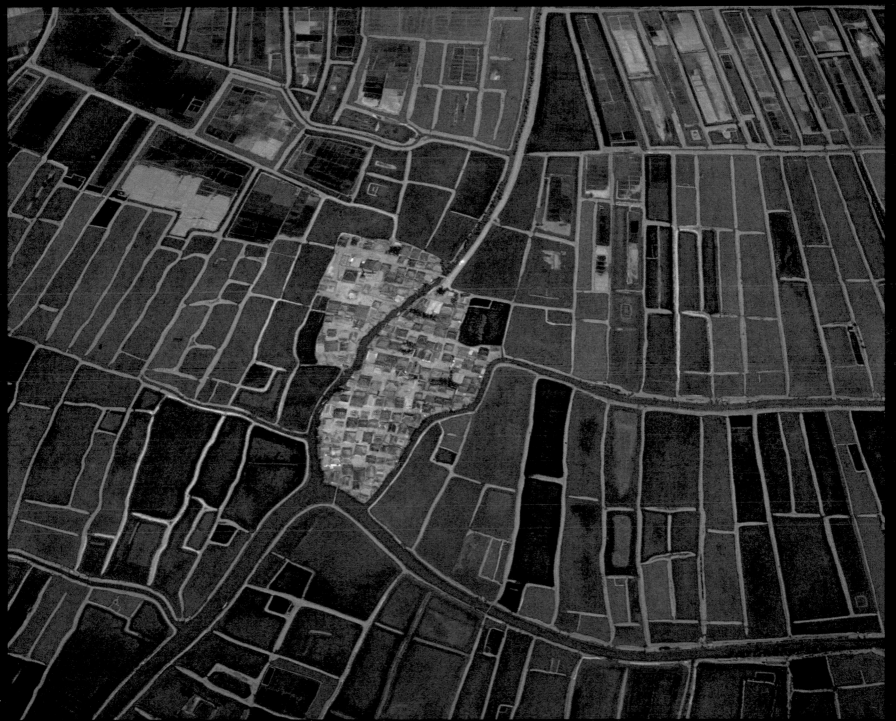

95

90 The Bagh-e Shah ("Garden of the King"), near Mahan in Kerman Province, Iran. A canal leads water to the garden from the foot of the mountains. As a garden, the Bagh-e Shah is a controversial creation; it dates from the time of the Quājārs (1779–1925). Confirmed purists, who cling to the standards set by earlier, more classical Persian gardens, gripe about the order of its plants, its buildings, and the width of its waterways. Its site is unique, though, as even detractors will admit. It clearly expresses the intention of Persian garden art: to transform, seemingly by magic, barren, parched, and dead desert into cool, shady, fragrant, and fertile space—from purgatory to paradise. Persian gardens have left traces even in our vocabulary. The old Iranian word for enclosure, *pairidaeza*, has become, via the Greek *paradeisos*, what we are still in search of today.

91 A sugar cane plantation at the foot of Haleakala, Maui, Hawaii. Irrigation canals pattern the fields. Growing sugar cane requires an annual precipitation of over ninety inches: one ton of water for every pound of raw sugar before it is extracted from the cane. On Maui the sugar cane matures in two years. After cutting, the sugar cane grows back from the root stock. The same plant can be harvested up to five times.

Per unit area, Hawaii's sugar cane fields yield more cane (some eleven tons per acre) and sugar than any other area in the world. The growers defend their fields against pests with biological methods only. Early on they enlisted the help of a dagger wasp to combat a harmful beetle, and in 1920 stemmed an invasion of the feared sugar cane cicada with the support of an Australian bug, a capsid.

92 Sorting tree trunks on Coeur d'Alene Lake, Idaho. Tug boats tow the logs in bundles from the southern end of the lake to the sorting and storage area on the northern end. The logs—white fir, hemlock, and Douglas fir, cedar, spruce, and larch, ponderosa and white pine—are grouped and separately stored according to species and processing characteristics. The sawmill in Coeur d'Alene calls for timber as its orders necessitate.

93 Cranberry harvest near Plymouth, Massachusetts. Cranberries have joined the sugar maple in spreading autumnal red over Massachusetts and New Jersey since farmers began to wet-harvest them instead of picking them dry. For the wet harvest they flood the bushes, with their ripe berries. Machines, working like eggbeaters, churn up the water; the turbulence knocks the berries loose. Surfaced, the berries float and are being corraled and sucked away or loaded onto a truck via conveyor belt. Wet-harvested berries end up as juice and sauce; only dry harvesting yields fresh fruit for sale.

Sour cranberries are a sweet half-billion-dollar business in the United States. The profitability of their cultivation is inferior only to the lawful growing of ginseng and the illicit growing of marijuana. Surely, the original inhabitants had valued the berries highly. Cranberries were an important ingredient of *pemmican*, the Indian's winter and traveling food. It's an open question whether the *Mayflower*'s passengers ate cranberries with their turkey at the first Thanksgiving dinner, as it is not even an established fact that they had turkey. Today, however, the descendants of the Pilgrim Fathers cannot imagine their holiday turkey without cranberry sauce.

94 Bamboo rafts with pearl oysters, in Ago Bay, on Honshu, Japan. Few Japanese share the view that a diamond is a girl's best friend—not since Kokichi Mikimoto, the son of a poor noodle maker, founded a million-dollar industry with the breeding of the first spherical pearl shortly after the turn of the century. A tiny grain of mother-of-pearl from a fresh-water shell, surgically sewn into the outer connective tissue of a pearl oyster, artificially stimulates the growth of a pearl. The grafted pearl oysters are hung in wire cages suspended from floats. Such floats are characteristic of the shallow, sheltered bays along the Shima peninsula, the center of the Japanese cultured-pearl industry. The traditional appearance of these cultured-pearl farms is rapidly changing, though. Buoys and other floats made from plastic are supplanting the bamboo rafts of old. The pearls mature in three to six years, depending on water conditions. The wire cages are brought to the surface from time to time in order to clean the pearl oysters and check their health. Typhoon warnings also force the retrieval and temporary relocation of the cages and their inmates.

95 Fish farming near Losari, on Java, Indonesia. Ponds such as these between farm land and the sea characterize many coastal areas of Java. Earthen dikes divide the basins containing brackish water. The crests of these dikes are often used for growing vegetables. The aquaculture of Indonesia, called *tampak*, breeds mainly mullet and milkfish. The latter especially play an increasingly important role as a source of protein in Indonesia, the Philippines (plate 64), and Taiwan.

Aquaculture has been around for thousands of years, particularly in eastern and southeastern Asia. But globally it does not contribute even half a percent to man's food supply. At least ninety-seven percent of food is produced on land anyway, although the seas cover some two-thirds of the world's surface and are home to the greatest number of species and organisms. Indeed, life originally evolved from the sea. This situation, compounded by the threat of food shortages, certainly guarantees a future for aquaculture. It is only the how and when of the Blue Revolution that the specialists are still debating.

98

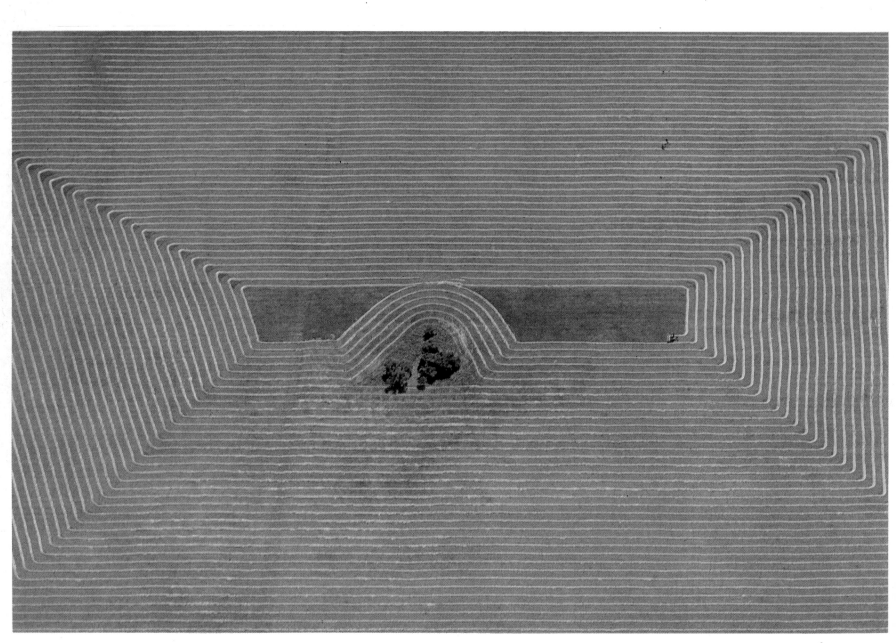

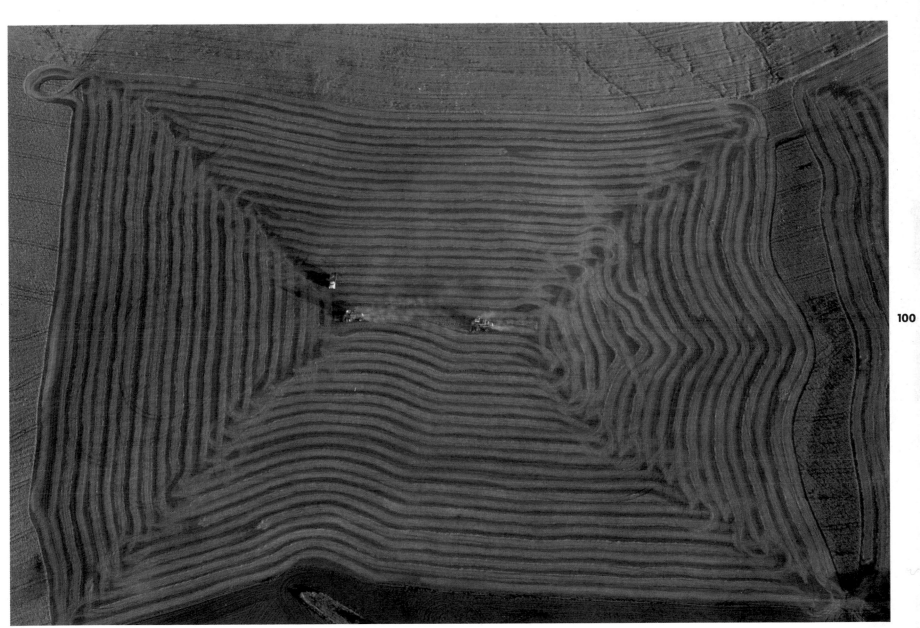

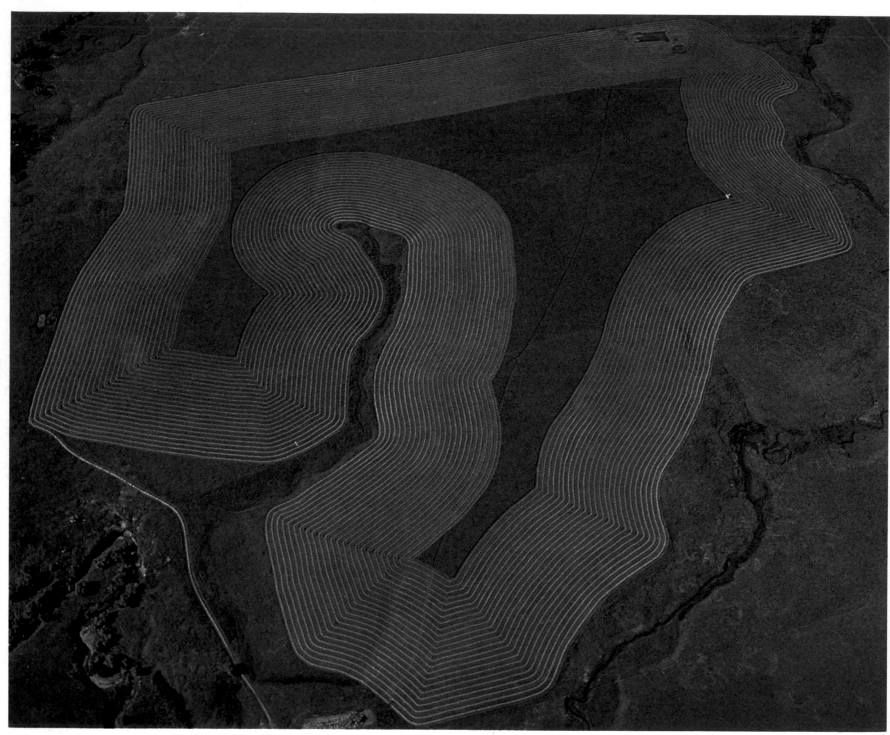

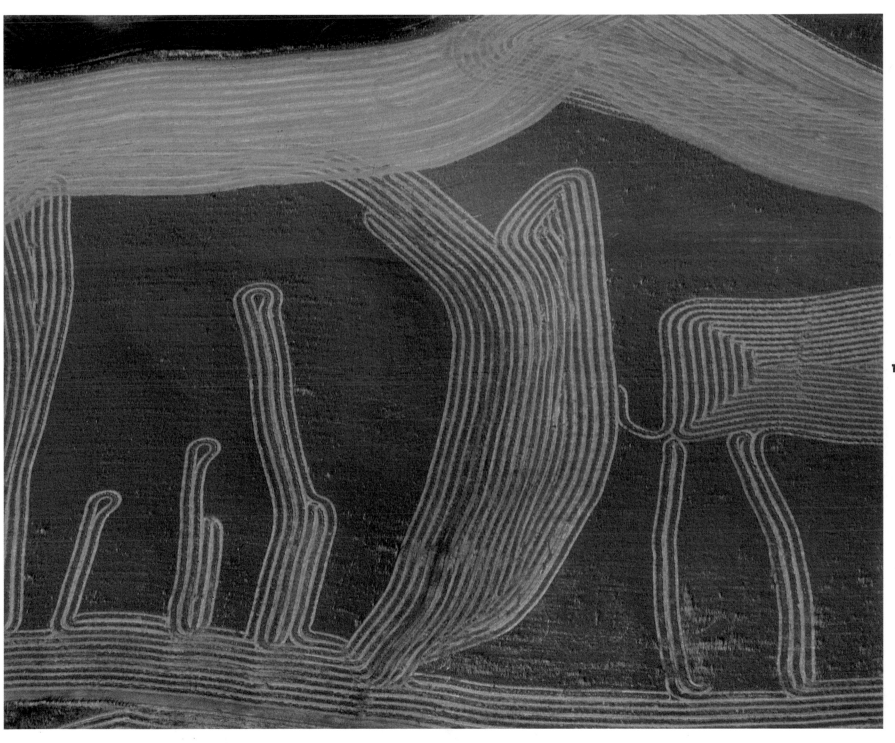

96 Farming near Dubbo, New South Wales, Australia. A winter picture: in June the farmer tills the field with a cultivator to stop the growth of weeds. Near the end of the calendar year, in the southern spring and summer, he will sow the fields with soy beans or sunflowers.

97 Irrigated cotton fields near Dubbo, New South Wales, Australia. The Macquarie River supplies water via the Burrendong Dam. Long- and medium-staple cotton grows on the fields of Dubbo. During the June harvest, the picking machines are always separated by two rows of plants, so that the breakdown of one machine does not force all the others to stop. Eighty-five percent of the cotton is picked during the first round. Late-maturing plants and careless misses during the first picking necessitate that the machines go over the fields a second time.

The water level behind the Burrendong Dam at the end of June determines how large an area of the irrigation-intensive cotton the farmers can afford to plant in the coming year. In crop rotation, they alternate cotton with rape—a crop related to mustard. With its strong, deep-growing roots, rape opens up lower soil layers almost as effectively as a subsoil plow.

98 Farm country near Scottsbluff, Nebraska. The picture shows exemplary soil management under dry farming conditions. Strip cropping stops wind from blowing the soil away and stores moisture. Where the terrain permits, strip cropping allies with terracing on the contour to improve water retention further and prevent gullies. The strips of green in this picture taken in May are wheat fields; they alternate with fallow fields, which are accumulating moisture for the next sowing. The wheat will be ready to harvest in July or August. Corn, watered by a center-pivot irrigator, grows beside the farm house (plate 72).

99 A harvest pattern in the Pampas, Argentina. The farmer who does not mind trees in his clover field can count on applause from ecologists, notwithstanding the geometric patterns produced by his machine, which suggest an industrial approach to agriculture. In terms of photography, this picture illustrates perfect timing. I regret now that I had not returned to the field after half an hour had passed, but then I would have had to watch how the farmer canceled his creation as he drove away on his tractor. The spontaneous land artist also vandalizes his own work; the creations of agricultural land art are always blessed with ephemerality.

100 Harvesting peas in the Palouse country, Washington. The field reminds one of wash flapping on a clothesline in the wind. Is it agricultural sloppiness echoing the indifference of the combine operator? Or the purposeful denial of order and geometry? Neither. The machine curves along the contours of the steep slopes. In the loess hills of the Palouse country (plate 129) this often amounts to nothing less than agro-acrobatics.

101 Harvesting hay near Sheridan, Wyoming. More than half of the field has already been cut. The grass is most probably a species of wheat grass, an import that has proven itself successful in the eastern foothills of the Bighorn Mountains. The signallike shape of the field is accidental. At the top it is determined by a property line and at the bottom by the terrain, above all by the sudden change in the incline.

One may suggest that this area was formerly planted with grain, which shows that the rancher is now ready to atone for his previous sins. The conversion of fields back to hay land, pasture, and range is in full swing in this part of Wyoming and lowers soil loss. Farmers who chased after big money with grain cultivation on marginal soils have now learned their lesson after being hurt.

102 Lentil field at harvest time in the Palouse Hills, Washington. The tracks left by contemporary agricultural machinery at times almost rival for mysteriousness the pre-Columbian ground drawings on the desert platcaus near Nazca, Peru. The lentil field lies on a slope. On the upper part a harvesting combine has already done its work. The farmer is using a "swather" on the lower part, where apparently higher soil humidity and lower soil temperature have slowed down ripening. The combine will later pick up the fully ripened crop and thresh it.

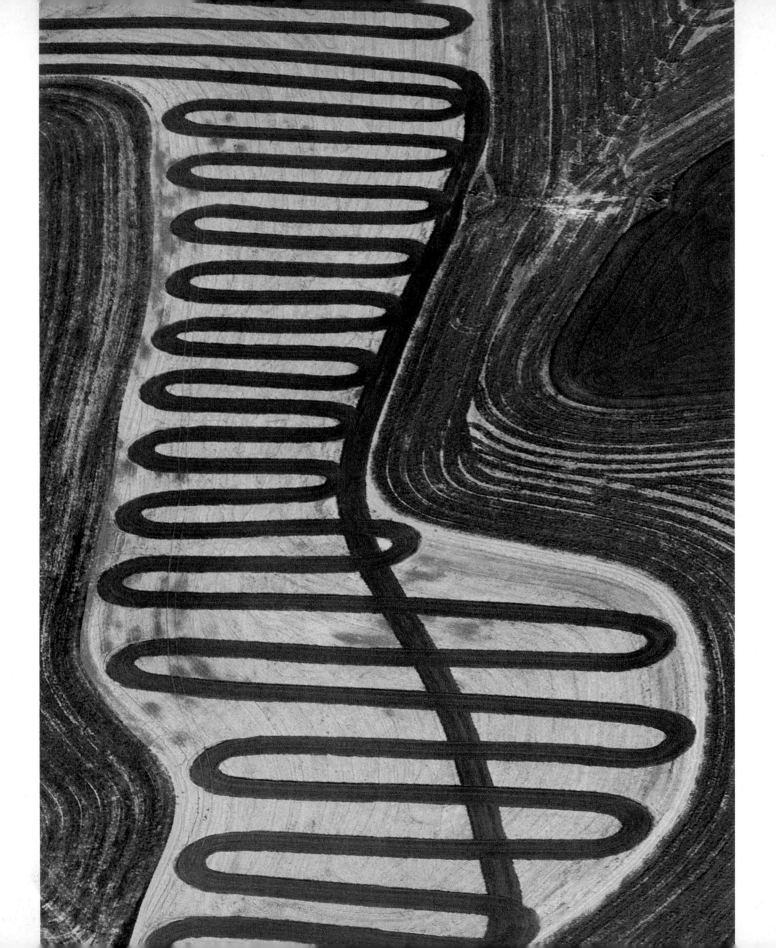

104

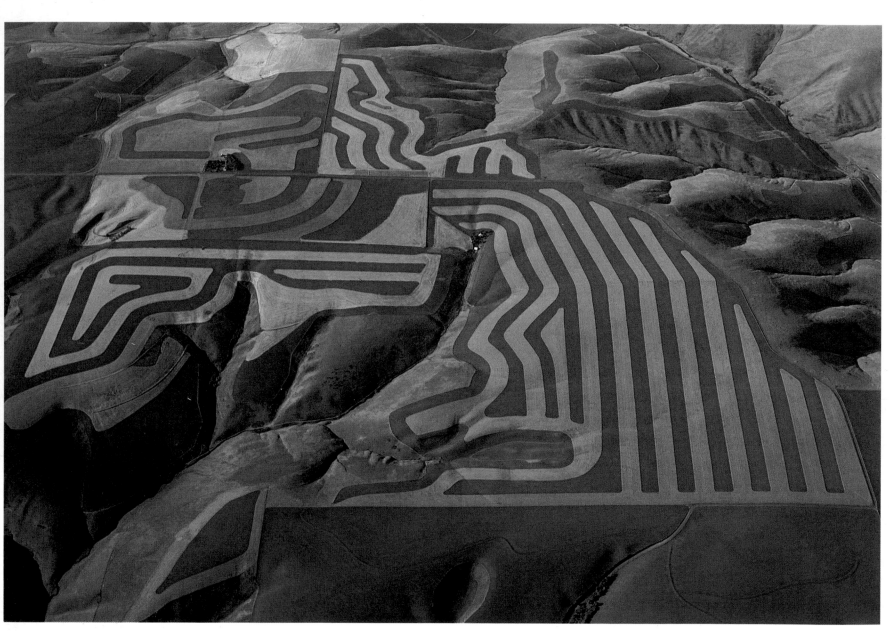

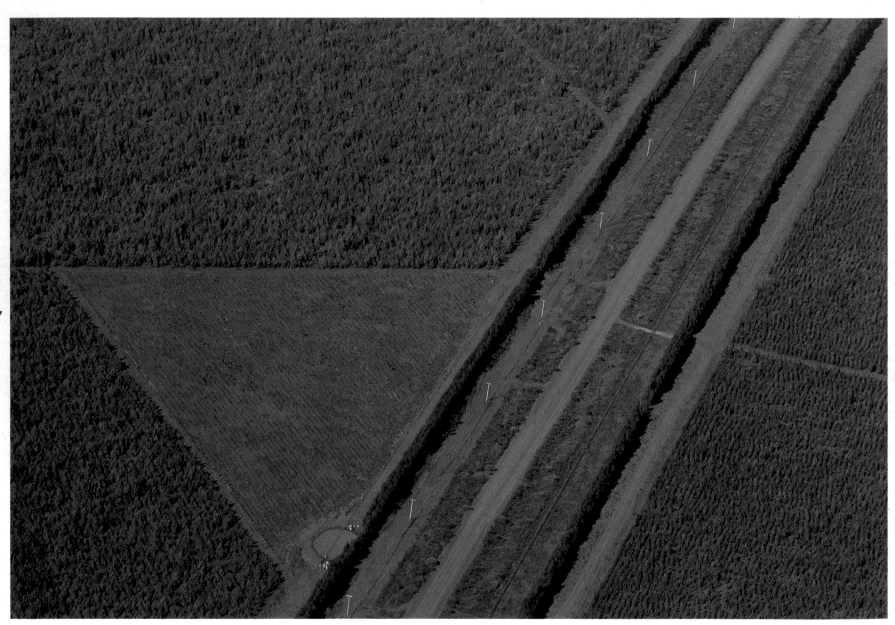

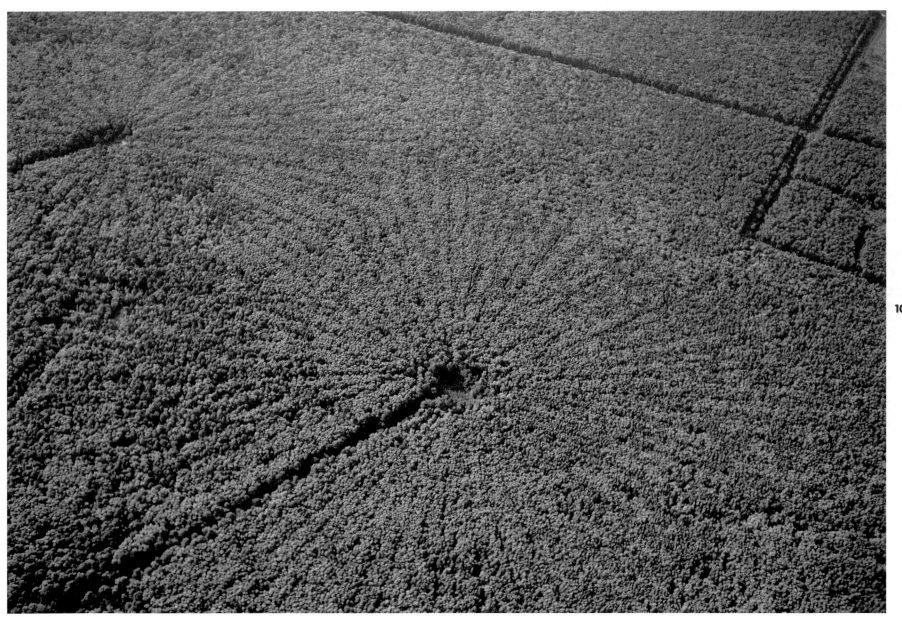

108

103 Battling wind erosion on a field near Wichita, Kansas. A sudden May wind spurred the farmer into action. He roughened up the soil with a spring-tooth harrow by driving haphazardly over the field. He simply wanted to secure the largest possible amount of land against the wind in the shortest possible time and with the least fuel consumption. Uncultivated fields lack sufficient protective surface cover of crop residue. The dry, whitish crust indicates just how vulnerable they are when bare. In Kansas every year the wind blows away an average of three tons of soil per acre—only about four-fifths of a ton less than what is lost through water erosion.

104 Battling wind erosion on a cotton field near Lubbock, Texas. Using a "sand-fighter," an implement up to eighty feet wide belonging to the family of rotary hoes, the farmer turns up damp clods, which offer more resistance to the wind than the dried-out and crumbling top layer. He repeats the operation a dozen times in the windy season, from November to May. The war against wind erosion each year costs High Plains farmers millions in fuel alone. The land is so prone to wind erosion that it should actually be used only as pasture land, permanently protected by its grass cover. The farmer drives without regard for the direction of the prevailing wind. For him it is simply a question of saving as much fuel as possible with the minimum number of turns.

In 1983–84, wind erosion damaged 5.7 million acres of crop and range land in Texas, droughts and high winds having collaborated more catastrophically than in the previous thirty years. Blowing soil destroys young crops, buries fences, covers streets and railway lines, sandblasts paint on cars and farm machinery, ruins electric motors and windshields, causes traffic accidents, and aggravates respiratory illnesses. Diminished soil productivity is, surprisingly, last on the list of complaints. With increased use of fertilizer and improved seed, the Texas cotton farmer, among others, has until now been able to overlook the loss of fertile soil to wind, cheating himself in the bargain.

105 Farm near Pomeroy, Washington. In this picture, made during August, the farmer has just brought in the wheat from the pale strips. The stubble has been left behind as a soil cover. He will plant the dark strips, which have been fallow for one growing season, with winter wheat at the end of September or the beginning of October. Low humidity demands two-year crop rotation, wheat alternated with fallow land, which stores up moisture. Occasionally, the crop rotation must be stretched, although the farmer is interested only in wheat: the cycle, then, is wheat—barley—fallow.

Strip farming on the contour demonstrably decreases soil loss by wind and water erosion to a third or even a fifth. Despite this fact, in the Palouse country (plates 34, 100, 102, 129), nine out of ten farmers balk at such precautionary measures, which they consider too expensive and time consuming. All the same, the zebralike beauty of a model farm seen from above might occasionally convince a recalcitrant farmer to do the right thing for his land at the last minute—as was the case with the incident related in the introduction to this book.

106 Crop and range land in the highlands of Azerbaijan, Iran.

107 Eucalyptus plantation near Belo Horizonte, Minas Gerais, Brazil. In the state of Minas Gerais ("general mines"), which conceals under its rolling green hills a single immense nugget of ore, charcoal fuels the blast furnaces of the small and large iron smelters that make up the native steel industry. The charcoal burners are everywhere, but they do not threaten Minas Gerais with deforestation and denudation. The charcoal kilns are located right next to extensive eucalyptus plantations. The law prohibits turning other wood into charcoal. Anyone who wants to prospect for ore in Minas Gerais, even if he does not so much as think of smelting raw iron, is obligated by law to start a eucalyptus plantation, whose size must correspond to the amount of ore to be extracted. Critics, however, find fault: in the hundreds of small charcoal kilns, valuable by-products of carbonization (wood spirits, wood vinegar, wood gas, wood tar) go up in smoke.

Besides producing charcoal, eucalyptus trees are used for making paper and also for supporting telephone lines.

108 Traces of old logging in the swamp-cypress forests, Atchafalaya Delta, Louisiana. A branch canal, connected with the many waterways of the delta, opened up a preselected cutting site. A pull boat equipped with a steam-powered winch was towed to its center, together with houseboats providing office space, sleeping quarters, and cooking facilities for the crew. The barge dragged the logs with a cable from the actual logging site, moving them through narrow openings in the swamp forest that were cut radially in all directions to a distance of half a mile. In the center the logs were tied together to form a raft, and in the spring, when the water rose, they were towed to the nearest sawmill.

Already by 1811 workers who feared for their jobs destroyed a steam-powered sawmill in New Orleans. Logging of cypresses in the delta swamps and the surrounding areas of the Atchafalaya and the Mississippi was early, but for a long time spotty and on a small scale. However, in 1876 the Timber Act opened up the cypress forests for industrial use. Lumberjacks from the north, with technically sophisticated methods, descended on Louisiana's forests like locusts. When they moved on forty years later they left behind ghost towns, dilapidated sawmills, and a ravaged forest. A half-century of new growth still has not healed the wounds of the brutal exploitation.

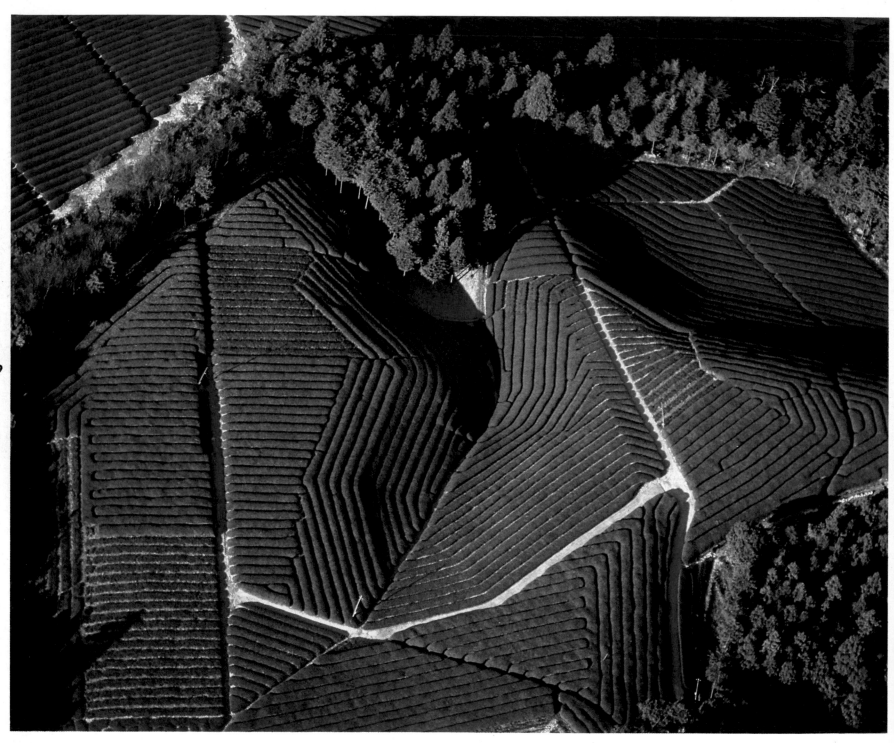

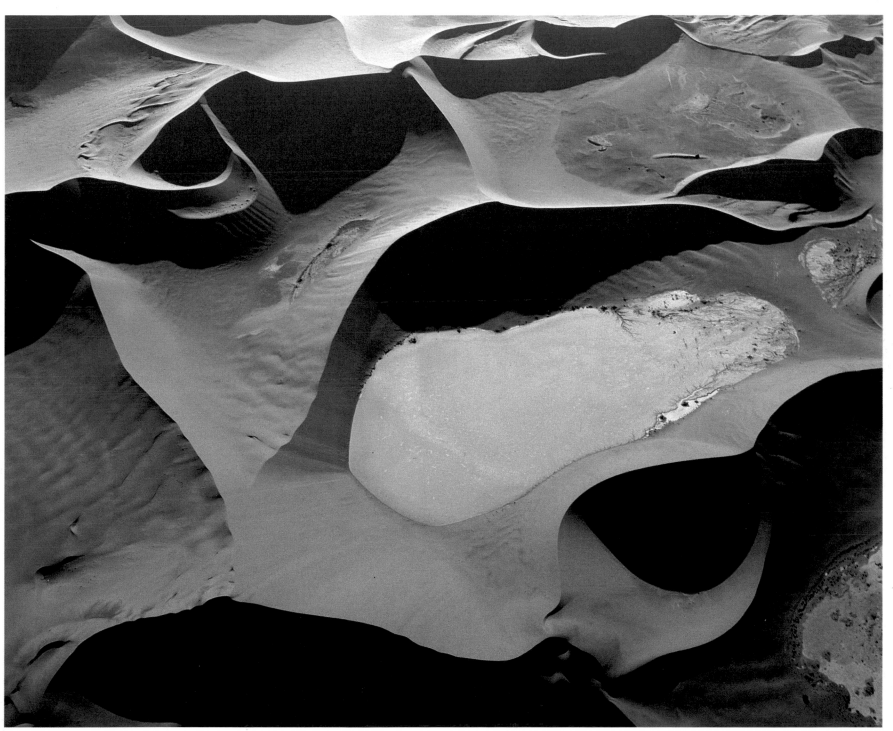

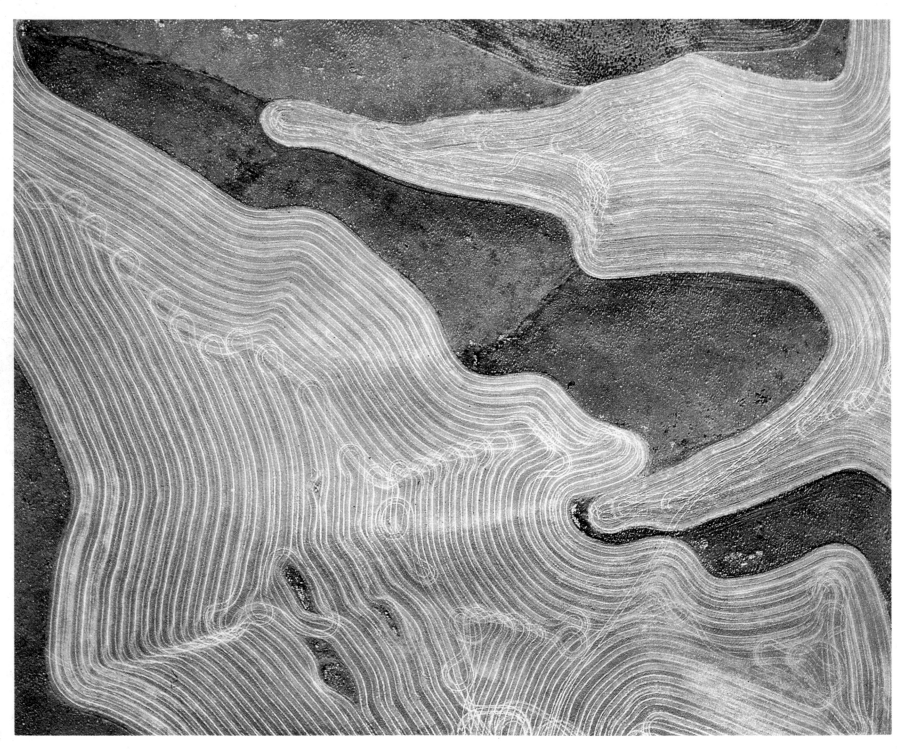

III

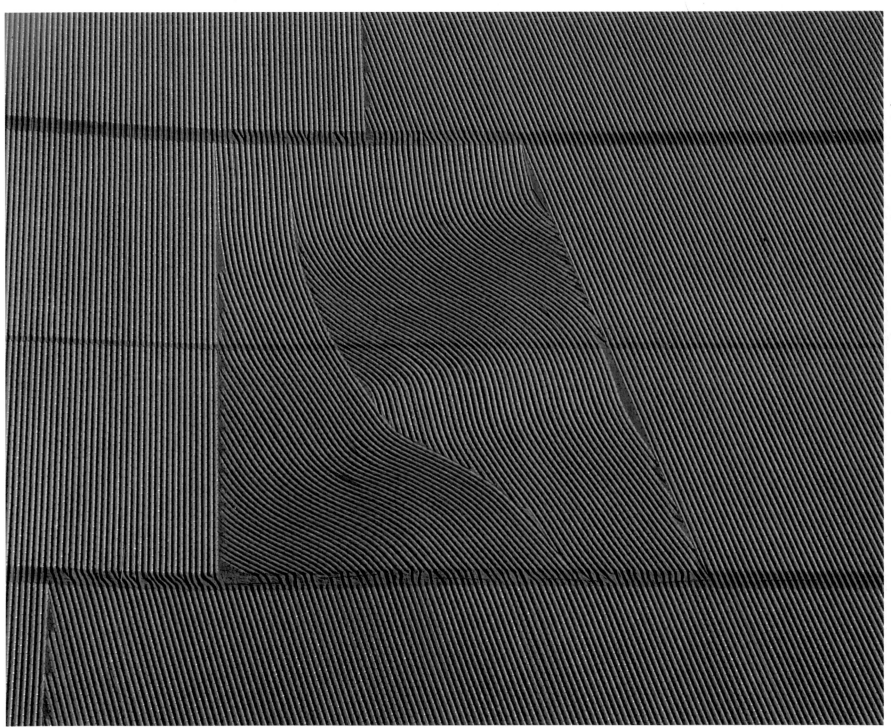

112

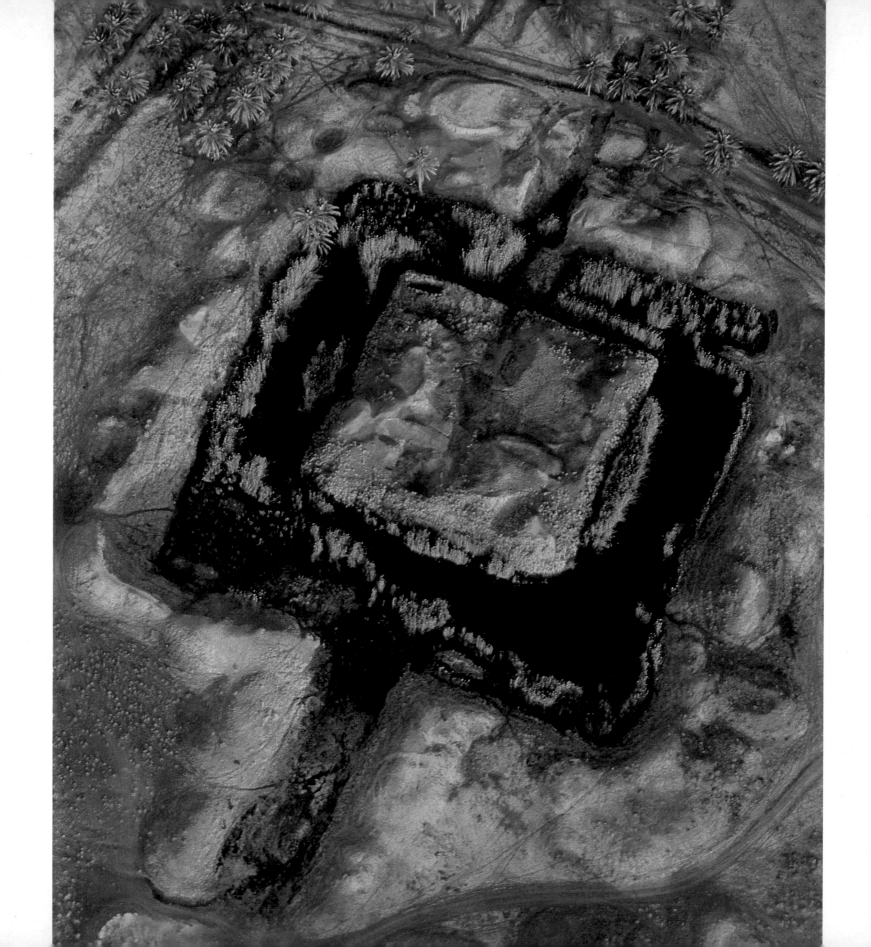

109 Tea gardens in Shizuoka Prefecture, on Honshu, Japan. Shizuoka Prefecture produces half of the 110,000-ton annual Japanese green tea harvest. As a rule, the tea leaves are picked three times a year. The first picking, on the eighty-eighth night after the beginning of spring (February 4), is to the Japanese what the three May days of the so-called "Ice Saints," proverbial for a belated cold spell, are to Europeans: only after this date is it deemed that the danger of frost has passed. Celebrations, songs, and poetry accompany the tea planter's year. Green tea is a beverage, but, above all, it is a way of thinking. Ostentation and discord are sins against the spirit of the tea. The Japanese approach to tea leads to humility and disciplined repose. In the tea cult ("tea ceremony") the tea mistress, by her natural grace raised to an art, transports the guests to a mood of serene relaxation.

Today, production efficiency rules the Japanese tea plantations as it does everywhere else. In Shizuoka Prefecture, the layout of the tea gardens allows for the fact that the tea is still picked by hand. Despite their tribute to modern times, the appearance of these plantations suggests an already ancient and beautiful Japanese achievement: refined simplicity.

110 Dunes and clay pans of Sossusvlei, Namibia. The record dune at Sossusvlei, a nature reserve in the Namib desert, towers 1,260 feet from base to crest, but the terrain secretly contributes to the unusual height. Sossusvlei's most impressive dunes overlay the rocky ridges of a valley, so that the terrain adds close to 660 feet. The clay pans are the beds of lakes without outlet formed by an intermittently flowing and always short-lived river, which spills from the highlands into the sandy wastes of the Namib during heavy rainfalls. It scoured out a valley to Sossusvlei and deposited the sand at the end—raw material for the play of the wind.

For a while the *Guinness Book of World Records* listed the dunes of Sossusvlei as the highest on earth, but they have had to yield their place to some Sahara dunes, which allegedly stand 1,400 feet tall. But perhaps they too have hidden help from the terrain. Specialists doubt that there are, or can be, unsupported dunes higher than 660 feet anywhere. The laws of physics prevent loose materials like wind-blown sand from accumulating past a critical height.

111 Winter wheat after the harvest, near Salt Lake City, Utah. The farmer worked from the outside toward the center. As the space for maneuvering decreased, sharp turns became necessary, which he executed on the already harvested part of the field. The farmer does not plow the straw under or burn it off, but uses it more effectively by means of stubble mulching, thereby creating for the upcoming fallow year an erosion-preventing, water-retaining soil cover.

In Utah's dry farming areas, wheat cultivation alternates with fallow fields. During a fallow year the soil retains a good third of the annual precipitation, an indispensable starting capital of moisture for the new crop. The Mormon state excels in the use of model soil protection measures. Contour plowing, terracing, stubble mulching to achieve a protective topsoil cover, control of water run-off from the neighboring ground; such precautions lower the loss of the topsoil in the dry farming areas of the state to an annual rate of little more than one ton per acre.

112 Strawberry farm near Carlsbad, California. The plants grow through holes in plastic coverings that prevent the berries from hitting the ground and consequently becoming moldy or contracting soil-borne diseases. In addition, the coverings help preserve moisture, warm the ground, and control weeds. The planting rows follow the contours of the slope. Uneven terrain is revealed by waves in the shimmering lake of plastic.

113 The Tower of Babel, Iraq, on the site of the city. This picture shows the results of plundering of the coveted fired bricks by local inhabitants during the nineteenth century. Ground water instead of fired bricks now encloses the core of the ziggurat, which is made of unfired clay bricks. Today the temple tower is irreverently known as the "sauce pan." Its handle is formed by the trench of the old stairway. The founding date of the ziggurat of Babylon, called *Etemenanki*, "foundation stone of heaven and earth," remains elusive. The lowest parts of the tower lie in the ground water and cannot be excavated. The oldest archaeological evidence dates from the reign of Esarhaddon (680–669 B.C.). The heyday of the shrine began with Nebuchadnezzar II (604–562 B.C.), ravager of Jerusalem. This New Babylonian version of the ziggurat combined Sumerian and Assyrian patterns of a temple tower: on top of two stories, accessible via a colossal outdoor staircase, rose four upper stories with an exterior spiral ramp. The height of the ziggurat of Babel was identical to the length of its sides (300 feet), and in this feature the biblical "proud tower" differed from all other temple towers of Mesopotamia. Xerxes reduced the Tower of Babel, and Alexander the Great began to demolish it to make room for a new structure, a project cut short by his death.

114 Calligraphy of a land-leveling machine, Florida. With sweeping, turning circles, it inscribes the muck soil near Okeechobee Lake. "Muck soil" is the term for the deep, heavy, insufficiently drained organic soils around the lake left by former marshes as a residue. A laser beam directs the leveling machine and, later, the mechanical monsters that plow the drainage pipes into the leveled land. In order to achieve efficient gravity irrigation and drainage, the farmer cannot afford to squander even a fraction of a percentage point of gradient. Sugar cane, sweet corn, lettuce, celery, green peppers, and snap beans grow in Florida's muck soils. Once drained and cultivated, these soils have the unpleasant characteristic of subsiding approximately three-quarters of an inch per year.

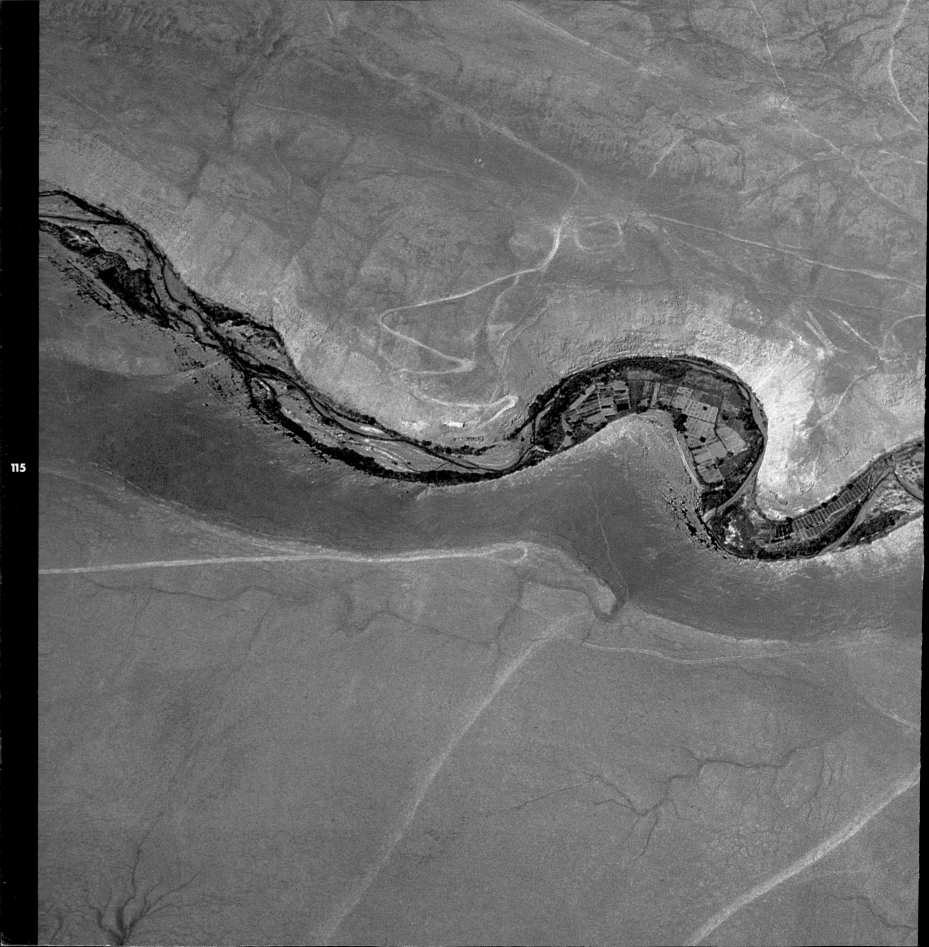

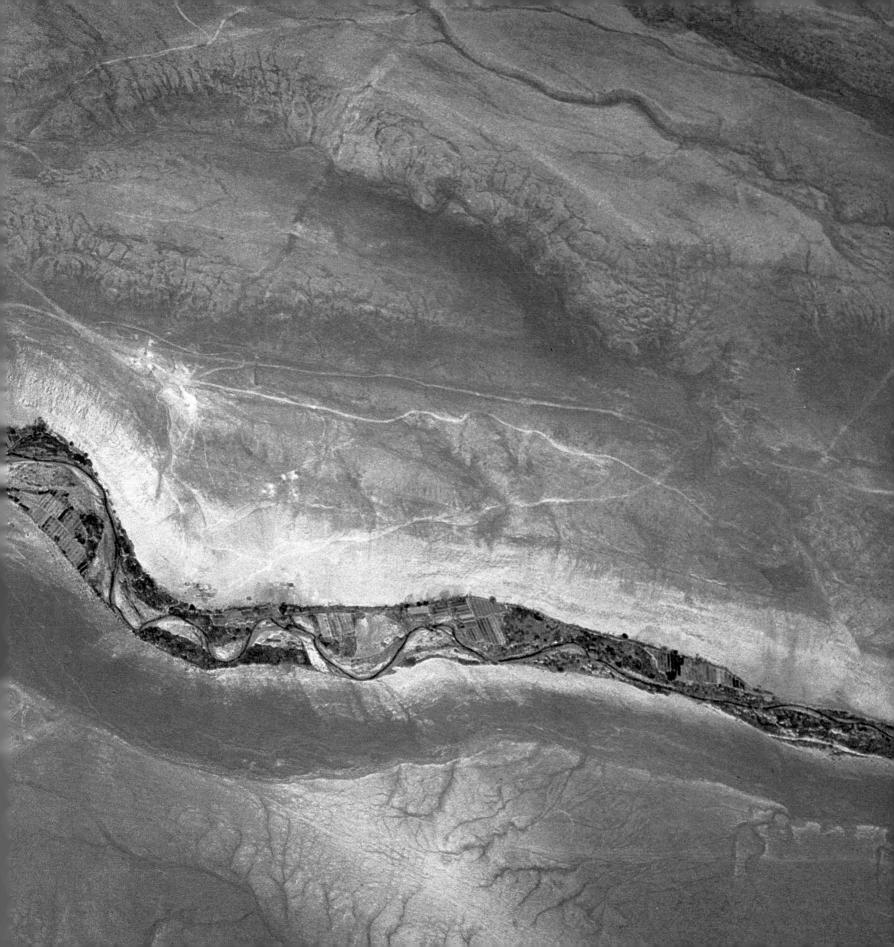

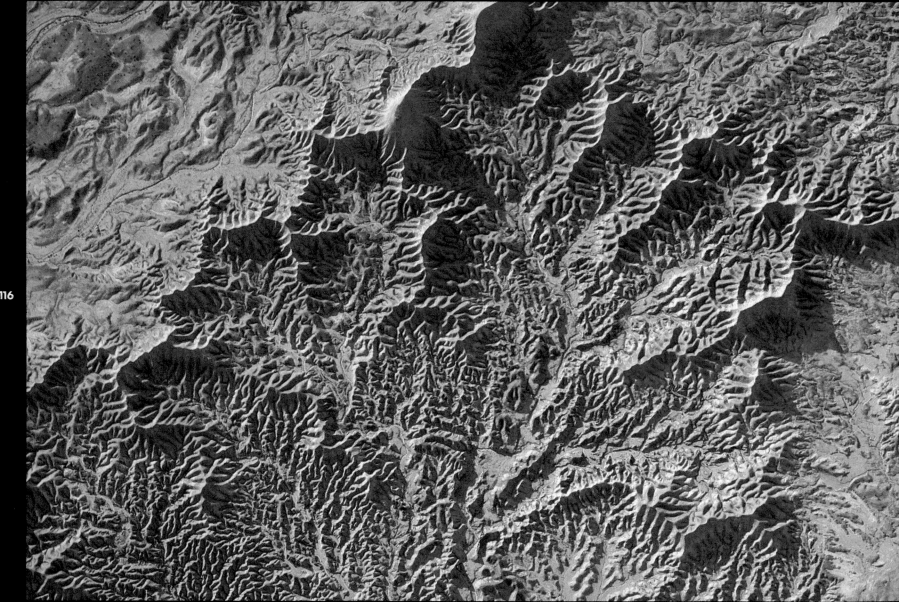

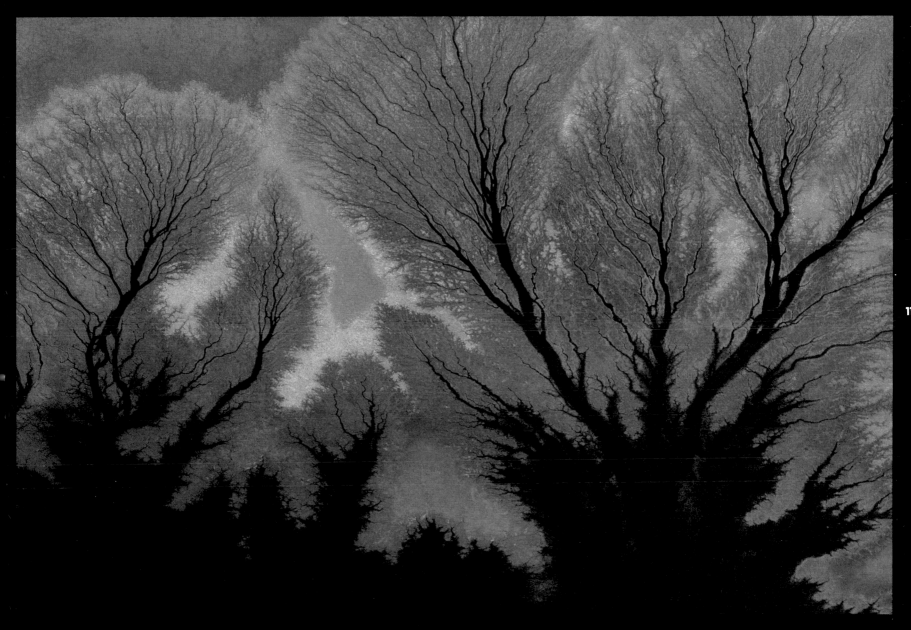

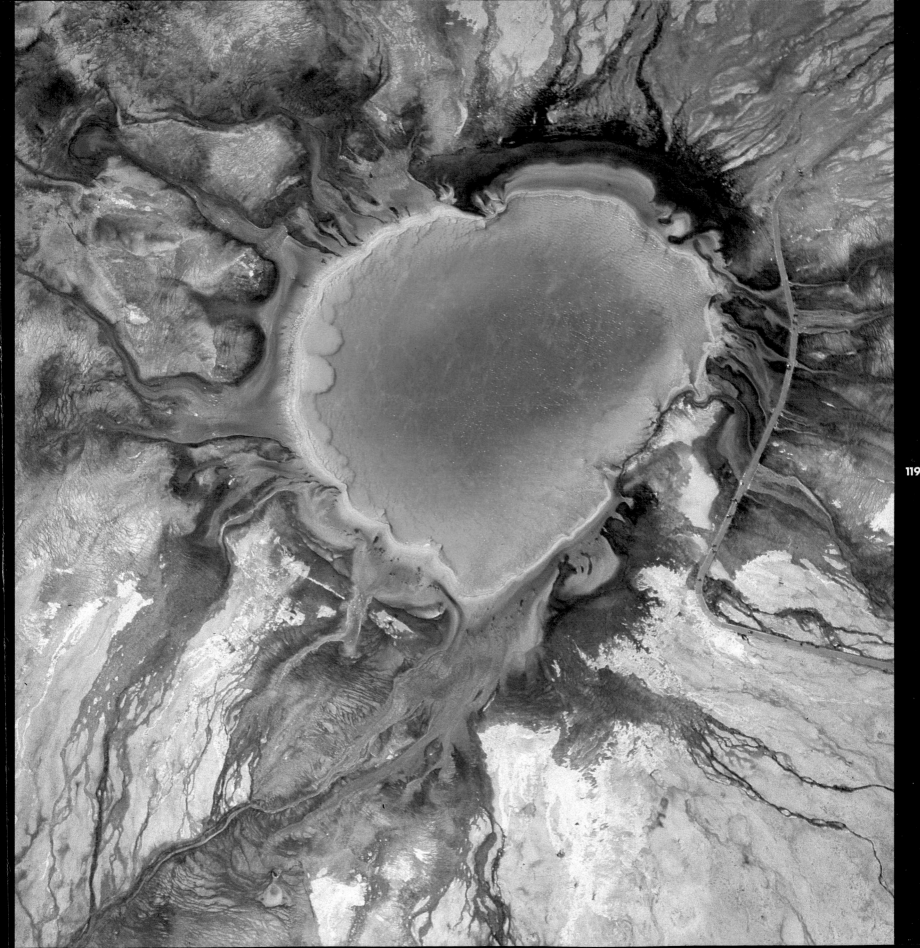

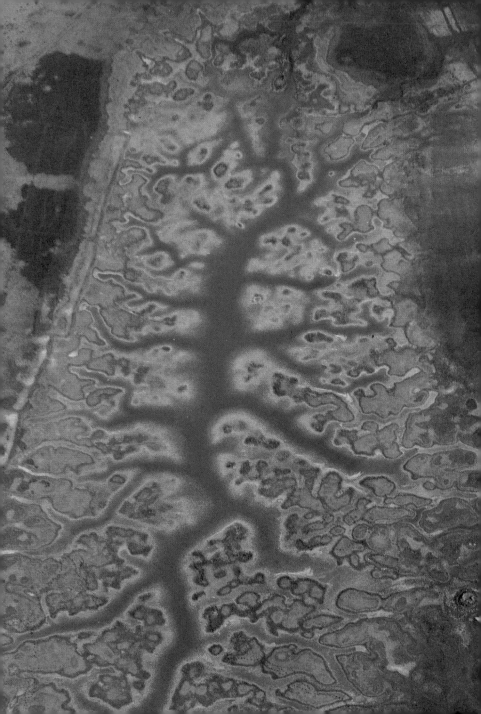

115 The serpentine band of vegetation in the Quebrada de Camiña, Atacama Desert, Chile. In the bone-dry wasteland between the coastal *cordillera* and the Andes (plate 37), life and, even more, agriculture are bound to the rare supplies of ground water and the even rarer rivers that thrust from the Andes to the Pacific, through the deeply crevassed canyons known as the Quebradas. Using a net of irrigation canals and terraced plots built by their ancestors in pre-Spanish times, the Aymara and Atacomeño Indians cultivate corn, peanuts, cotton, beans, sweet potatoes, garlic, pumpkins, and potatoes in the valley oases, as did those ancestors. But the water supply decreases from generation to generation. Snow- and rainfall over the Andes have diminished, perhaps as a result of a fluctuation or permanent shift in the global atmospheric circulation. Many Quebradas have dried out completely during recorded history.

116 Erosion-ravaged hinterland of Bandar Abbas, on the Persian Gulf, Iran.

117 Drainage patterns made in the saline mud of Lake Natron, Tanzania. The patterns resemble so-called dendrites, for example, the treelike branching figures produced by manganese in rock. Nowadays, such comparisons are no longer suspect as mere analogies, surreptitiously and gratuitously introduced and too cheap to bother with. A new line of research, synergetics, is looking into the amazing correspondences between the world of the big and very big and the world of the small and very small: the open branching in a river delta and the dendritic ends of nerve cells; the spiral galaxies and a double helix of DNA. Synergetics is concerned with processes of self-organization in biology, chemistry, and physics; it analyzes structures of animate and inanimate nature that develop from the interaction of the individual parts of systemic wholes. Synergetics enlarges its scope by including even man-made structures for examination. For example, the German Research Association's "special field of research number 230" compares the processes of structured formation in nature with those in technology and architecture.

118 Ponds from melted snow and ice on the Long Glacier (Langjökull), Iceland. The picture shows a transition zone of the glacier. From its actual birthplace, where snow turns into ice, the glacier sent a tongue-shaped ice floe toward the valley. The glacier moves from right to left, faster at the top than the bottom. Shearing produces the S-shape of the ribs. Water from melting snow and ice does not drain away from the transverse crevasses, which is a characteristic feature of a pressure zone. At the end of July the ice is almost free of snow; some snow endures, especially in the crevasses. The aerial view shows the glacier a little below the so-called firn line; the layered structure of the ice indicates the same altitude. The dark layers contain volcanic ash from the weathering of lava flows.

Glaciers cover more than one-tenth of Iceland's surface. The 4,325 square miles of ice correspond to almost four times the total surface area of all Alpine glaciers. With approximately 366 square miles, the Long Glacier is the second largest of four "glaciation centers" on the island.

119 The Grand Prismatic hot spring, Yellowstone National Park, Wyoming. The heart of the park in the northern Rocky Mountains is a *caldera* from a volcanic explosion that buried the surrounding area as well as parts of the present states of Texas and California 600,000 years ago. Residual heat from that natural catastrophe still maintains 10,000 hot springs and steaming ponds, geysers, fumaroles, and mud volcanoes. Presently some of the parkland bulges measurably; a rock chamber under the bulge fills with lava, a time bomb ticking away. On some tomorrow it will blast the oldest national park (established 1872)—and the one that spread the idea of national parks throughout the world—into pieces.

The Grand Prismatic spring pours out 50 gallons of water per minute, at 153.5 degrees Fahrenheit, and has formed a lake that measures up to 367 feet from shore to shore. An elevated boardwalk protects visitors from scalding. Heat-loving microorganisms, particularly single-cell algae, not only survive, but even thrive in the water and dye the shores and flaming protuberances of the lake. The changes in color mirror temperature gradients as the water cools away from the rim of the lake. Some microorganisms like it especially hot in Yellowstone. Not even piping hot water (at this altitude it boils at 194–203 degrees Fahrenheit) deters certain bacteria.

120 Erosional pattern in the low plain between the Euphrates and the Tigris, Iraq. Rain and surplus irrigation water flow into a depression and take on the shape of a many-limbed dragon. The monster gets its color and oily sheen from minerals in the soil.

121 Corals in the Duff Reef, Lau archipelago, Fiji. The corals protrude thornlike on the seaward side of the reef.

Coral reefs are oases in the desert of the sea. They are among the most tightly knit and most complex ecosystems. But peace does not reign in the coral realm; a war of poisons is waged on the reef. Corals and other members of this community use toxic excretions as weapons in a fight for living space. For all that, because of the exemplary coexistence of reef corals and algae, the reef is also one of the most productive ecosystems known. The algae supply the corals with the carbohydrates they produce by photosynthesis; and, with their metabolic products, the corals supply the phosphate and nitrogen requirements of the algae. No wonder that even small changes in the environment can unbalance this sensitive system. Nutritively enriched water, perhaps the result of waste-water contamination, lures the algae away from the corals. Drunk on nitrogen and phosphates, they grow rampant and kill the reef.

Marine biologists puzzle over the demise of the reef presently observed in the South Pacific. In addition to increased dumping of harmful substances, the scientists chiefly consider changes in global air and water circulation, which cause a warming of the seas that is fatal to the corals.

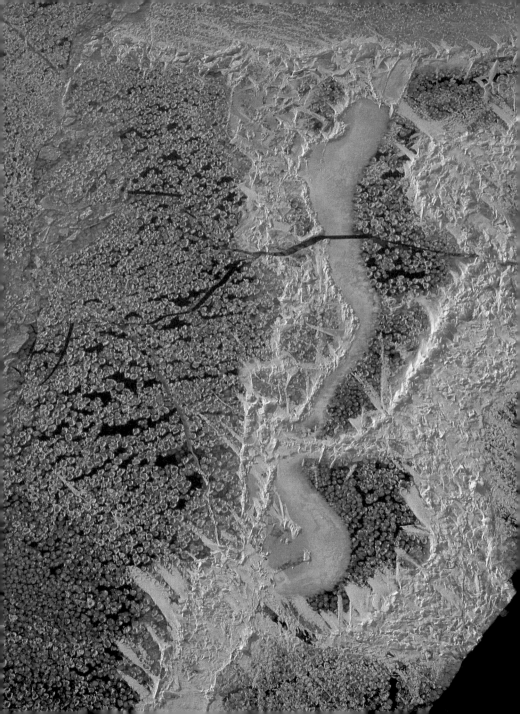

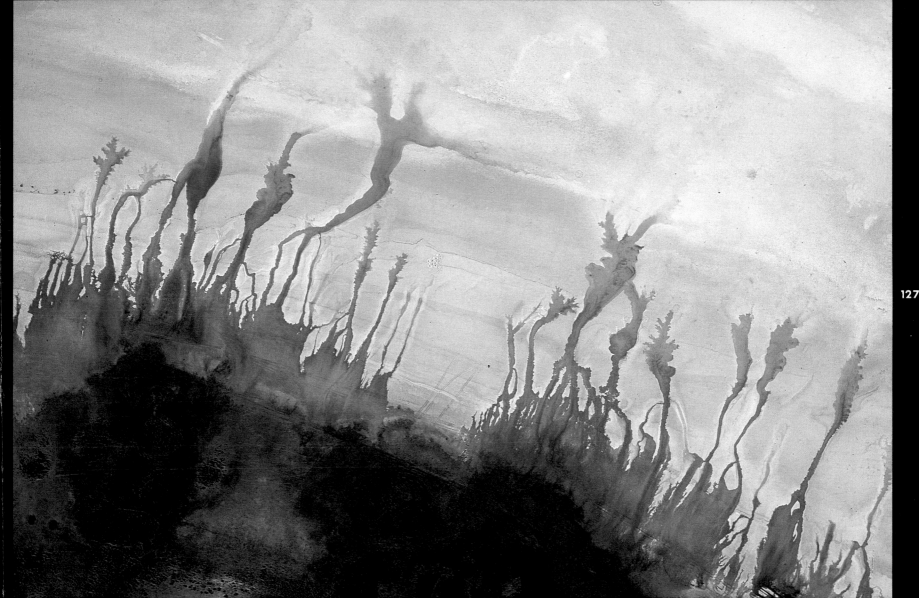

122 Ice on Lake Michigan. Ice floes with edges curved upward dominate the left half of this aerial view. They resemble water lilies or, perhaps a more appropriate— since cooler—comparison, giant frost flowers. These ice floes, aesthetically attractive as they are, puzzle specialists. They appear to ride on top of the exceptionally translucent ice, which one would hardly expect on the surface of this normally choppy Great Lake. In the sequence of ice formation, the production of ice floes doubtlessly preceded the transformations of the ice cover. This is evident in the right half of the picture: a rupture accompanied by a subsequent flooding and refreezing—visible as a milky meandering shape—and piled-up ice partly buried by snow drifts. The picture does not, however, reveal *how* the ice floes were formed.

At least the rupture may be due to man's intervention. The record-cold of February 1977 had trapped several supply ships, including an oil tanker, on Lake Michigan, and ice breakers had to clear a channel for them.

123 Salt gardens near Walvis Bay, an exclave of the Republic of South Africa, in Namibia. The sun bleaches the crystallized salt in the final pond of a salt farm. The bacteria that give the salt its red color (plate 24) are slowly dying.

124 Field of California poppies (*Eschscholzia californica*) near Lompoc, California. The worn spots in the flower carpet probably reveal a temporary failure of the sowing machine; however, they also might be read as symptoms of soil erosion: the wind blew away the seeds or suffocated them with blown soil. Poppy seeds are not planted deeply.

The flowers wilt on the field, then machines harvest the seed capsules. Lompoc's long, rainless summers create ideal conditions for the harvest. No wonder the valley produces more than half of the world's seed for garden flowers.

The sepals, which grow in the shape of a little cap, and perhaps also the fact that the flowers open late and close early have earned the California poppy the nickname "little sleepyhead." Nevertheless, it, or at least a saffron yellow variety of it—the golden poppy—has been formally honored: it is the official flower of the Golden State, California.

125 Tracks in the snow near Rochester, Minnesota. After a snowfall, cattle left behind these trampled paths on a corn field. The tracks congregate near the entrance to the fenced field. Hardy Hereford cattle spend even the severe winters of Minnesota in the open.

126 Magma lake in the big crater of the Erta Ale volcano, Ethiopia. The molten lava develops a thin skin where it is exposed to the air. Where the skin breaks, hell blazes and bubbles through. The Erta Ale in the Afar Depression is, technically speaking, a basaltic shield volcano in process of formation. It is one of only two volcanoes in the world with a permanent lava lake. Its diameter at the time of this photograph measured approximately 165 feet. The Erta Ale can even keep another honor all for itself— though this distinction might impress only geologists and volcanologists: it is completely unique as a continuously erupting volcano in the median valley of a dried-out oceanic ridge.

127 On the shore of Lake Maharlu, near Shiraz, Iran. The water level has fallen. Mature, and therefore reddish, brine has collected at the deepest points of the drainage channel. On the lake the salt has crystallized.

To use the word *lake* to describe this puddle in the Iranian heartland is perhaps rather generous. The winter rains do expand the surface area to twice that of Lake Zurich, but it is not—never and nowhere—deeper than thirty-one inches at any point. It begins to shrink in June. Then the air over the high plateau, like a piece of blotting paper, sucks up all the humidity. The dryness, aided by the wind, can snatch up to 15.6 inches of water from the lake per month. With this shrinkage (and attendant increase in salt content—up to ten times the salinity of sea water) the busy days of the salt producers begin. Presently they remove 110,000 tons of common salt from the lake annually. Before the sun can completely empty the lake in the hot season, underground salt springs begin to gush, for reasons that are not yet understood. At first they barely compensate for the evaporation loss, but later overtake it. Even before the first rains, Lake Maharlu suddenly creeps up its banks again.

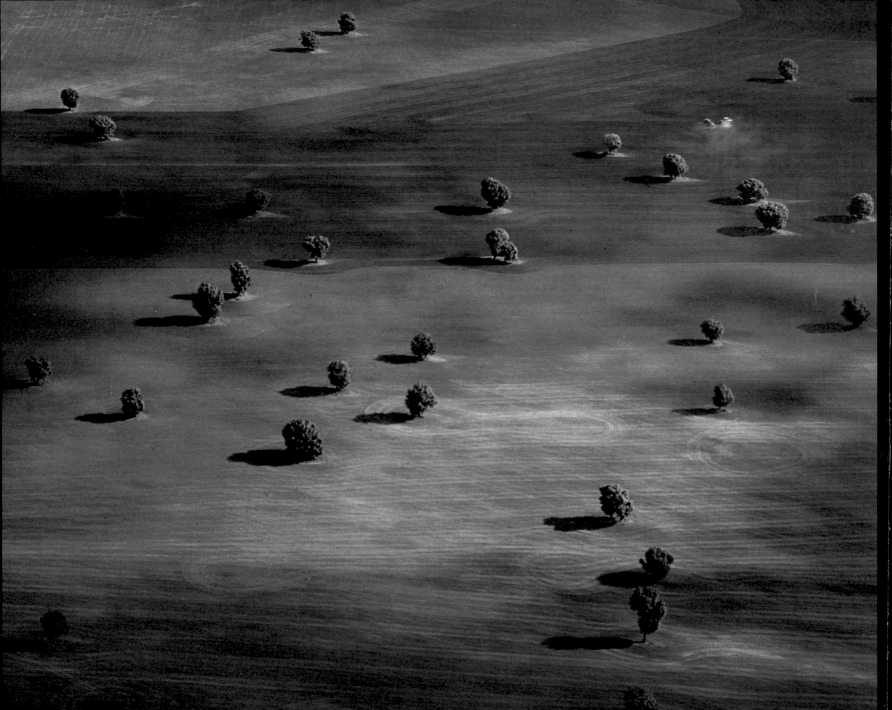

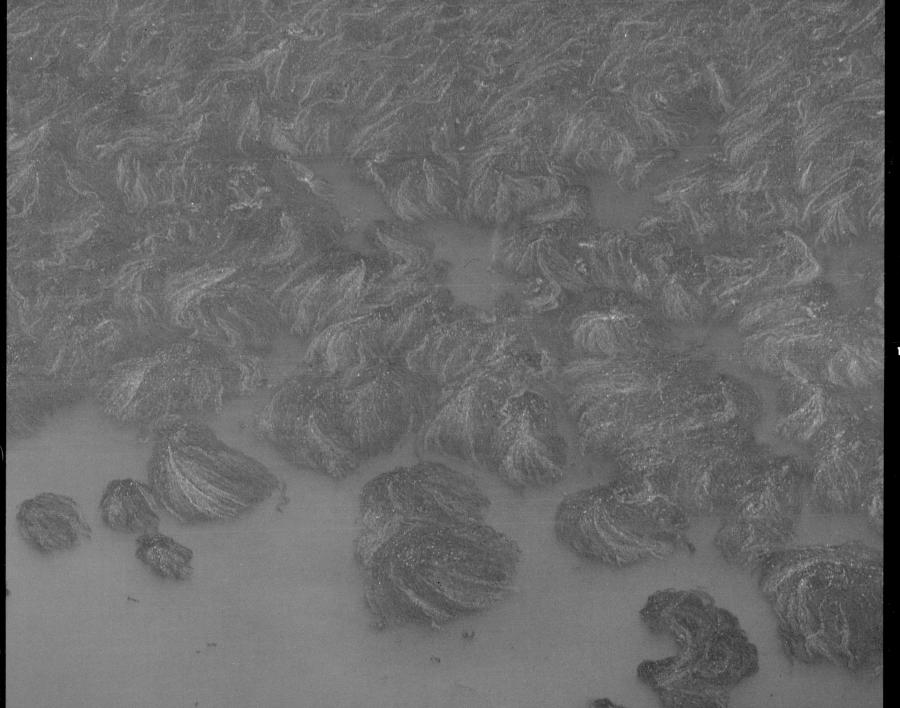

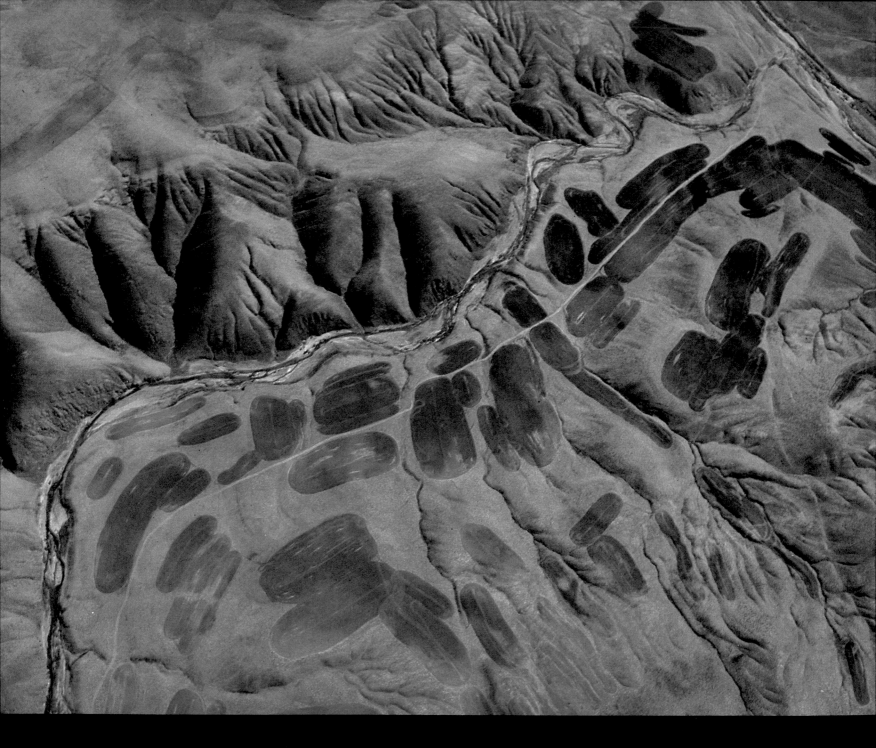

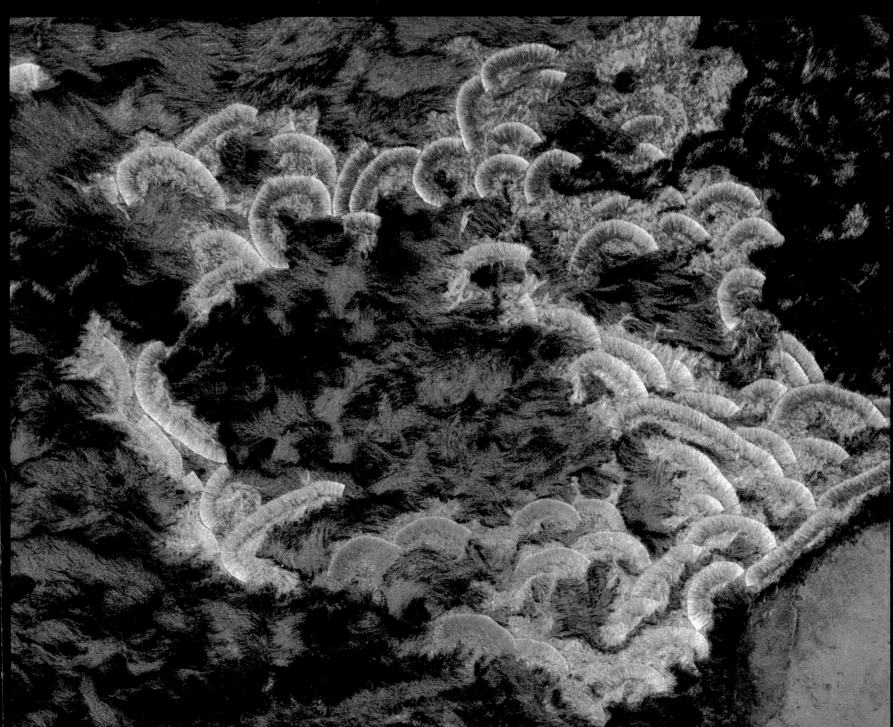

128 Tree and grass islands in a field near Dubbo, New South Wales, Australia. Should one praise the farmer for leaving behind at least a few trees or should one scold him for leaving behind so few? The eucalyptus are what is left of a formerly closed deciduous hardwood forest in the present wheat belt of New South Wales. In the poem "To Future Generations," Bertolt Brecht complained, "what kind of times are these where / a speech about trees is almost a crime / because it includes a silence about so many atrocities?" The "future generations"—only two generations after Brecht's poem—do not, however, want to keep silent about atrocities and injustice, but have become "greener" in ecological awareness if not necessarily wiser. These are the kinds of times when it is almost a crime *not* to talk about trees.

129 Pea farming in the loess hills of the Palouse country, Washington. The speckling on the picture comes from various degrees of ripeness of the peas and the ash, which the wind drove like snow after the eruption of Mount St. Helens in May 1980. The erupting volcano blew half a cubic mile of ash into the air. The peas do not come up in some areas under the ash deposits, especially where water erosion has worn down the topsoil to the loamy subsoil.

The Palouse country, in southeastern Washington and neighboring areas of Oregon and Idaho, is plagued and endangered by erosion as few other agricultural areas in North America are. Palouse farmers who do not brace themselves against wind and water with strip farming, crop rotation, and contour plowing (plate 105) annually lose up to 156 tons of topsoil per acre. It may be noted in passing that the fertile loess cover of the Palouse country is itself a product of erosion: in the geological past, winds sprinkled its hills with silt—though this should be perceived less as a consolation than as an irony.

130 Papyrus islands in a shallow lake in the upper reaches of the Zaire River, Zaire. One of Africa's last contiguous papyrus swamps occupies the Upemba Depression on the Zaire. A large part of it becomes temporarily mobile. At flood time, papyrus mats drift along with the wind and waves on a dozen of the shallow lakes. In the dry season, when the Zaire recedes, they become anchored once again.

Papyrus is a champion of plant productivity. At optimal locations papyrus yields a harvest of 14.25 tons of biomass per acre. A year after cutting, the plants have regrown to the same mass. Papyrus, like sugar cane or corn, is a so-called C4 plant and therefore has an unusually high net photosynthetic performance. In addition, papyrus roots have their own natural fertilizer factory in the form of nitrogen-fixing microorganisms. In Rwanda the making of briquettes from dried and chopped papyrus is being tried as a possible solution to the African fuel crisis. Experts also praise the briquettes as a practically smoke- and ash-free fuel. But Luba fishermen, who live on the floating papyrus islands of the Zaire for a few months each year, say that what smoke papyrus fires do produce has a high mosquito-repelling effect. Perhaps, in this case, less is not much more: they might fare better with increased smoke.

131 Kelp near Point Conception, California. Brown seaweed, called kelp, forms extensive underwater forests off numerous coastlines throughout the world. Air-filled floating spheres hold these giant seaweed upright. With suckers and claws, the plants cling tightly to the rocky floor. Seaborne breakers would smash the rock itself before they would succeed in prying loose the algae's grip. The big brown seaweed present the highest organizational stage among all algae. They have true tissue (parenchyma) like the higher plants. World record holders are found among them: they are the largest known aquatic plants. Rumor tells of specimens up to one thousand feet in length; even verifiable measurements have indicated lengths of more than two hundred feet.

Brown seaweed is an extremely useful plant. Kelp is eaten by humans and fed to animals, yields high-quality fertilizer, can be fermented to produce biogas, and is a source of iodine and soda. But above all, kelp supplies alginic acid, highly valued in textile, paper, food, and cosmetic industries, as well as in medical technology and pharmaceutics.

132 Fields near Sanadaj, Kurdistan Province, Iran. The opinion of non-Kurdish Iranians on this type of cultivation unique to Kurdistan, is brusque: "sloppy, irrational—just like the Kurds." Reasoned judgment or simple prejudice? At least from the point of view of farming technology, but perhaps also ecologically speaking, this "nice mess" has something to it. The tractor with trailed equipment (as opposed to the use of a tractor with mounted equipment or even, more traditionally, the use of traction animals) considerably reduces the farmer's maneuverability. The Kurdish farmer therefore makes a virtue out of necessity and chooses a circular or oval shape for his field. He plows from the inside in one pull without time-consuming turns. The plow is in constant use, and the output substantially increases. The unfavorable climate, in any case, makes bad years the rule; a sizable harvest is as good as winning the lottery. To keep the stakes in this agricultural gamble low, the farmers till the biggest possible (potential) harvesting area with the smallest expenditure of energy. The photograph also shows plots from the previous year, which are presently untilled. Evidently the farmers practice crop rotation.

133 A harvest of rushes in a coastal swamp near Supe, Peru. The cut rushes dry, laid out in the shape of half-moons. They are primarily used for matting. Also, in a few spots along the northern Peruvian coast, the construction of boats from rushes—and their use in fishing and shrimping close to the shore—has survived. There rush boats are known as *caballitos,* "little horses," because of the way fishermen ride them when they do work that requires a secure hold, for instance, pulling in the nets. Machica and Chimu pottery frequently portrays such "little horses" and their paddlers. It appears that there was even something like an old Indian marine corps, equipped with rush boats. In any case, a vessel of the Viru culture, in the shape of a "little horse" mounted by a warrior holding a club band shield, has been identified.

LIST OF PLATES

1 Waste-water purification plant at a pulp mill, Lewiston, Idaho.

2 Flooded area in the Mompos Depression, Colombia.

3 Pools at the northern edge of the Etosha Pan, Namibia.

4 Wandering dune in Kharga Oasis, Egypt.

5 Low tide near Kunduchi, Tanzania.

6 Tidal gullies in the mud flats near Bandar Abbas on the Persian Gulf, Iran.

7 Coral reefs off Townsville, Queensland, Australia.

8 Waste-water purification lagoon along the Mississippi, north of Baton Rouge, Louisiana.

9 Rotting fruit near Homestead, Florida.

10 Sand shoals in Moreton Bay, near Brisbane, Queensland, Australia.

11 Waste-water purification plant near Baton Rouge, Louisiana.

12 Salt pans near Massawa, Ethiopia.

13 The opal field at White Cliffs, New South Wales, Australia.

14 Bryce Canyon National Park, Utah.

15 Coral reefs off Abaco Island, Commonwealth of the Bahamas.

16 Crystallizing soda on Lake Magadi, Kenya.

17 The fishing village of Nueva Venecia, Colombia.

18 Tree skeletons in the red mud of an alumina works near Gove, Australia.

19 Spruce trees snapped like matchsticks, Yellowstone National Park, Wyoming.

20 Rice cultivation near Semarang, central Java, Indonesia.

21 Citrus groves near Morphou, Cyprus.

22 Irrigated fields near Yazd, Iran.

23 Mosaic of fields near Bushehr, on the Persian Gulf, Iran.

24 Salt gardens on Lake Magadi, East African Rift Valley, Kenya.

25 Flamingos on Lake Bogoria, Kenya.

26 Mosaic of fields in Lasta, Wollo, Ethiopia.

27 Cell grazing on an oil field near Wink, Texas.

28 Pineapple plantation on Lanai, Hawaii.

29 Salt harvest in San Francisco Bay, California.

30 A manor house near Badajoz, Extremadura, Spain.

31 Palm gardens in the "Souf," a group of oases in the Sahara, Algeria.

32 Nesting and brooding islands for waterfowl near Germantown, New Brunswick, Canada.

33 Neuf-Brisach, Département Haut-Rhin, France.

34 Farm near Palouse, Washington.

35 Mangroves in the Niger Delta, Nigeria.

36 Irrigated wheat fields near Hamadan, Iran.

37 Wandering dunes in the Atacama Desert, Chile.

38 A forest lake in Banff National Park, Alberta, Canada.

39 The maze at Longleat House, Wiltshire, England.

40 Madame Lisa in the grass, near Alamo, California.

41 Wheat, ready for harvest, near Lewiston, Idaho.

42 *Spiral Jetty* by Robert Smithson, in the Great Salt Lake, Utah.

43 Strip farming on the contour near Canton, Ohio.

44 The Giant of Cerro Unitas in the Atacama Desert, Chile.

ACKNOWLEDGMENTS

THE PHOTOGRAPHS

The book draws from material gathered in seventy-four countries and territories throughout the world, and taken from small chartered planes during almost three thousand flight hours. In making the selections for this book, I did not take into consideration the locality of the picture. I did not strive for variety in geography or countries; nevertheless, thirty-six countries and all permanently inhabited continents of the world are represented here.

All of the images are unfiltered 35-millimeter photographs made on Kodachrome film. Color separations were made from master duplicates supplied by the Color Copira AG, Maur/ZH, except when separations from previous publication were already available. I used Nikon cameras and lenses exclusively. For details of their use in aerial photography, please refer to the introduction, "Found Objects."

THANKS

First I would like to extend my special thanks to Swissair, particularly its former head of advertising, Albert Diener (now head of the Corporate Identity Department) and Art Director Fritz Girardin. As in the case of my previously published aerial photographs, I would like to thank Mr. Diener and Mr. Girardin not only for the assignments they gave me, but also for motivation and encouragement that came from a shared conviction that beauty out of the blue must not be noncommittal and that aerial photographs contribute in a contemporary manner to man's experience of himself. I would also like to include the photographer Emil Schulthess in my thanks: as the designer of a series of posters and calendars of aerial photographs, for which my pictures were used, he influenced the direction and aim of my photography from the beginning.

I wish to thank the National Geographic Society in Washington, D.C., which made many of my world-wide travels possible and thereby greatly enriched the range of the present material. The society recently allowed me to indulge my hobby of celebrating farmers as unintentional artists by giving me two hundred flying hours above the American agricultural landscape.

I would like to thank my wife, Anita, for her help in juxtaposing the pictures. A few especially gripping, as well as piquant, pairings are her work.

I wish to thank everyone who assisted me during the preparation, execution, and evaluation of my flights. I have always been committed to precise descriptions of the pictures. If I must founder on the shoals of inaccuracy or those of over-accuracy, I much prefer those of pedantry. Information on a picture is often as useful as Ariadne's thread: it guides one through the labyrinth. Occasionally the information on a discovery has provided me with greater satisfaction than the discovery itself. I say this in advance so that my thanks to informants will carry the proper weight.

I could count on the Soil Conservation Service, an office of the American Department of Agriculture, for help in deciphering the sign language of the American landscape. The following generously gave me their knowledge: Eugene Andreuccetti, Davis, California; Byron E. Chase, Lewiston, Idaho; Billy C. Griffin, Temple, Texas; Homer R. Hilner, East Lansing, Michigan; G. Wade Hurt, Gainesville, Florida; Kenneth D. Kaul, Rochester, Minnesota; Robert K. Kissler, Columbus, Ohio; Greg Sokora, Lubbock, Texas. I would also like to thank the following for explanations and illumination: Juergen Barth, Sydney, Australia; Helga Besler, Stuttgart, West Germany; Joyce S. Diamanti, Calcutta, India; Phil Dreisbach, Coeur d'Alene, Idaho; Rob Harding, Banff, Canada; Edwin Höhn, Tänikon, Switzerland; David E. Hughes, Eastbourne, England; Tony Kay, Magadi, Kenya; Julian Klug, Jakarta, Indonesia; Alain Kupferman, Jakarta, Indonesia; Margarita Marino de Botero, Bogotá, Colombia; Keith McAloney, Amherst, Nova Scotia, Canada; Naomi Nero, Herzlia, Israel; Oscar H. Orajuela M., Bogotá, Colombia; Hans Röthlisberger, Ürikon, Switzerland; Walter A. Schmid, Zurich, Switzerland; Mary Seely, Gobabeb, Namibia; Tom Sterling, Kamloops, British Columbia, Canada; Max Ziegler, Luterbach, Switzerland. I thank Radka Donnelle-Vogt, Boston, Massachusetts, and Zurich, Switzerland, for critically reading the translation.

As far as I have used pictures from *Grand Design (Der Mensch Auf Seiner Erde)* and *Brot und Salz,* the thanks that I voiced when those books were published remains undiminished. The captions that accompany these photographs were, when necessary, reworked and brought up to date.